COLOR WORKBOOK

Becky Koenig

Illustrated by Becky Koenig

Prentice
Hall

Upper Saddle River, New Jersey 07458

Library of Congress Cataloging-in-Publication Data

Koenig, Becky.
 Color workbook / Becky Koenig; illustrated by Becky Koenig.
 p. cm.
 Includes bibliographical references and index.
 ISBN 0-13-093317-1
 1. Color. 2. Color in art. I. Title.

 QC495 .K75 2003
 701'.85-dc21

 2002075984

Publisher: Bud Therien
Editorial Assistant: Sasha Anderson
Production Editor: Jean Lapidus
Manufacturing Buyer: Sherry Lewis
Copy Editor: Stephen C. Hopkins
Line Art Manager: Guy Ruggiero
Formatter: Rosemary Ross
Artist: Mirella Signoretto
Indexer: Murray Fisher
Cover Image Specialist: Karen Sanatar
Cover Design: Kiwi Design
Cover Art: Jasper Johns (B. 1930) "False Start 1," 1959. 67½" x 53". Oil on canvas, 1959. Collection of
David Geffen, Los Angeles. © Jasper Johns/Licensed by VAGA, New York, N. Y.

This book was set in 10.5/12.5 Times Roman by HSS In-House Formatting and Production Services Group,
Pearson Education, and was printed and bound by Phoenix Color Corp. The cover was printed by Phoenix
Color Corp.

© 2003 Pearson Education, Inc.
Upper Saddle River, New Jersey 07458

Printed in the United States of America
10 9 8 7 6 5 4 3 2 1

ISBN 0-13-093317-1

PEARSON EDUCATION LTD., London
PEARSON EDUCATION AUSTRALIA PTY, Limited, Sydney
PEARSON EDUCATION SINGAPORE, Pte. Ltd.
PEARSON EDUCATION NORTH ASIA LTD., Hong Kong
PEARSON EDUCATION CANADA. LTD., Toronto
PEARSON EDUCATION DE MEXICO. S.A. de C.V.
PEARSON EDUCATION—Japan. Tokyo
PEARSON EDUCATION MALAYSIA. Pte. Ltd.
PEARSON EDUCATION, Upper Saddle River, New Jersey

To my father, James R. Koenig,
who introduced me to the world of color.

Brief Contents

Contents

Preface

Color is at the center of our strongest sense, vision. Color, in nature, influences our daily lives through our sensory input of skies, flowers, trees, stones, and water. Color is a product of the light that we experience in the course of days and seasons: cloudy, overcast, wintry, hot and steamy, sunny, clear and cool.

We emulate the colors of nature through our art, architecture, clothing design, graphic design, and functional objects. Color guides our preferences in both appreciation of aesthetic objects, and also the purchase of functional items for our daily living: cars, color inside our homes, clothing, and food.

Color is both a physical and an emotional human phenomenon. We respond to color because of its associations. We have our own personal preferences for particular color combinations. Our experience of the world is in some ways synonymous with our observation of color: a green apple, a red sports car, the pink sky of a sunset, the blue of a robin's egg. These colors evoke not only an outward experience but also form colors in our memory, our inner eye. Color is thus not merely a decorative element in art, but a part of our inner consciousness. Color is life enhancing.

For the artist and designer, color is both the most complex design element as well as the most powerful and visually compelling. Color can soothe, disturb, express personality or culture, suggest or reflect reality, convey light or dark moods and emotions. Our personal color preferences may be rooted in our life experience, the collective unconscious, our physical surroundings, and our instincts. Color is unique among the art elements as it crosses the boundaries between art and science. Some of the information presented here may seem scientific to the student of art, but this book is aimed toward visual art and design. The scientific material is included to enhance a fuller understanding of color phenomena.

Color study is an under-taught yet ever-evolving field. There is more color in our lives than ever before. More publications are produced in color, due to color copiers and computer printers. Web design is displayed in illuminated color. There are also more color choices presented to the artist than ever before, more color media and pigments available along with the capability of a computer to produce 16 million colors. Due to technology, the arena of color in art and design has virtually exploded. The role of color in art and design calls for a high degree of color knowledge for every artist and designer.

Color study is a misunderstood area of art. Artists often harbor preconceptions about the element of color either as a simple or overly complex aspect of art. Sometimes color study is viewed as a hindrance to an artist's color instincts. This is emphatically untrue. The study of color opens doors to a fresh approach to color, and helps us to avoid obvious color selections chosen simply from the computer swatch palette or directly out of a tube of paint.

Why another book on color? During my twelve years of teaching color theory, I used various texts, most of which only covered portions of color and design information that was useful to students. This led to my decision to write a text myself. I wanted to present color theory in an understandable manner as well as address the impact of color on formal design. The color study activities included in this text have been developed over years of teaching color theory to make color experiential for students.

In this book, Part I is a complete color-study section, covering color basics, color theory and systems, attributes of color, color materials, and computer color. In Part I, color is addressed as an entity independent of composition. Part II pertains to design, compositional theory, and the role of color in design and art. The two parts are meant to form a systematic journey for the student through color and design knowledge.

The key factor in color and design knowledge is for students to experience putting theory into practice. This is the rationale for the inclusion of activities specific to the contents of each chapter. Hands-on study in color and design is invaluable. We cannot learn to be artists by simply listening to lectures or reading books. The point of the chapter activities is to make design and color theory accessible to all students.

This text can also serve as a self-guided tour of color for a dedicated student or artist. Even a sampling of the activities would be extremely helpful to a student's understanding of color. Color is best comprehended by hands-on experience. This book provides a broad base of knowledge meant to demystify the complex world of color.

Becky Koenig

Buffalo, New York

Acknowledgments

Assembling this book has been a process enhanced by both professional and personal support.

First, I would like to thank Bud Therien, the editor, for his patience, understanding, and belief in this project. Also, I offer much appreciation to Corrina Schultz for pitching my idea to Prentice Hall. Wendy Yurash, Sasha Anderson and Jean Lapidus at Prentice Hall provided much help, and I thank them for their patience with my endless queries.

I would also like to thank the following reviewers for their critical input: Douglas Latta, Oral Roberts University; Ken Burchett, The University of Central Arkansas; and Richard C. Green, Eastern Arizona College.

Thanks to the photographers, Laura Snyder, Keith Broadhurst, and my dear brother David Koenig, for their work.

I appreciate the support and cooperation of the Adobe ® Corporation for permission to use screen captures and for their invaluable software. I also wish to thank Pantone ® for their color system and permission to use their product name. My thanks also go to Color Aid ® Corporation for their great product and for permission to use their name.

Thanks to the administrations at both Villa Maria College and the University at Buffalo for the use of student works. Specific colleagues at both places have been very supportive, particularly Brian Duffy at Villa and Adele Henderson at the University at Buffalo.

The role of my students in this book cannot be overstated. Many of the illustrations from this book are the result of my students' hard work and dedication. My gratitude is extended to all of my students, who inspired this book. This book would not have been possible without you.

Last I would like to thank my friends and family for their patience and unwavering support through this project. Thank you to both Dr. James Dolan and James Astrella for their professional advice. Thanks to Mary Mullet Flynn, Wendy Maloney, Barbara Baird, Valerie Colangelo, and my dear sister Karen Koenig, for their support and enthusiasm from the beginning. My love of art, painting, and color started with my dear parents, Catherine Catanzaro Koenig and James R. Koenig, both fine artists. My mother has been understanding and supportive of my hard work, and this book is dedicated to the memory of my father. I am appreciative for the support of my entire extended family as well.

My love and thanks to my children, Kate and Sean, who have been remarkably patient and supportive of their preoccupied mother. My special love and thanks go to my dear husband, George Emery, who has been both a sounding board and editor, and whose encouragement and love have helped to bring this idea into being.

Notes on Materials

NOTES ON MATERIALS

There are some basic materials necessary in order to execute the color and design studies in this book. There are four main types of activities in this book: color studies, design studies in neutral colors, color design studies, and computer studies. A range of materials is needed for each type of study.

Color Study and Design Materials:

Acrylic or gouache paints as follows:

Yellow: Cadmium Yellow Light or Hansa Yellow or Spectrum Yellow

Orange: Cadmium Orange or Orange Lake

Red: Cadmium Red Medium or Permanent Red or Napthol Red, and Magenta or Quincridone Red

Violet: Dioxizine Purple or Permanent Violet or Spectrum Violet

Blue: Cobalt Blue or Brilliant Blue, and Ultramarine Blue

Green: Permanent Green Light or Green Medium and Viridian Green

White: Titanium White or Zinc White

Black: Ivory Black

Note that there are many more pigment color choices than are included here. Sometimes several versions of a color are necessary. For instance, both Permanent Red and Magenta are needed to mix a full range of colors. For a more complete hue and pigment list see Chapter 5.

Brushes as follows:

Rounds: #2 and #7 or #8

Flats: ¼" and ½" widths

Note: Short-handled watercolor brushes work best for the studies and nylon fiber is more affordable than sable.

Illustration board and good quality drawing paper

Color Aid® Paper Pack

Miscellaneous supplies as follows:

Drafting and clear frosted tape
Knife and extra blades
Glue stick and/or rubber cement
Ruler
Grid paper
Trace paper
Metal ruler

Neutral Color Media for Design Studies:

Fine and medium tip black markers
Variety of drawing pencils
India ink and dip pens
Charcoal and graphite sticks
Erasers

Computer Media:

Computer setup with printer
Graphic drawing or painting program
Manual for specific graphic program
Zip discs for graphic file storage

These supplies should cover the needs for most of the activities in this book. To understand the nature of color at least some of the chapter end studies should be executed.

Part One

COLOR STUDY

Chapter 1

The Nature of Color:
Color Physics and Perception

INTRODUCTION

This first half of this book is devoted to color study. Color study is an objective examination of the many aspects and attributes of color. Color study encompasses not only knowledge about color but is also a method for students to assimilate color knowledge through hands-on experience. For this reason, activities specific to each chapter have been designed to give the student this hands-on experience. These activities facilitate learning about color in a manner that enhances and reinforces a reading of the text. Objective knowledge of color frees the student to use color in either a formal or instinctive fashion. To begin our study of color, first we must understand that color study exists in the areas of both visual art (aesthetics) and science (physics). For artists, a foundation in the physics of color is essential for the comprehension of color phenomena and color perception.

Color has three important aspects. The *physical* aspect pertains to color physics and perception, covered in this chapter. The *psychological* aspect of color encompasses color psychology, expressive color, and color intuition, covered in Chapter 11. The *chemical* aspect of color refers to color media, either traditional media such as pigments, dyes, and inks or electronic media, such as computers and video. The chemical aspect of color is addressed in Chapters 5 and 6.

Color truly exists in the eye of the beholder. Color is a human experience generated collectively by the eye and the brain. In the concepts of both light and substance, the art and science of color are completely interconnected.

The nature of color is based on three basic concepts: color perception (how we receive color information), the relationship of color and light (additive color), and physical colored substances (subtractive color). *Additive color* is the color system of

light and color perception. Color is defined as a component of light; light is how our eye receives color information. *Subtractive color* is the system of surface color and colored substances. The subtractive color system describes the way light reflects from and absorbs into colored surfaces. Subtractive color is also significant in the mixing of the physical colors of pigments, inks, and dyes. Subtractive color deals with how colors are affected when they are mixed together.

Of these three basic concepts, the relationship of color and light to colored physical surfaces and materials can be the most problematic for art students. This is because artists traditionally use the physical substances of color, namely, paints, inks, dyes, and colored surfaces. Most artists find it difficult to think of color as light (additive color), because the science of color and light seem to exist outside the realm of traditional art materials. But the advent of computer art and web graphics has made the additive color system as important to artists as the subtractive system.

COLOR PHYSICS

Color physics is the science of color. Color has been explored, systematized, and explained throughout human history. A groundbreaking scientific exploration of color began in 1676 when Isaac Newton (1642–1727), the English mathematician and physicist, initiated his examination of color. In 1676, Newton projected white sunlight through a prism and a spectrum of colors was cast onto a white surface. [1.1]

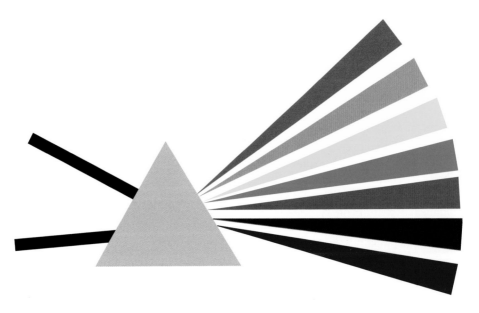

Figure 1–1 In 1676, Newton's experiment proved that color is a component of light. The seven distinct colors produced by the refraction of white light through a prism are called *spectral hues;* red, orange, yellow, green, blue, indigo, and violet.

Figure 1–2 The color spectrum as it appears when white light is refracted; the hues gradate into each other.

A prism refracts light, bending the light rays and sorting the colors in white light into their individual wavelengths. Newton then projected the spectrum back through a prism to re-form the white light. From this seminal experiment, Newton concluded that the refraction of white light revealed the individual components of light to be separate colors called *hues*. Newton's experiment definitively illustrated that color was a property of light and that light was composed of seven distinct hues: red, orange, yellow, green, blue, indigo, and violet. [1.2] In 1704 Newton published *Opticks,* which presented his optical light theories in a complete volume. Newton's discoveries, which are now taken for granted, were controversial in their time. The experiments of Newton led to the current definition of *color* as a visual sensation caused by the components of light either transmitted or reflected to the receptors in our eye.

By refraction, the components of light break into seven separate hues, which are called *spectral hues,* or *prismatic hues.* We are familiar with the spectrum in the form of a rainbow. The rainbow is an ordered band of spectral hues refracted from sunlight by water droplets in the atmosphere. Newton correlated the seven hues of the spectral band with the notes in a musical scale. This is one of the many analogies formed between color and music that recur throughout the history of color. Newton placed the additional color of purple (red-violet) to the spectrum connecting the spectral band to itself, thereby forming a continuous color circle. [1.3] Newton formulated the color circle as a scientific device to illuminate relationships between the spectral hues.

Electromagnetic Spectrum

As the study of light and color continued, the white light containing all of the spectral hues was found to be a very small part of the *electromagnetic spectrum.* [1.4, see page 5.] Wavelengths of light (color) are radiant energy, which originates in sunlight. The electromagnetic spectrum represents the energy waves produced by the oscillation of an electric charge. James Clerk Maxwell (1831–1879), a Scottish physicist, presented the theory of electromagnetic waves in the 1860s. Maxwell theorized that visible light was an electromagnetic phenomenon. Unlike other types of energy transmission, such as conduction and convection, electromagnetic waves

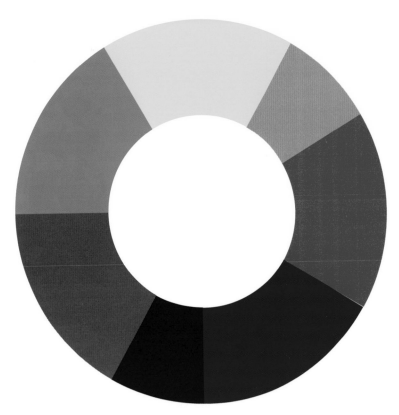

Figure 1–3 Newton attached the spectrum to itself to form a color circle. He added purple (red-violet) as an intermediate hue between red and violet.

do not need any material for heat transmission. Both light and radio waves can pass through space at great distances and allow us, for example, to be able to perceive the light from a star. Electromagnetic waves are arranged in a spectrum that organizes waves of high frequency (short wavelengths) to those of low frequency (long wavelengths). The electromagnetic spectrum ranges from gamma rays to radio wavelengths as shown. The *visible light spectrum* is a small portion of the electromagnetic spectrum that we can actually see. "Infra" and "ultra" prefaces signify wavelengths of the electromagnetic spectrum that are out of our visual range or capacity, such as ultraviolet light.

Within the visible spectrum, each hue is individually defined by a specific wavelength. The wavelengths of light are measured in *nanometers,* which are only one billionth of a meter. Each hue is visually unique due to differences in tiny measurements between the crests of each wavelength. Red has the longest wavelength and violet the shortest wavelength. Within each hue, we can also see subtle differences, such as a red that is more orange, or yellow that is greener. White light, theoretically, is all seven spectral hues in equal balance.

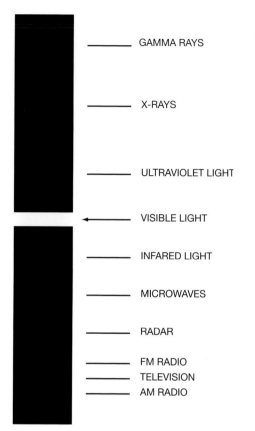

Figure 1–4 Of the full electromagnetic spectrum, the only section that is visible to humans is the area of visible light, which includes the spectrum & color wavelengths.

GAMMA RAYS

X-RAYS

ULTRAVIOLET LIGHT

VISIBLE LIGHT

INFARED LIGHT

MICROWAVES

RADAR

FM RADIO

TELEVISION

AM RADIO

PRIMARY COLORS OF LIGHT

Primary colors are hues that are not obtainable by mixing other colors. They are the components of all the other hues. When we think of primary colors, we usually think of the traditional pigment primaries of red, yellow, and blue. James Clerk Maxwell identified the three *primaries of light* to be red, green, and blue, which we refer to as RGB. Maxwell based his theories, called the trichromatic theory, on the earlier research of Thomas Young (1773–1829) and Hermann Helmholtz (1821–1894). Young, a British physician, had proved that all colors were generated from the three spectral hues of red, green, and blue, which aligned with the color receptors in our eye. [1.5] Helmholtz, a German physiologist and physicist, later expanded upon Young's ideas and the two theories synthesized to form the Young-Helmholtz three-component theory. The three light primaries were determined to be the colors needed to form all the colors that we see as the color receptors in our eye correlate with these light primaries. Maxwell presented the RGB additive perceptual hues in a color triangle. [1.6] The remaining spectral hues, yellow, orange, indigo, and violet, represent various intermixtures of RGB.

Figure 1–5 The primaries of light are red, green, and blue or RGB. Notice that the primary red is a red-orange and the primary blue is almost violet.

The surfaces of colored objects either reflect or absorb one or more of the wavelengths of light. Understanding how RGB wavelengths either reflect off of or are absorbed into colored surfaces clarifies the relationship between color and light. For example, we see a red surface because a red wavelength is the only light primary that is reflected back to our eye. The other light primaries, the green and blue wavelengths, are absorbed into the red (appearing) surface. The chemical makeup or colorant of the red surface causes the phenomena of absorption and reflection to occur. This illustration displays how light reflection and absorption causes us to perceive red, green, blue, as well as black and white. [1.7] White reflects all of the primaries, which re-form into white light. Black reflects no light (all colors are absorbed), so we see a visual void, which is black.

ADDITIVE COLOR SYSTEM

The *additive color system* is the color system pertinent to colored light and our physiological color perception. When we see white, all the hue wavelengths are reflected or *added* together, hence the term *additive color*. This concept aligns with Newton's recombination of the spectrum to form white light. In the additive system, when colored

Figure 1–6 James Clerk Maxwell identified the three light or additive primaries as RGB and designed a triangle to show how they mix into all the colors.

Figure 1–7 This illustration shows the primaries of light either reflected from or absorbed into colored surfaces, causing us to see color. When we see green, for example, both the red and blue light wavelengths are absorbed. The only wavelength reflected is green, which is received by the color receptors in our eyes. With white surfaces, all the primaries are reflected; with black, none are reflected.

light is mixed, it becomes lighter and closer to white. For example, if the three light primaries, red, green, and blue spotlights are overlapped the result is white light. [1.8] In the *trichromatic* (meaning three-color) theory of light, RGB are the three source colors that in combination form all colors. Each additive light primary has its own character: the light primary red is rather red-orange, the light primary blue is quite blue-violet, and the light primary green is a slightly bluish green. Computer monitors, television, and stage lighting are media that all use illuminated color (colored light).

The additive primaries of RGB mix to create secondary hues. *Secondary hues* are defined as the mixture of two primary hues. Notice that the secondary hues of the

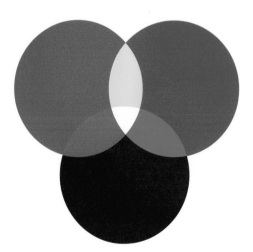

Figure 1–8 The additive primaries, RGB, form white light when mixed together as colored spotlights. Mixtures of the additive primaries form secondary hues of cyan (blue), magenta (red), and yellow. The secondary hues of light are close to the primaries of pigment, and they are the same colors as the primaries of process color.

additive system, cyan (blue), magenta (red), and yellow, are similar to the traditional primary hues of pigment, which we know as red, yellow, and blue. Cyan (C), magenta (M), and yellow (Y) are process colors also known as CMY. Process colors are the standard colors used in the four-color printing process and color photography. Process colors (CMY) are used together with black to create all the colors we see in printed media. The light primaries mix to create cyan, magenta, yellow, and white as follows:

> Blue + Green = Cyan
> Red + Green = Yellow
> Red + Blue = Magenta
> Red + Blue + Green = White

The primaries of light, RGB, are presented in an additive color circle with their secondaries placed in between them to indicate the additive color mixtures. [1.9]

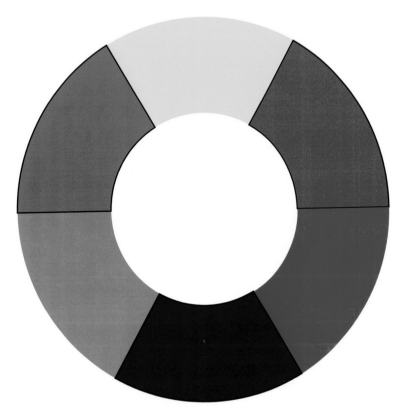

Figure 1–9 The additive color circle shows the light primaries RGB (outlined) in a circle format with the light secondary hues CMY, indicating how they mix.

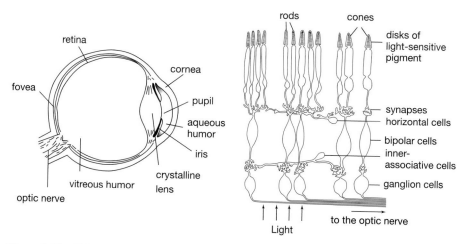

Figure 1–10 Color Perception Our eye takes in color information through retinal cones, which have RGB receptors.

COLOR PERCEPTION

Color is a uniquely human experience. We see color because our eyes are sensitive to a particular section of electromagnetic energy called the *visible spectrum.* A surprising aspect of color theory is that color actually is an illusion caused by reception of light wavelengths by our eye, which form colors in our brain. For example, the yellow of a lemon is not a property of the lemon skin itself, but is due to a lemon's capacity to absorb and reflect specific spectral elements from light, which our eye perceives as yellow. Yellow light, which is reflected off a lemon, is an example of *residual light,* since it represents only a portion (the red and green wavelengths) of white light. Residual light is an information transmitter rather than a color. A color exists only if there is a person or animal to receive the light/color information being transmitted. Light rays are messengers of color information to our eye.

How do we receive light information to see a color? The human eye has two different types of color receptor cells. *Rods* are cells that help us perceive light/dark (value) differences and lighting strength, particularly in dim lighting situations. *Cone* cells are at the heart of our color perception. Cones cells selectively respond to specific colors. There are three types of cones: red cones, green cones, and blue cones. [1.10] Each cone type is thus receptive to each of the additive or light primaries (RGB). Obviously, a green cone is stimulated by green light to produce the sensation of green in our brain. However, cones also work together in combination to produce all of the colors that we perceive. For example, as yellow light stimulates both red and green cones, the optic nerve transmits this information, and RG combine to form a yellow image in the brain. Cones are receptive to RGB (hues) but are only active in adequate light. For this reason, it is difficult to discern hue differences at low levels of light.

Lack of green or red cones can cause difficulty in the ability to distinguish between greens, yellows, oranges, and reds. This is called red-green color blindness. Color blindness is almost exclusively found in males since color genes are linked to the female X chromosome.

Visual information that we receive is broken into dots or patterns. It is then re-formed in duplicate in our brain. We can also "see" a color mentally with our eyes closed during dreams, migraines, meditation, etc. Factors that influence color perception include the following:

- The amount and quality of lighting on colored surfaces: natural or artificial, the level of light (as determined by the time of day and the weather) etc.
- Our visual health, the condition of color blindness, etc.
- The surface quality of the colored object itself: Is it light, solid, or textured?
- Color relationships: How is the color affected by its surroundings?

Since color is a property of light, we need light for color perception. The type and quantity of light greatly effects our color perception. Specifically, a given color will appear to be different under varying lighting conditions. The same color in sunlight, in half-darkened rooms, under fluorescent light, or in light from northern

Figure 1–11 Quality and amount of light affect color. Note that the same color surfaces appear to be different in light and shadow.

or southern-facing windows will all create different color sensations. At varied times of day the light is different in color temperature. Morning and evening light tends to have red or orange wavelengths, whereas midday sunlight is a cooler light. At different times of day, the walls of the same color facing different directions, for example, may appear to change in hue, value, and/or color intensity dependent on the light at that time. [1.11] Many artists have made a study of varied color effects based on time of day or season.

Lighting is also a critical factor in an artist's studio. Incandescent light is warm and fluorescent light is cool. Southern light is too changeable and warm in the Northern Hemisphere so north-facing window light is preferred. Southern light is the preferred light in the Southern Hemisphere.

ADDITIVE COLOR MEDIA

The importance of the additive system to artists has increased substantially over the course of recent years. Additive color used to be an interesting introductory concept that was put aside as students worked with traditional art materials. Today, artists and designers must understand additive color because of its pervasive uses in video, electronic media, and lighting. Primary applications of the additive system of colored light are television, computer graphics, web design, holography, and stage lighting. The additive color circle is also integral to photography.

Stage lighting utilizes colored light on colored surfaces to achieve dramatic and atmospheric effects. A lighting technician must understand additive color in order to adequately predict the effects of colored lights when used in combinations and when used on different colored surfaces on the stage sets. Overlapping RGB spots will create a white spotlight. When a red light, for example, shines on a green area of the set, the resulting color is black. [1.12] We see black because the red wavelength is absorbed by the green surface. There is no green light wavelength in the red spot light to reflect green back to our eye, so black is seen.

Television color is generated from the three additive light primaries. Television uses tiny dots of projected (RGB) colored light that visually mix to form a wide array of colors. Cathode ray tubes are equipped with electron guns that project RGB dots onto the surface of the screen in varying proportions to produce colors and movement. Projected RGB light is fed through a mesh of dots or stripes to form a pattern on the inside of the screen. If we hold a magnifying glass to the surface of a television screen, we can see an elaborate configuration of RGB dots.

Cathode ray computer monitors also use projected color on their display screens. Display monitors are capable of a much wider color range than television screens. Computer color is also composed of variations on RGB hues. The computer "thinks" in the additive RGB system when it creates or selects colors. The RGB system in a computer mixes colors in an additive manner and may aid our understanding of additive color mixing.

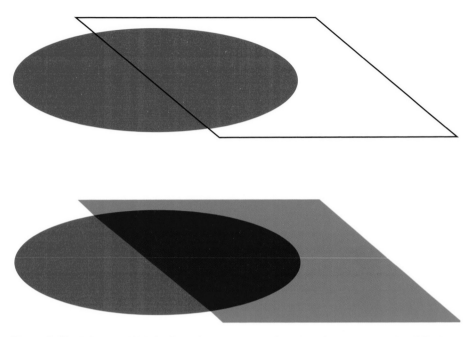

Figure 1–12 When a red light is directed onto a green surface, there is no green wavelength in the light to reflect, so the resulting color is black.

SUBTRACTIVE COLOR SYSTEM

The subtractive color system refers to both surface color and the physical color of pigments, inks, or dyes. *Subtractive* can be defined as both the process by which we see color surfaces as well as the way traditional colored materials are mixed together. The *subtractive color system* describes the way light reflects from or absorbs into the colored surfaces of objects. Subtractive colors are surfaces that reflect light, rather than being source colors, such as light itself. For this reason, pigment colors or colored objects are considered second-hand colors. In the *subtractive system,* as hues combine, light waves are absorbed or "subtracted" resulting in a reduction of the amount of light reflected to our eyes. The reduction of reflected light subtracts from the color intensity that we, in turn, perceive.

Subtractive color is the color system of the traditional materials of art and design: the physical colors of pigments, dyes, or inks. Subtractive color describes the way that physical colors subtract intensity from each other when mixed together. The traditional way to alter or control colored surfaces is to use pigmented materials. As strange as this may seem to the artist, traditional colored media such as paint, inks, and dyes are not in themselves colored. The colored substances of art merely serve to reflect a specific colored light wavelength to our eye. Objects appear to be varied colors due to their differences in spectral composition and their ability to reflect light. Our brain creates the sensation of color by the absorption

or reflection of light waves off of colored materials to create color sensations on our retina. *Surface color* reflects or absorbs one or a combination of the three light primaries, RGB.

Subtractive Primary Colors

The subtractive system is the basis for the system of *traditional pigment primary hues,* red, yellow, and blue and the *process primaries,* cyan, magenta, and yellow. [1.13] Thus, there are subtractive primaries that apply to two different media. The traditional subtractive pigment primaries for paints, inks, and dyes are red, yellow, and blue or RYB. The subtractive process primaries, used in process printing, photography, and computer printing, are cyan, magenta, and yellow or CMY.

The traditional primaries are the primaries of paint or any pigmented color, dye, or ink. The German poet Johann Wolfgang von Goethe (1749–1832) developed a color theory based on subtractive color surface perception and traditional pigment mixtures. The original intent of Goethe's color theory was to refute Newton's theories of color/light optics. Goethe identified the color primaries as red, yellow, and blue. He presented primary and secondary hues in both a color circle and a color triangle configuration.

Secondary subtractive colors are the mixtures of two primary colors. Both sets of subtractive primaries, RYB and CMY, mix to create secondary hues that differ from secondary hues of light. The subtractive secondary hues are green, orange, and

Figure 1–13 **Top:** Cyan, magenta, and yellow are secondary hues of the light (additive) system, and are also known as the process primaries of the subtractive system.

Bottom: The traditional pigment (subtractive) primary hues are red, yellow, and blue.

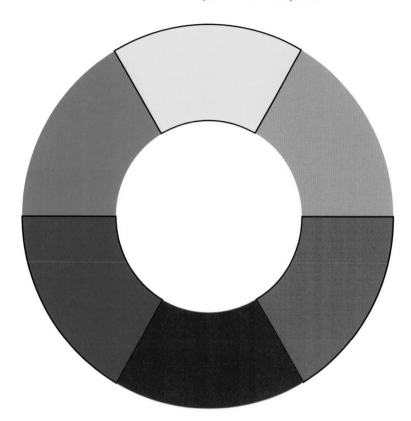

Figure 1–14 A simplified version of the traditional color circle or wheel. RYB are the pigment primaries, OGV are the secondary hues mixed from combinations of the primary hues.

violet as displayed on both subtractive color circles: the *traditional pigment color circle* [1.14] and the *process color circle* [1.15] Color circles serve as visual guides to color; one of their functions is to demonstrate how primary colors mix to make secondary colors. Subtractive primary hues mix to form secondary hues as follows:

Pigment Primary to Secondary	Process Primary to Secondary
Red + Yellow = Orange	Magenta + Yellow = Orange
Blue + Yellow = Green	Cyan + Yellow = Green
Blue + Red = Violet	Cyan + Magenta = Violet

In paint or dyes, subtractive colors lose intensity by mixture because the light wavelengths reflected to our eye are decreased or subtracted. For example, when red and green pigments are mixed, the two hues tend to cancel each other out, forming a brown or gray. All object or surface color is subtractive because the process of subtraction of hues allows us to see only the reflected wavelengths of a particular color.

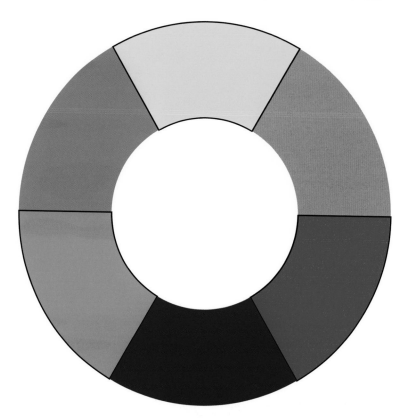

Figure 1–15 Process Circle A subtractive process color circle, the primaries hues of CMY are outlined. The process colors also mix to create the secondary hues of orange, green, and violet.

Logically, then, the mixture of all three subtractive primaries, RYB or CMY, creates a void, black, in which no light wavelengths are reflected. [1.16]

Theoretically, in paint, all the known colors can be generated from three subtractive primaries of RYB. In reality, pigments are rather unpredictable, which makes it difficult to mix all the colors from the three primary hues. Several versions of the primaries are needed to mix "clean" secondary colors, or secondary colors can be purchased ready-made. Painters can obtain a much wider range of color without the limitations of only RYB pigments.

THE RELATIONSHIP OF ADDITIVE AND SUBTRACTIVE COLOR

The seeming incompatibility of the additive and subtractive color systems is precisely what confuses many color-study students. The relationship between additive

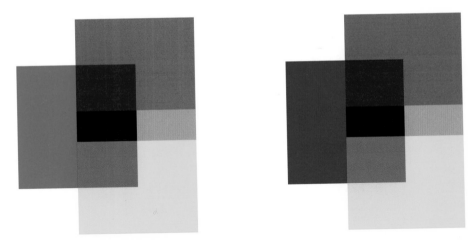

Figure 1–16 The subtractive primaries, RYB or CMY when mixed, form black, since they subtract the reflecting color wavelengths when mixed together.

and subtractive color systems, however, is a clear inverse relationship. This integral relationship is as follows: The primaries (RGB) of light form secondary hues that are also the subtractive primary process hues, namely cyan, magenta, and yellow. Cyan (blue), magenta (red), and yellow, the secondaries of the additive light system, are actually the process primaries of the subtractive color system. The relationship between the additive and subtractive colors is clarified by the placement of hues on the color circles. A comparison of the additive color circle with the subtractive color circle will aid the student in the shift from one color system to another.

Another problem for the color-study student is to simultaneously comprehend the operation of both the additive system (of light) and the subtractive system (of surface color and pigments). The manner in which process colors (CMY) and the traditional pigment colors (RYB) mix with each other, for instance, completely opposes the additive system. We know from experience, for example, that paint colors of red, green, and blue, when mixed together, would never produce white as they do when RGB lights are mixed. Artists and designers, however, should be able to understand and work with both functional systems of color: the additive and the subtractive.

COMPLEMENTARY COLORS

In color study, the concept of color opposites or complements is significant. *Complementary pairs* are composed of two hues located directly across from each other on the color circle. Refer to the additive color circle [1.9] to find the *additive complementary* hues. [1.17] In additive color the complementary pairs are as follows:

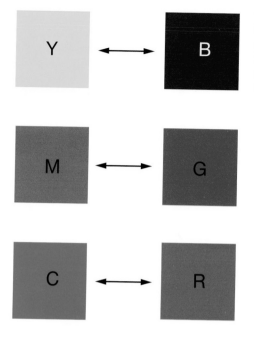

Figure 1–17 Additive complements
Complementary colors are directly across the color circle from each other. Additive complements affect how we see colored surfaces, since complements absorb the light wavelengths of each other.

Yellow—Blue
Magenta—Green
Cyan—Red

A complementary relationship in color is that of two opposite components that complete each other. Complementary colors complete each other in a type of color balance. For instance, a yellow and blue complementary pair from the additive color circle represents the hue primaries as follows: yellow (red and green) *opposite or opposing* blue. In this manner, all three light primaries are represented in each pair of additive (light) complements. The same principle holds true for the subtractive complementary pairs.

Additive complements are important in understanding color perception. To aid the comprehension of subtractive color perception, we can imagine cyan, magenta, and yellow as absorbing filters for RGB light. Cyan, magenta, and yellow absorb light in a fashion that explains how and why we see RGB. [1.18] This is shown below:

red (magenta + yellow) absorbs blue and green light and thus reflects red.
green (cyan + yellow) absorbs blue and red light and thus reflects green.
blue (cyan + magenta) absorbs red and green and thus reflects blue.
cyan + magenta + yellow absorbs red, green and blue and results in black.

So logically this is why we see CMY hues [1.19, see page 19], as shown below:

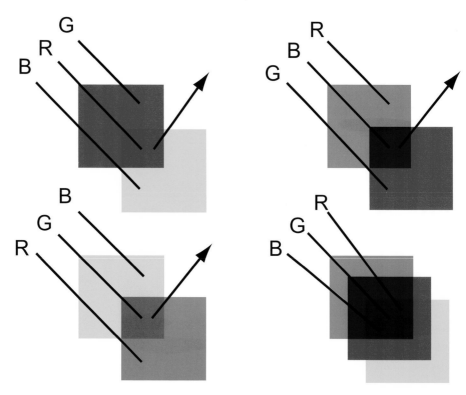

Figure 1–18 The importance of additive complements to our perception of subtractive color. On the top left, magenta, for example, absorbs its complementary hue, green. Yellow absorbs its complementary hue of blue. The only remaining primary hue of light to be reflected is red.

 cyan absorbs red light – reflects blue + green light (cyan)
 magenta absorbs green light – reflects red + blue light (magenta)
 yellow absorbs blue light – reflects green + red light (yellow)

LOCAL AND RELATIVE COLOR

Local color is the general color of an object under normal lighting (daylight or white light) conditions. Local color is a traditional method of color perception and interpretation of a colored surface. For example, the sky is blue, an apple is red, and a lemon is yellow. Our mind tends to generalize color for object identification. For example, we know that an apple is red even in a dimly lit room because of our color memory. However, in reality, a single apple may contain many different reds or appear to be magenta or purple, dependent on lighting. [1.20, see page 20.] Lighting, surrounding color, highlights, and shadow areas all cause the reds in an apple to form many different red variations. The surface quality of an object will also influence

Figure 1–19 This illustrates how we see subtractive surface color of CMY. The light primaries are either reflected or absorbed in varied combinations to give us the appearance of cyan, magenta, or yellow.

color perception. Is the observed object emitting light, like a computer or video? Does an object have a matte or glossy surface? Is it highly textured or reflective? These are all factors in color perception.

Colors are also perceived in context. In reality, we rarely see a color isolated on its own. Even if we see color against a neutral color, such as black, white, or gray, that color is affected by its surroundings. The red shown here on the white surface looks heavier, darker, and larger than the red on the black surface. [1.21, see page 21] Red on a black surface will appear lighter, more luminous, and smaller in scale than the same red on a white surface. When colors are presented on more competitive terms with other colors, more radical changes can occur. On an orange surface, a blue appears to be enhanced in color intensity. On a dark blue surface, the blue seems lighter and much less intense. Thus, our color perception is based on comparison and contrast. This concept is called *color relativity* or color interaction.

For clarity and consistency, a major portion of this book is based on the traditional color wheel. In discussions of photographic and electronic color, however, we must shift to the additive RGB color circle. Color printing and photography use the process primaries CMY to create a wide array of colors. The CMY mode on computers re-creates this process. Cyan, magenta, and yellow on the computer can be manipulated by percentage or by sliders to form a huge range of colors.

Figure 1–20 In the photo of an apple, there are many more red variations than in our symbolic image of an apple.

The color discoveries of Isaac Newton and Johann Goethe are still pertinent today. Two approaches of optics and light (additive) and of pigments and surface color (subtractive) co-exist and interrelate in color study. Both theories are conceptually correct and can be applied to either color media or color perception. The additive and subtractive systems of color are interdependent systems that determine how light and pigment mixtures are made and perceived.

ACTIVITIES

1. COLOR AND LIGHT EXPERIMENTS

Objective: The student will understand the nature of additive color through hands-on experiments.

- Use a prism or a crystal in a window to refract light into the spectral hues.
- Experiment with colored lights; use a red-, a green-, and a blue-colored bulb to understand both additive (light) and subtractive (surface) color systems. The room must be dark for these experiments with colored light to work. Example: Shine a red light on a green surface, a green light on a red surface, a blue light on a green surface. What colors result from each?

2. SUBTRACTIVE COLOR STUDY

Objective: For the student to understand the subtractive process by using physical paint mixtures.

- Use either process colors (cyan, magenta, and yellow) in acrylic or gouache.
- Mix secondary colors by mixing two primaries [1.22], see page 22
 magenta + yellow, yellow + cyan, and cyan + magenta
 Or: Mix traditional primaries, red + blue, blue + yellow and yellow + red. Or you can do both and compare the results. How do the secondary hues compare?

Figure 1–21 Color appears differently depending on its surroundings. Notice the different appearance of the blue and red in each color environment. This is called relative color or color interaction.

- Now mix all the primaries in order to make a neutral. The neutral should look close to black or gray.
- You can now form them into a chart as shown. [1.16].

3. ADDITIVE COLOR ON COMPUTER

Objective: For the student to see how additive colors intermix. Also serves as an introduction to computer color mixing.

Figure 1–22 Traditional pigment primaries RYB mixed to form secondary hues.

- On any computer graphic program go to the RGB color mode.
- Using the RGB sliders, slide red bar to 100% and green and blue to 0%. What color results? Why do you see it that way according to what you read in Chapter 1?
- Slide all bars to 100% What color results?
- Slide all bars to an equal percentage. What color results?
- Slide R and G to 100%. What color appears?
- Slide B and G to 100%. What color appears?
- Slide R and B to 100%. What color appears?
- Try various other mixtures and try to explain them according to the information in Chapter 1. [6.7]

Chapter 2

The Color Circle And Color Systems: An Exploration

Throughout history, artists and scientists have studied color. The influential color theorists have been philosophers, scientists, and artists who have attempted to explain the phenomena of color by the formulation of color circles and systems.

Why is a color circle necessary to color study? First, a color circle or wheel organizes the spectral hues in chromatic (color) order. Secondly, the circle enables us to form color relationships between the hues. Hue relationships would not be readily apparent if we were to use the spectral color "band". Lastly, the circle allows us to regard each hue as a separate color entity.

COLOR CIRCLES AND SYSTEMS—
 A BRIEF HISTORY

Color helps humans to orient themselves to the world. Early in history, color was recognized as a concept independent of objects. The earliest concept of color was that of white and black: light and darkness. The first chromatic concept to be identified was red. Primitive man responded to its powerful associations with blood, fire, and the sun. The next hues were identified in this order: yellow, green, blue, orange, and brown.

Early color study was a part of philosophy. To philosophers, color represented one of man's ways of interacting with the world. The first documented color theorist was Pythagoras, the Greek mathematician, in approximately 500 B.C. He surmised that color existed on the surface of objects and was activated by a hot emission from our eyes. Empedocles, another Greek, concluded in 440 B.C. that energy flowed from both our eyes and the object itself to produce a color sensation. He formed color associations with the four elements: fire with white, air with yellow, water with black, and earth with red. The ancient Greeks accepted the four basic elemental colors of white, black, yellow, and red as the primaries.

The Greek philosopher Aristotle (384–322 B.C.) formulated a color theory that was considered authoritative through the Middle Ages. Aristotle's theory was that all colors were actually imperceptible mixtures of black and white, dependent on light. Aristotle believed that colors were formed by the interaction of white as light and black

Figure 2–1 Aristotle believed that all colors were the result of mixtures between white and black, or light and darkness.

as darkness. His theories were based on observations of colors in the sky in the course of a day, yellow at noon, changing to orange, then red, green, and dark blue. Aristotle envisioned the hues in a linear sequence; his seven basic hues were white, yellow, red, violet, green, blue, and black. [2.1] The basic hues are thus placed between white and black. Another Greek, Theophratus (372–287 B.C.), concurred with Aristotle's theories but also conceptualized that colors were the result of varied light sources.

Color research resumed in the Renaissance. Leone Battista Alberti (1404–1472), an Italian architect and painter, stated in his book *On Painting* that color perception was dependent on light. He also made color comparisons with the four elements: red-fire, blue-air, green-water and yellow-earth, which he later amended to gray for earth. [2.2] He rejected Aristotle's theory that each hue was a mixture between black and white. Alberti regarded the chromatic hues of red, yellow, green, and blue separately from the achromatic neutrals of black, white, and gray. He placed the hues in a square formation to show their interrelationships.

The Italian painter and inventor of the high Renaissance Leonardo da Vinci (1475–1564) also sought to identify the main colors that were the building blocks for all other colors. In his *Treatise on Painting,* published in 1651, da Vinci concluded that the main colors listed in order of their importance were white (light), yellow (earth), green (water), blue (air), red (fire) and black (darkness). Yellow, green, blue, and red are today referred to as the *medial primaries.* [2.10]

The English philosopher Francis Bacon (1561–1626) introduced the inductive method in science. The inductive method encouraged scientists to prove theories by experimentation and data rather than by simply making theoretical pronouncements. This new method of forming scientific theories influenced all scientific research, including color studies.

Studies of light reflection and refraction were concurrent with the development of lenses for microscopes and telescopes. Rene Descartes (1596–1650), a French philosopher and mathematician, defined color as dependent on particles in light. He envisioned the speed and movements of these light particles as the cause of specific color sensations. He also came closer to an explanation of the formation of rainbows.

A Belgian Jesuit named Franciscus Aguilonius (1567–1617) created what is possibly the oldest known color system of subtractive primaries, naming the colors red, yellow, and blue. His system was presented in a linear formation similar to Aristotle's color sequence. Aquilonius also coined the term *median* or *medial* primaries.

Figure 2–2 Comparisons were often made between the hues and the four traditional elements. Alberti connected the elements with these colors clockwise from top right: fire—red, air—blue, earth—yellow, and water—green.

In a text discovered in 1969, a Finnish astronomer and priest named Aron Sigfrid Forsius appears to be the creator of the first color circle. Forsius's volume on physics, dated 1611, contained the first color wheel, drawn in a sphere. It included red, blue, green and yellow as the main hues, interacting with black, white, and gray.

Previous research on the association between color and light laid the groundwork for the discoveries of Isaac Newton (1642–1727), as discussed in Chapter 1. In addition to his discovery of the color components of light by refraction, Newton definitively identified seven spectral hues. By the refraction of light, Newton discovered the color components are red, orange, yellow, green, blue, indigo, and violet. [2.3] Newton surmised that all other colors are compounds of these spectral hues. The idea that the spectral hues can also create black and white is a theory that diametrically opposes the theories of Aristotle. Newton's other major contribution to color theory was the formation of the first widely known color circle. Since Forsius's color circle was not discovered until much later, Newton is commonly credited with originating the color circle format. By adding one hue (purple or red-violet) to the spectral band, he attached the spectral band to itself in a circle [1.3]. Newton's circle presents the size of each hue proportional to its width in the spectral band. The center of Newton's color circle is white to indicate an intermixture of all the colors of light.

Figure 2–3 The seven distinct hues that Newton identified from the light spectrum correspond to the notes of a musical scale.

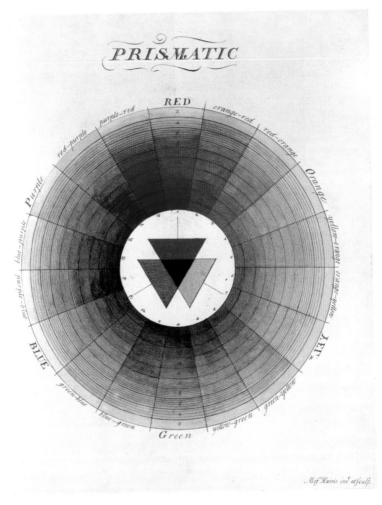

Figure 2–4 Moses Harris's wheel is based on the subtractive primaries and shows each hue tinted with white and shaded with black. From the *Natural System of Colors,* Collection Royal Academy of Arts, London.

Artists involved in the color reproduction processes of printing and engraving made other major color discoveries. A French artist and printer, Jacques Christophe le Blon (1667–1742), discovered that careful mixing of three hues—red, yellow, and blue, along with black—could create a large variety of colors. Today, he is considered to be an early developer of the four-color printing process used for commercially printed material. Le Blon's discoveries were the first clear indication of the subtractive primary colors.

Moses Harris, an English engraver (1731–1785), took the discovery of the pigment/subtractive primaries one step further in his development of a color wheel. In his book *The Natural System of Colors* (1766), he presented a detailed color circle based on the subtractive primaries of red, yellow, and blue, which he placed in the center of the circle. [2.4] He emphasized red, yellow, and blue as the greatest opposites of all the colors—therefore placing them at the greatest distance apart from each other on the color wheel. Harris's color circle presents tints of each hue on the outside of the circle, moving toward the pure hues, and shades of each hue moving toward the center of the circle. His color circle has three primaries, which he called *prismatics* or *primitives,* three secondaries, called *mediate* or *compound* colors, and twelve tertiary hues.

Johann Wolfgang von Goethe (1749–1832), the German poet, was instrumental in the development of a subtractive color system and wheel. In 1810, he published *The Theory of Colors,* a book that focused on visual phenomena such as colored shadows. He sought to bring order to the confusion of color. Goethe devised a color circle that was based on the laws of subtraction. [2.5] He meant for his color concepts to be in direct opposition to Newton's Goethe brought a subjective slant to his theories of color. He saw blue and yellow as the hues that held the strongest

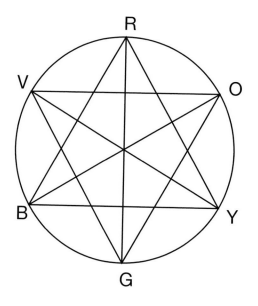

Figure 2–5 Goethe's color wheel had three subtractive primaries and three secondaries.

contrast to each other. His obvious preference for warm hues is expressed by his description of them as "warm, lively and exciting." Cool hues, in contrast, he considered "weak, unsettled and yearning." In his theories, color was created by the interaction of light and shadow, an idea that he supported by experimentation. His color wheel clearly indicates the three primaries and three secondary hues of subtractive color.

Philip Otto Runge (1777–1810), a German painter, introduced the first spherical color system in 1810. This color sphere was the first system to take into account all three attributes of color: hue, value, and saturation. His sphere included the three subtractive primaries, red, yellow, and blue and three secondary hues. [3.18].

Ogden Rood (1831–1902), a physicist with an interest in color, formulated a color circle based on his discoveries of precise complementary or opposing hues. He also experimented with the concept of optical mixtures. The theories were presented in a book titled *Modern Chromatics,* written in 1879. He used various complementary hue combinations on spinning tops to discover the precise hue opposites. The combinations that formed the most neutral grays when spinning determined precise hue opposites. His color circle has both hue and pigment names to assist artists in finding the exact complement of each hue.

Herbert E. Ives (1882–1953), an American physicist, developed the hues that are used as primary printing process colors, namely cyan (syan), magenta (anchlor), and yellow (zanth). His goal was to select three hues which, when mixed, would form the truest secondary and tertiary hues. Ives' color wheel indicates the primaries as cyan, magenta, and yellow, the secondaries as green, orange, and violet, and the teritaries as purple, blue, blue-green, yellow-green, yellow-orange, and red. This circle was an early version of the process color circle.

Albert Munsell (1858–1918) was a highly influential American color theorist whose color theories and systems are still widely in use. Munsell's major contributions to color study include a careful color notation system which became standard in the United States, Great Britain, Germany, and Japan. He developed a color circle with ten hues, and with five primary or "principal" hues: red, yellow, blue, green, and purple. He called his secondary hues "intermediate" hues. Munsell also developed a more extensive color circle, which displays 100 separate colors. Munsell's emphasis was on an objective color standard. His color system evolved into the development of a color "tree" which addressed all the variables of color. [3.14, 3.16]

Ewald Hering (1834–1918), a German physiologist and psychologist, was interested primarily in color perception. He established the psychological or medial primary hues as the primary colors of perception. [2.6] His color circle presented the four primary hues in equal proportion, opposing each other. Hering's color circle was the basis for the Natural Color System known as NCS.

The German chemist Wilhelm Ostwald (1853–1932) won the Nobel Prize for chemistry in 1909. He based his color system on the theories of Ewald Hering. Hering's theory presented the concept that three opposing pair combinations, the red-green, and yellow-blue pairs from his color circle as well as black and white result in all the visible colors. Ostwald adopted this concept and expanded on it. He de-

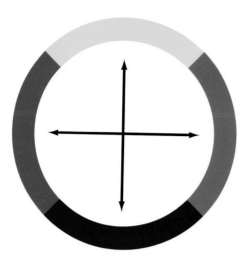

Figure 2–6 Hering's color circle indicated opposing hue pairs, which he felt determined perceptual color.

veloped a highly technical approach to pigmented color. His color wheel is heavier in the cool area of blues and green than on the warm side with reds and yellows. [2.7] He also completed a system that was comprehensive for its time due to its organization of the saturation variety of each hue.

In the more recent history of color study, the focus has been on a scientific understanding of the physics of light and color perception. Another focus has been on the international standardization of colors themselves. As mentioned, the Munsell system is considered standard in some countries. The Commission International D'Eclairage or CIE introduced a standard color table in 1931. The objective of this group was to formulate a Color Standard Table based on the perceptual additive primaries of red, green, and blue. Precise color matching was achieved by

Figure 2–7 The Oswald color circle has eight main hues and it is weighted toward the cool colors.

Figure 2–8 The CIE color chart is based on visual perception of color.

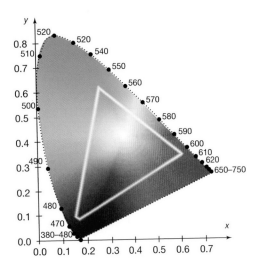

using a colorimeter, which measured hue, luminance (light intensity, and saturation (purity). These three components determine the overall "chromacity" of a color. [2.8] CIE employs a mathematical formula to form color areas, providing an objective international color model. A more recent incarnation of the CIE system (1976) is called CIE $L^*A^*B^*$ color, a more specific color guide, designed for color standards in industry.

The history of color theory is helpful in expanding our color knowledge. Frans Gerritsen is a contemporary color theorist. In his book *Evolution in Color* (1982), Gerritsen presents his own color system prefaced by historical color systems, which he classifies into four major categories. The first category of color theory is color ordering between light and darkness, as in the theory of Aristotle. An opponent or unique color system is the second type identified by Gerritsen: color systems that are concerned with the identification of primary hues and their color opposites, as in Hering's color wheel. The third type of color theory involves the physical mixing characteristics of colors, as in a painter's color wheel. The fourth category of color notation is color systems with color perception as their basis of color organization, such as the theories of James Clerk Maxwell, CIE color, and Gerritsen's own color theory. Gerritsen's color theory contends that human color perception, namely RGB additive color, is the ultimate guide for all color theoretical systems.

The preceding information is a sampling of pertinent color systems. Given the amount of research in the scientific, perceptual, and artist-oriented color systems developed throughout history, it is difficult to choose a single most significant color system. No single color circle or system is technically suitable for all the aspects, dimensions and applications of color. What we gain from the history of the color circle and color theory is an understanding of the incremental steps toward our current color knowledge. The process is ongoing, as the nature of color always leaves us with more to discover.

COLOR CIRCLES—A RATIONALE

Artists work in one or the other of two color modes: additive or subtractive. There are three color wheels that are significant for our use today: the additive color circle, the subtractive process color circle, and the traditional color circle. All of these color circles are significant for artists in different applications.

As artists or designers, we are primarily working and thinking in the subtractive color mode. The traditional color circle is the most functional one for artists' materials such as pigments, inks, and dyes, since it applies laws of color subtraction. [2.9] Since most artists use at least one type of traditional media; a traditional 12-hue color circle is the rational choice for reference.

For graphic designers, the subtractive process color circle based on the primaries of CMY is the proper reference for printed color. [1.15]

The additive color circle is significant for color/light processes such as photography, the RGB mode in computer color, and color lighting. [1.9] It should be noted that the additive circle should not be used as a reference for the printing process or traditional art materials.

Because both additive and subtractive color circles are references for varied art processes, we should be aware that the medial or psychological primaries are red, yellow, green, and blue. [2.10] The medial primaries are the two groups of primaries, additive RGB and subtractive RYB, combined. Having four primaries is a slight diversion from the traditional approach to color, but it does not prevent us from using

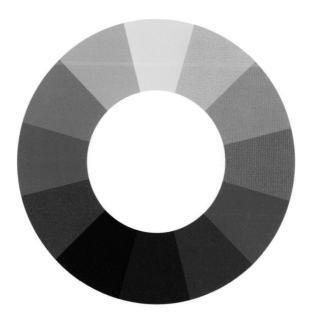

Figure 2–9 The traditional color circle has three primary hues, RYB; three secondaries, OGV; and six tertiary hues: RO, RV, YO, YG, BV, and BG.

Figure 2–10 The medial or psychological primaries are the combined primaries of both additive and the subtractive color systems.

the traditional wheel as a tool. For clarity and consistency, much of this book is based on the traditional subtractive color circle. When important for understanding a particular media, the additive circle or process circle are also used as references.

THE TRADITIONAL SUBTRACTIVE COLOR CIRCLE

The traditional color circle has three primaries: red, yellow, and blue. There are three secondaries: orange, green, and violet, and six tertiary hues: yellow-orange (YO), yellow-green (YG), blue-green (BG), blue-violet (BV), red-violet (RV), and red-orange (RO). [2.9]

 The traditional color circle includes hues that align with our mental image of pure red, yellow, and blue. One disadvantage of the process wheel is that cyan and magenta do *not* fit our idea of a true blue or red, although the yellow seems the same as in the traditional color circle.

 The color circle is an organizational system that allows us to perceive the differences among the hues. It compartmentalizes the concept of the *chromatic* aspect of color which is based on the unique appearence of each hue. Johannes Itten stated that a functional color wheel should be simple enough to carry in our memory. The distinct hue characteristics of a traditional twelve-hue color circle are an important element of a functional color system.

 The organization of the traditional color circle allows us to see relationships between the hues in varied ways. The color circle can be seen as a representation of the gradual change from one hue to another. We can also regard the circle as a means of identifying opposite hues, neighboring hues, or hues spaced apart from other hues on the color circle.

 The traditional color circle makes it clear how hues are formed. The primaries have equidistant placements in relationship to each other, with yellow at the top of the circle. At the halfway points between the primary hues are the secondary hues, which represent the mixtures of the primaries. [2.11] These mixtures are as follows:

> yellow + blue = green
> red + yellow = orange
> red + blue = violet

 The tertiary hues are those produced by the mixtures between a primary and a secondary. [2.12] The tertiary hues are mixed as follows:

Figure 2–11 Mixtures of the traditional subtractive primary hues form secondary hues, as shown.

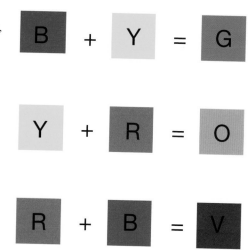

B + Y = G

Y + R = O

R + B = V

Y + G = YG

Y + O = YO

R + O = RO

B + V = BV

R + V = RV

B + G = BG

Figure 2–12 How a primary and a secondary hue mix to form each tertiary hue.

Y + G = YG
Y + O = YO
R + O = RO
R + V = RV
B + V = BV
B + G = BG

The tertiary hues are visual halfway points between primary and secondary hues. Other color circles have a wide variety of names for tertiary hues. In the traditional color circle, the tertiary names are easy to remember as each is prefaced with the name of the primary hue followed by the secondary hue in each mixture. Sometimes the traditional subtractive wheel is presented with a gray or black circle in the center to indicate the color that would result if all the hues were mixed together subtractively.

The word *hue* is defined as either a specific wavelength from the spectrum or a color, in its pure state, from the color circle. The word *color* means a color derived from any hue; for example, violet is a hue and light violet is a color. Unlike a hue, a color is not necessarily chromatically pure.

HUES—COMPONENTS OF A COLOR CIRCLE

Each hue has its own characteristics, which define its visual impact. The primary hues are subtractive colors that contain no other hues. We must have primaries to create all the other hues. Both primary and secondary hues have qualities that vary in lightness, density, warmth or coolness, and associations with reality. A brief overview of the primary and secondary hues is detailed in Table 2–1.

ACHROMATICS AND THE COLOR CIRCLE

The traditional color wheel contains no black, white, or gray. The neutrals are *achromatic,* meaning that they contain no chroma or hue. White, black, and neutral grays define our concept of light and dark in a pure manner. Sometimes white and black are not regarded as true colors because white represents light and black represents the absence of light in the additive color system. However, for the purposes of subtractive color, black and white are essential. Neutrals relate to the wheel as entities of value (light and dark) and as hue *effectors.* Neutrals are hue effectors due to their ability to change the value or saturation of any given hue. The value steps between black and white form a series of grays called an *achromatic scale.* Grays are gradual steps that connect black with white or perfect light with perfect darkness.

The achromatic scale is an entity aligned with, but separate from, the color circle. Achromatics are also considered to be neutral "colors" themselves. An achromatic scale aligned with a color wheel presents an appropriate relationship between the two essential components of color. The relationship of chromatic hues to achromatic

Table 2.1

CHART OF PRIMARY AND SECONDARY HUES

Color	Characteristics	Temperature	Descriptive Names	Pigments
Red	Heavy in density, highly saturated and medium in value. It is stimulating and active. Refers to blood, fire, and the sky at sunset. It seems to "glow within itself" (Kandinsky). A subtractive and an additive primary.	Warm	Scarlet, Crimson Maroon, Flame, Burgundy	Cadmium Red, Quinacridone Red, Alizarin Crimson, Indian Red
Yellow	The lightest value hue, High saturation, low in density. Seems to emit its own light. Reflects both red and green wavelengths. A subtractive primary. Refers to the sun and activity.	Warm	Lemon, Brass, Gold, Sand, Amber	Cadmium Yellow, Hansa Yellow, Yellow Ochre, Zinc Yellow, Naples Yellow, Gamboge
Blue	Medium in value and density, saturation and weight. Quiet and restful. Refers to distance, the sky, and water. An additive and subtractive primary hue.	Cool	Sky blue, Azure, Navy Blue, Indigo	Ultramarine Blue, Cobalt Blue, Cerulean Blue, Phthalo Blue, Prussian Blue
Green	Medium density saturation and value. Quiet and soothing. Refers to plants, trees, water, and landscape. An additive primary and a subtractive secondary.	Cool	Sea green, Emerald, Leaf Green, Jade, Apple green, Olive	Permanent Green, Green Earth, Viridian Green, Sap Green, Cadmium Green
Orange	Has light from yellow and glows like red. Light in value and low in density; high in saturation. Associated with warmth and assertiveness. A secondary hue.	Warm	Pumpkin, Peach, Sunset, Rust	Cadmium Orange, Cadmium Yellow Deep, Azo Yellow Orange
Violet	Darkest hue, heavy in density and weight, and medium in saturation. Dignified and rich; suggests darkness, night, and water. A secondary hue.	Cool	Mauve, Purple, Plum, Lavender	Dioxazine Purple, Manganese Violet Cobalt Violet, Ultramarine Violet

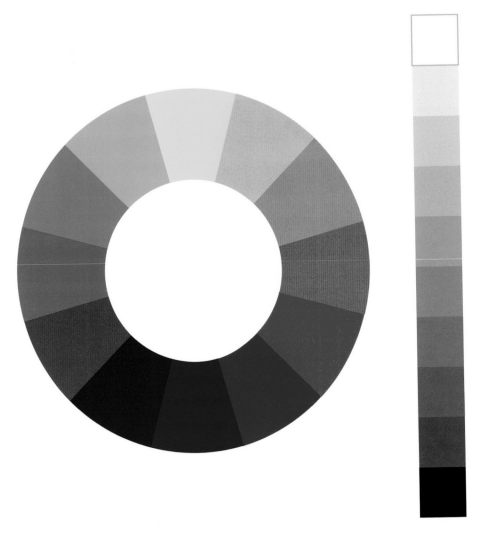

Figure 2–13 The neutrals or achromatic colors can be seen as hue effectors. Color variations are made from combinations of neutrals and hues.

colors conveys the starting point for all colors. [2.13] Chromatic colors begin with a hue and are affected by mixture with other hues or neutrals of black, white, or gray.

HUE CONTRAST

A characteristic of hues is their ability to contrast. The strongest type of color contrast is *value* contrast, pure white to pure black. In chromatic hues, the strongest contrast is between the subtractive primaries, red, yellow, and blue. The juxtaposition of

Figure 2–14 Hue contrast: The highest color contrast is between black and white. The strongest chromatic contrast is between the primary hues. The secondary colors contrast somewhat less. The greater the seperation of hues on the color circle, the stronger the contrast between hues.

pure primary hues displays a potent contrast, because each hue contains none of the other hues. Secondary hues, green, orange, and violet also visually contrast with each other, however, the contrast is softened because secondary hues have primary components in common, red in both violet and orange, yellow in both orange and green, and blue in both green and violet. [2.14]

Other, less formal contrasts are achieved by the juxtaposition of opposing hues or light/dark combinations. Usually, pure undiluted hues (high saturation hues) create the strongest hue contrast. When black and white are included in the hue contrast grouping, the contrast is even more intensified. The further apart hues are on the color wheel, the stronger the contrast between the hues. [2.9] For example, a yellow and blue-green combination has stronger hue contrast than that of yellow and orange. The greatest contrast (besides the contrast between primary colors) that of hues directly across from each other on the color circle. These are called *complementary* hues.[2.18]

HUE RELATIONSHIPS ON THE COLOR CIRCLE

Hue Values

As we explore the color circle, we can discern several types of hue relationships. Relative value of the hues on the color circle should be noted, as the color wheel serves as an informal value (light/dark) chart for the hues. As we move down the

Figure 2–15 Cool and Warm sections of the color wheel. Approximately half of the color wheel is considered warm and half is cool, RV and YG are the borderline hues.

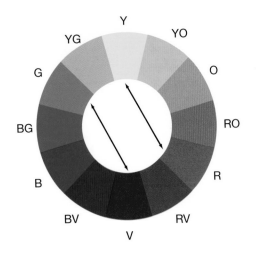

color circle from the top, which is yellow, the hues gradually become darker as they are located closer to the bottom of the circle. Violet, placed at the base of the color circle, is unquestionably the hue with the darkest value. Yellow, at the top of the circle, is the hue with the lightest value. Red and green are at approximately the same level as middle value hues.

Color Temperature

The color wheel also charts relative *color temperature*. It is natural for us to associate the notion of temperature with color. Strong visual associations from our culture and environment cause us to feel that red is warm in temperature because of its reference to blood, fire, and the sun. Due to similar associations we know that blue is cold in temperature because it refers to water, ice, and the sky. Warm hues seem to emit light and heat and cold hues suggest coolness, distance, and shadow. The placement of cool and warm hues on the color wheel roughly divides the wheel into two halves, a cool side and a warm side.[2.15] The color circle section of yellow through red is definitely warm, whereas the slice of green through violet is definitely cool. Tertiary hues of yellow-green and red-violet are borderline hues. Color theorists are divided on whether these hues are warm or cool so it is best to think of them as flexible in temperature.

Cool and warm hues not only refer to temperature, but also create a temperature sensation in the viewer. This effect is particularly strong in interior design, when colors visually surround the viewer. Red used in an interior is stimulating and creates a warming effect on the occupant of the room. A blue in an interior has a restful, yet cooling effect on the occupant of the room. It is debatable which hue is the coldest and which is the hottest. According to the Swiss artist and color theorist Johannes Itten (1888–1967) in his *The Elements of Color,* the warmest hue is red-orange and the coolest is blue-green. Usually a red and a blue are chosen as warmest and coolest hue, respectively.

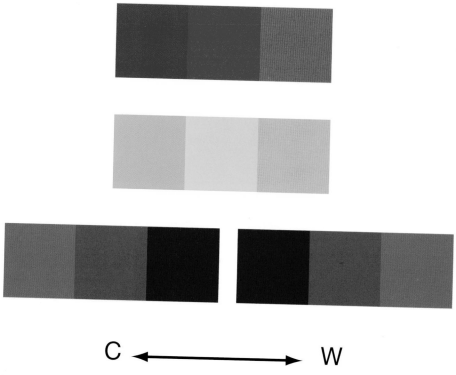

Figure 2–16 Each primary can have either a cool or warm aspect, as shown here. The cool/warm aspect of blue can be seen two ways, with either BG or BV regarded as a cool blue.

In addition to a color's cold or warm placement on the color wheel, each primary and secondary hue may have a cool or warm *aspect*. For example, this means that red, a warm color, is even warmer when yellow is added to make red-orange. Red is cooler with blue added, creating red-violet. [2.16] There is also a cool and warm aspect of each secondary hue for example, a red-violet is considered to be a warm violet. Color theorists are divided on the definition of a cool and warm blues. Sometimes a cool blue, for example, is identified as one that leans toward blue-green and often a blue-violet based blue is considered to be cool. For painters, however, a cool blue always bends toward blue violet, such as ultramarine blue, whereas a warm blue is more blue-green like cerulean blue.

The concept of cool and warm color is a useful way for the artist or designer to create varying color contrasts and visual effects. Using cool/warm contrast is a striking way to bring about the contrast of hues and colors, and it is also a form of color harmony. Manipulation of the cool and warm aspect of color is a method of varying a hue or depicting spatial depth in a work of art. Cool colors are traditionally thought to recede spatially. Warm colors are traditionally seen as colors that advance spatially. This "rule," though valid, is easily broken. Cool colors may advance if they are sufficiently pure or high in saturation. Warm colors recede

if they are low in saturation or muted. Cool/warm contrasts evoke the following visual opposites:

Warm		Cool
light	—	shadow
summer	—	winter
fire	—	water
fall	—	spring
dry	—	wet
close	—	distant

Color Families

Another important hue relationship on the color circle is the concept of color families, also called neighboring or *analogous hues.* Analogous hues are groups of two or three neighboring hues on the color circle. [2.17] Analogous groups are adjacent to each other on the color wheel; for example, blue, blue-violet, and violet. Each hue of this analogous group contains blue in some proportion, visually connecting them. The close relationship of these hues creates a chromatic harmony, or scheme. Working with a color family is a simple and harmonious way to organize color.

Color Opposites

The importance of hue opposites, called *complementary colors,* cannot be overemphasized in color study. Chromatic opposites are two hues located directly across the color circle from each other. They are called *complementary hues,* or complementary

Figure 2–17 Hues that are neighbors on the color circle are in an analogous hue relationship.

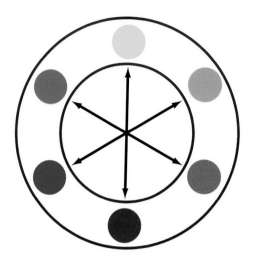

Figure 2–18 The traditional subtractive complementary pairs are red-green, blue-orange, and yellow-violet.

dyads since they are in pairs. [2.18] The complementary opposites from the traditional subtractive color circle are blue to orange, yellow to violet, and red to green, each one of these pairs having one primary and one secondary color. Complementary pairs are chromatically balanced because each pair contains all three primaries as follows:

Red—Green (yellow + blue)
Blue—Orange (yellow + red)
Yellow—Violet (blue + red)

Note that the subtractive complements vary slightly from the additive color complements of magenta-green, yellow-blue, and cyan-red.

We have a physiological relationship with the concept of complementary colors. When our eye becomes tired or saturated with one hue, our eye automatically produces its visual opposite or complement. This phenomenon is called an *afterimage.* The concept of afterimage is an important part of color interaction. [4.1]

The complements also neutralize each other. In the subtractive color system, the three primaries will cancel each other out to create a near neutral when mixed. As each complementary pair contains the three primaries in various proportions, each pair will neutralize each other, creating neutrals such as brown or gray. A red to green scale shows how the mixtures create muted hues near the end of the scale and a neutralization of the hues in the center of the scale. The complement or dyad pairing is also considered a type of color harmony. [2.19]

Color Chords

Groups of hues that spaced apart on the color circle are called *color chords.* Color chords are hue selections from the color circle that create particular color harmonies. The analogy to the chords of musical harmonies refers to the varied spacing of three

Figure 2–19 Complementary hues in the traditional subtractive mode will neutralize each other. Shown here are incremental mixtures of red and green.

or four notes to create a harmonious sound. Each musical chord has a different quality of sound. Color chords are also spaced intervals of color with different qualities. Hue spacing may be equidistant as in a selection of red, yellow, and blue: a triadic chord. Spacing may also be varied to make a selection of yellow, blue-violet, and red-violet—a split complement chord [9.13] Another group uses four hues in an evenly spaced arrangement, such as yellow, blue-green, red-orange, and violet—a tetrad chord. A color chord brings together three or four seemingly unrelated hues to form a color harmony.

COLOR PROPORTION

In color study, there is always a quest for color harmony. *Color proportion* is a measured amount of relative area of pure hues meant to attain color balance and harmony. Color proportion is based on the variations in saturation or color intensity levels of pure hues. For pure hues to balance compositionally, one may employ a proportional system based on relative value and saturation level hues. Johann Wolfgang von Goethe, the author of *The Theory of Colors* (1810), formed a system of color proportion that is a simple ratio system for relative areas of pure hues. Goethe reasoned that yellow, as the lightest hue but also the highest saturation hue, should occupy the least space in a composition. Since violet is the darkest and a lower saturation hue it should occupy more physical area than yellow for compositional balance. According to Goethe's system, a physical area for each hue is based on a numerical code assigned to each hue. [2.20] This code dictates how much space each hue should occupy relative to other hues. The numerical value for each hue is as follows:

<div align="center">

Yellow—3 Orange—4 Red—6 Green—6 Blue—8 Violet—9

</div>

According to this proportion, harmonious areas of red and green should be equal, each using 50% of any given space. Violet and yellow would use ¼ yellow to ¾ violet, since the value of violet is three times as much as yellow. [2.21] Yellow's proportion to green would be ⅓ yellow to ⅔ green. This "rule" should be considered merely a guideline. For greater hue contrast, the harmonic area ratios can be ignored or even reversed. To create a more visually exciting proportion, for example, the yellow can be allowed to dominate violet.

The exploration of the color circle leads us to several conclusions. First, the color circle is an essential tool for the study of color relationships. Second, the color

Figure 2–20 In Goethe's numeral value system of color proportion, each hue should occupy a designated area for color balance.

Figure 2–21 Goethe's proportional system applied to design. This proportional system can be inverted for a more exciting color effect.

circle provides us with a guide from which to select hues for color harmony. Third, the color circle is the starting point, in conjunction with the achromatic neutral scale, to create the millions of colors that we see.

ACTIVITIES

1. COLOR WHEELS

Objective: For the student to several types of color circles or wheels to understand the differences the traditional color circle or wheel, the process color wheel, and a subjective color wheel.

Media: Gouache or acrylic on paper, mounted on illustration board.

A. Traditional Color Wheel

- Make a traditional color wheel using tempera, gouache, or acrylic paint.
- Make sure that you have both primary and secondary color paints before you start. See notes on materials.
- First paint out swatches of the three primary hues, *RYB*. Pure colors out of the jar or tube are the best. Next, paint the three secondary hues OGV. Each swatch should be painted out on good drawing paper at least 3-inches square.
- Next, mix the tertiary hues, YO, YG, BG, BV, RV, RO. When mixing light value hues such as yellow-green, start with the lighter hue, yellow, and add green to it. Make sure that you use a magenta based red when mixing RV. Compare each tertiary hue to make sure it is a visual halfway point between your primary and secondary colors.
- Color circle wedges are made by using a compass to make an 8- or 10-inch circle. A protractor then divides the circle into 30° parts, to make 12 sections. The wedges are cut with a template that is made from this guide. Assemble the circle onto a drawn image of the color wheel with the 12 divisions shown, in order to correctly place the parts. [3.29]

B. Process Color Wheel

- Another or alternate color circle can be assembled from the process hues, cyan, magenta, and yellow. Many brands of paint offer a reasonable facsimile of these hues.
- In this color circle, all the hues should be made from the process primary colors. First paint out the process primaries, then mix the secondaries as follows: cyan and yellow for green, magenta and yellow for orange, cyan and magenta for violet.
- Mix six tertiary hues carefully, considering relative proportions of each CMY primary involved in each color mixture. YO, for example, would be yellow with just a tiny amount of magenta. BG is cyan with just a small amount of yellow and so on. [2.22] Assemble the color circle as indicated previously.

C. Subjective Color Wheel

- Make a color circle based on a personal concept of the most important hues. The circle can, for example, have more cool colors than warm hues. Use your own conception of

Figure 2–22 The subtractive process color circle uses CMY primaries mixed into the secondary and tertiary hues.

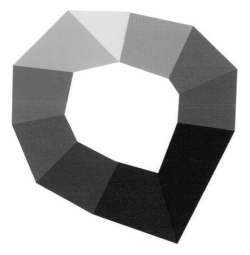

Figure 2–23 An invented subjective color wheel based on personal color preferences.

pure red, yellow, blue, and green, even if you have to mix the colors. Come up with a format (it doesn't have to be in a circle) based on your own design. [2.23]

2. COMPLEMENT SCALE

Objective: The student should try to understand the neutralization (the creation of a chromatic neutral) of each hue when mixed with its complement. Also, the complementary mixtures can be mixed to produce a group of harmonious colors.

- Make a scale based on each major primary-secondary complement pair or dyad: blue to orange, yellow to violet, red to green.
- Make all swatches on good drawing paper. Start with one hue; for example, first make a swatch of pure red. Then add small amounts of green to the red. Paint a swatch after each addition. As the green is added, red will become successively more neutral, toward brown or gray. Then start with pure green and gradually add more red, painting a swatch each time the color changes.
- Present the entire scale with red at one end and green at another as shown. There should be nine or eleven steps in this scale, each represented by a 1-inch square. The central step in the scales should be the most neutral color. [2.19]

3. WARM/COOL ASPECTS OF HUE

Objective: The student should be able to create or choose warm and cool variations of hues.

- Use each primary color to make warm and cool hue variations.
- For example, paint a swatch of primary red or pick out one from a Color Aid® paper pack.
- Now make a warm red. Adding a tiny amount of yellow or a larger amount of orange can do this. With colored paper, be sure that your warm red has a slightly more orangey cast than your primary red.

Figure 2–24 Hue contrast study: Hue and color choices in juxtaposition emphasize maximal hue contrast.

- Make a cool red. Adding a tiny amount of blue or a larger amount of violet will achieve this. In doing this with paper, you will look for a red with a more violet cast.
- Repeat the same process with red and yellow. This study can be also executed with secondary hues. How can a violet be cooler? Warmer?
- Present each hue with the main hue in the center and the cool and warm aspects of the hue on either side. Make each part using 1-inch squares of color as shown. [2.16]

4. HUE CONTRAST STUDY

Objective: To perceive and juxtapose the strongest hue contrasts.

- From colored paper or painted swatches pick out ten strongly contrasting hues or colors. Black, white, and gray can also be included.
- Place colors in a grid that maximizes the contrast between the hues, as shown. Each grid piece should be 1 by 2 inches. Making the overall size 4" × 5".
- For maximal color contrast, try adjacent placement of complementary colors or pure hues contrasted with neutrals such as black or white. [2.24]

5. COLOR PROPORTIONAL STUDY

Objective: To use the balanced proportional system for pure hues as devised by Goethe. To create an opposing system to make an exciting combination of hues.

- Use two or three hues in a simple proportional study. Try to employ correct proportions for each hue according to Goethe's numerical system as described in the text. [2.20]

- For example, if you made a study out of violet and yellow, use three times as much violet as yellow (be sure to measure square inches of each) You can use painted paper or Color Aid® paper. [2.21]

- Cut apart the colors into simple geometric shapes and then make your design only using the "correct" Goethean proportions.

- Next make a study where you reverse or invert the proportions. For example, you can use more yellow and less violet.

Chapter 3

Attributes of Color

INTRODUCTION

The complexity of color offers the artist a world of choices that can make color decisions exciting but daunting. Given the sheer number of color variations, some confusion is understandable. A respect for the complexity of color can actually assist the artist or designer. James Clerk Maxwell (1831–1879), the Scottish physicist, made huge contributions to the field of color research. One of the most important results of his discoveries was his identification of three distinct *color dimensions* or *attributes*. Awareness of the three variable attributes of color can simplify the process of color selection.

The three main dimensions or attributes of color are the variable factors or characteristics of *hue, value,* and *saturation*. *Hue* refers to a specific color wavelength from the spectrum and color circle. The traditional subtractive twelve-hue color circle will be used as a standard color reference. *Value* is simply the lightness or darkness of a color. *Saturation* is the property of color that refers to its purity, intensity, or chroma. Since it is difficult to utilize all three color characteristics at once, we will explore each attribute—hue, value, and saturation—as a separate entity.

HUE

The term *hue* refers to a spectral color in its pure state. A hue is a color selection from the color circle, such as violet, referred to as a spectral primary, secondary, or tertiary hue. [3.1] A hue is also defined by its location on the color circle. A hue selection is the basis for other color dimensions or attributes. For instance, the selection of specific hues for a color scheme determines the basis for all the colors in a design.

Hue Names

The terms *hue* and *color* have separate and distinct definitions. A *hue* is a specific spectral color from the color circle, while a *color* is any variation on a hue or neutral. Thus, a hue is the basis for color variation. The neutrals are *achromatic* (containing no hue or color), whereas colors are *chromatic* (containing some hue). For clarity, the name of each spectral hue should be used in reference to its many color

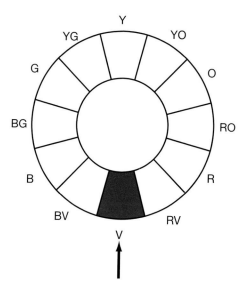

variants; for instance, red mixed with white, is referred to as a tint of red. A descriptive, as opposed to a spectral, name for this same color would be pink. Color names can be descriptive or referential such as: fire engine red for a warm red, teal for blue-green, and chartreuse for yellow-green. [3.2] Descriptive color names are useful for identifying large numbers of colors of commercial paint or consumer products, such as the colors of makeup. For color-study purposes, however, it is clearer to refer to a color as a tint of red-violet, for example, rather than using its descriptive name of "hot pink."

There are numerous types of color names. Sometimes color names refer to pigments, which are colored powdered materials that form paints. Pigment names often confuse students. Students want to know which red pigment is the "true" red, blue, and so forth. Pigment names often refer to the chemical or mineral content of the colors. We do need to know at least some pigment names in relationship to hue

Figure 3–2 Descriptive names for colors include, from left to right, fire engine red for *RO,* teal for *BG,* and chartreuse for *YG.*

Figure 3–3 Base hues of colors. Notice that each color on the left relates to a base hue on the right: red, yellow, and blue.

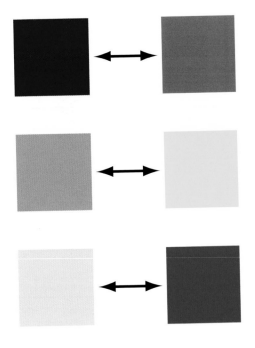

equivalents on the color circle. Cadmium Red Light is, for instance, a red orange, magenta is a red violet, and napthol crimson is a spectral red. Familiarity with pigment names is essential when working with various types of paint.

Hue Standards

There are several international systems used to standardize hues. Printer's process inks in the hues of cyan, yellow, magenta, and the achromatic black (CYMK) are used internationally. The letter K is used as an abbreviation for "black." Computer graphic color modes, such as RBG and CIE color are also standards. An older standard for hues is the Munsell system of colors. It is a color standard in the United States used by the National Bureau of Standards. Great Britain, Japan, and Germany also use the Munsell system as a standard color system.

Hue Identification—Base Hues

To use color successfully, the eye should first be sensitized to heighten color perception. Hue identification is a process whereby hue perception is used to identify the base hue of a color. The *base hue* of a color is a spectral hue from the color circle from which a color is related or derived. The concept of a base hue is this: thousands of colors that we see can be visually traced back to the twelve hues of the traditional color circle. [3.3] Colors which do not have a spectral base hue are pure neutrals (achromatics), that contain only black and white. A true neutral has no dis-

Figure 3–4 A questionable color placed against a neutral can help determine its base hue.

cernable chroma or hue base. Even a metallic color such as gold can have a hue relationship to yellow, red, or orange. Earth colors are often based on a hue; for example, burnt sienna can be traced back to a red-orange.

To effectively implement color selection and color harmony, our eye should be able to discern the base hue of almost any chromatic color. In order to sensitize our eye for this process, sample colors are first taken from several types of sources. Colors from found colored paper, magazine stock, fabric, wall-paint samples, and Color Aid® paper may be used for this exercise. Each color sample is then related visually to a primary, secondary, or a tertiary hue. To implement color perception, each color in question should be isolated against a neutral background of black or white. Found colors should be placed on an appropriate neutral; light colors are best identified against white, dark colors against black. [3.4] Each color should be identified in relationship to a single hue, such as a lilac color, which has a base hue of BV. This exercise seems to be rudimentary, but is in fact quite difficult. The greatest challenge is to identify colors that are very muted, neutral and low in saturation, very dark shades and very light tints.

Hue Variation

When the student becomes proficient at base hue identification, the next step is to make hue variation studies. The purpose of a hue variation study is to find as many widely different variations of one hue as possible. The first study should have at least ten variations on any chosen base hue (such as violet) [3.5]. Found colored paper or Color Aid® paper are the best source materials. This study is called a found hue identification/variation study.

A second hue variation can be made manually with paint. The point of this study is to radically vary colors while retaining the same base hue. A large group of colors—light, dark, dull, and bright—that share the same base hue of green, for example, can be mixed. To make hue variations on green, green can be mixed with white in a number of lightening steps, or shaded with black in a number of darkening steps. The

Figure 3–5 A hue identification exercise on the hue of violet. The point is to find or make a wide variety of colors which share in common same base hue.

green can also be mixed with gray in varying proportions to create more colors. Green can also be intermixed with other hues in modest proportions, taking care that a green hue still ends up being visually dominant, in other words, the resulting color should not be too blue-green or yellow-green. All of these color mixtures should be ultimately traced back to green as the base hue. Each study will end up being a monochromatic variation on a single hue.

In studies for this chapter, one will discover that in the process of mixing color, light hues such as yellow are easily changed by the addition of any other hue. Darker hues, such as red or violet, are stronger in retaining their power to dominate color mixtures when other hues or neutrals are added.

With any hue-to-hue mixtures, the base hue is affected differently by additions of other hues, based upon their relative positions on the color circle. Neighboring hues do not as strongly affect the base hue as those that are located farther away on the circle. For example, a red is only slightly affected by the addition of RO, yet it is strongly affected by the addition of blue. When blue is added to red, a very strong change occurs in the original hue of red, moving the red toward the secondary color of violet.

Hue identification and variation introduce the student to color perception and the formation of many colors, even within the restriction of a single hue.

VALUE

Value is an attribute of color as well as an element of design. *Value* refers to all the perceptible levels of light and dark from white to black. Value levels are most easily understood as a series of neutral grays. Our eye can discern a large number of

Figure 3–6 A neutral or achromatic scale with ten value steps, including black and white.

neutral gray steps between white and black. A workable value scale, however, is a reasonable size. Standard value scales used by color theorists usually have between ten to twelve value steps, including white and black. [3.6]

Value Scales: Tints and Shades

Adding varied amounts of white or black to a hue controls its value (lightness or darkness). The simplest way to lighten the value of a hue is to add white. The simplest way to darken the value of a hue is to add black.

Our perception of value steps is even more acute when color is linked with value. For this reason, our eye can easily discern many more steps between white and black when we use a hue in a value scale. A hue + white is called a *tint*. A hue + black is called a *shade*. [3.7] When a hue is gradated in a value scale, the inherent value of the hue is lightened and darkened by tinting and shading the hue. As the word "shade" is commonly used to describe any color, for clarity, in this book a *shade always refers to a color mixed with black.*

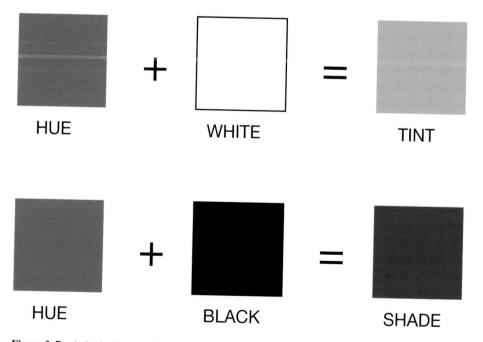

Figure 3–7 A tint is a hue + white and a shade is a hue + black.

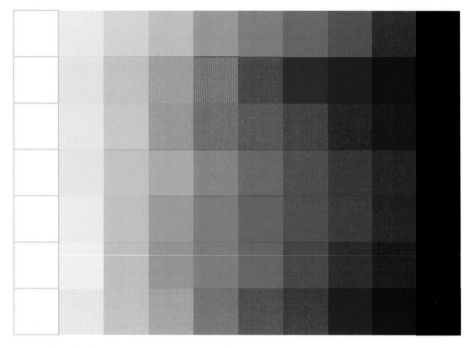

Figure 3–8 A primary and secondary tint/shade value chart; note the varied placement of pure hues in each value scale.

A good quality painted value scale is achieved by controlling white and black pigments very carefully. Most students master this quickly. Students will find that both color mixing skill and value perception improves simultaneously. The act of mixing colors manually is a key to better color perception. Most students will end up making many more colors than necessary simply because they are able to both mix and see the value and color differences more accurately as they work.

The traditional primary hues of red, yellow, and blue, and three secondary hues of orange, green, and violet, when scaled out modestly into ten steps each, make a range of 48 colors, not including black and white. Shown here, the hue value scales have similar value increments as each other and as the neutral gray scale. [3.8]

Inherent Value of Hues

The value scale chart displays the primary and secondary hues scaled in a ten-step value chart. Pure hues are included in various locations in each scale. This varied placement is because pure hues are not all at the same value level. Pure hues have levels of light and dark called inherent value. *Inherent value* is the light or dark value of a hue at its maximum saturation or purity. [3.9] The color circle may be used as not only a hue selector but also as a simple value guide to the inherent value of hues.

Figure 3–9 This chart shows the inherent value of hues. Notice that the layout of this chart is identical to their placement in the traditional color circle. The lightest hues are at the top and the darkest hues are at the bottom.

Yellow is placed atop the color wheel to signify its place as the hue with the lightest value. As we scan the wheel downward, the hues gradually darken until we get to the bottom, where violet is easily seen as the darkest hue. The pure hues have an approximate light-to-dark range as follows: yellow, very light; YO and YG, light; orange and green, medium light; RO and BG, medium; red and blue, medium; RV and BV, dark, violet, very dark.

It is difficult to perceive pure hues in terms of merely light and dark value. Most of us tend to respond to the identity of the hue itself—its associations, personality, and characteristics. We respond to the identity and warmth of red, not to red as a middle-value color. On the value chart, the neutral black, white, and gray value scale is placed in direct relationship to the hue value scales. [3.8] This demonstrates how the gray scale matches the exact value steps of each hue. As the student creates value scales, the gray scale should be a value key or guide. Pure hues are located in various placements in the value scales. For example, pure yellow is very close to white, pure red is approximately halfway between black and white, and violet is much closer to black because it is the darkest hue. Value/hue relationships are notoriously confusing for students. Most people want to believe that all the pure hues

have the same placement within each value scale, which would be convenient, but certainly is not accurate.

Value Keys

Color can be conceptualized not only as steps on a value scale but also as keys on a value keyboard. If we imagine high and low notes on a piano keyboard, this is a useful analogy for the concept of color *value keys*. High-value key colors are light-value steps, inherently light hues and tints. [3.10] Middle-value key colors are medium-value range hues and darker tints. [3.11] Low-value key colors are the darkest hues and shades. [3.12]

When colors are value-keyed, they are brought as closely as possible to the same level or value key range. An important aspect of this process is to select dif-

Figure 3–10 All the colors in this group are light in value key.

Figure 3–11 These colors are all value-keyed to a medium-value level.

Figure 3–12 Dark value key colors.

ferent colors but to make the values of the colors as similar as possible. A value key exercise can be implemented by using a variety of colored paper. When a group of colors is keyed correctly, one color does not recede or come forward. To distinguish colors that are keyed to the same value level, a group of possible colors can be viewed in a dimly lit room. A low lighting situation helps us see similarities in value because low light decreases hue perception, and increases light/dark sensitivity. When viewed in a half-lit room it should be hard to distinguish any light/dark contrast between colors. Colors can also be keyed to a light value by manually mixing paint. A group of light value colors can be obtained, for example, by tinting (adding white) to each of group of varied hues. Dark value keys are relatively easy to perceive and execute by shading numerous hues to the same dark value range. Attempting to key middle-value range colors can be more difficult. Medium-value colors tend to be purer, and it is harder for the eye to perceive the value differences in colors at full saturation.

SATURATION

The third characteristic of color is saturation. The attribute of color *saturation* refers to the purity or intensity of a hue or color. It is also sometimes referred to as *chroma*. High saturation colors are pure, bright, and intense. Low saturation colors are duller, subtle, and muted.

Saturation and Value

When manually mixing colored pigments, we are using the subtractive color system. This means that the more different colors are mixed together, the duller the colors become. When creating value scales, tinting and shading the hues considerably lowers their intensity. Tinting lightens a hue to a higher value level, yet lowers its saturation (intensity) level. Compare a pure red, for example, with a tint of red (such as pink), and the difference becomes obvious. [3.8] The same effect occurs when shading a hue. When mixing paint for tint/shade value scales, it becomes evident that adding black to a hue such as red both darkens and lowers its saturation. Lower saturation occurs both when shading a hue with paint and when adding black in the CMYK process color mode on a computer graphic program. Thus, changes in value and saturation often occur simultaneously.

Students usually have difficulty separating the color characteristics of saturation and value. They will call a highly saturated yellow, for example, a "dark" yellow. A pure yellow is both high in color saturation as well as having a light value key. A dark yellow actually refers to a dark value of yellow, possibly a shade or another dark mixture of yellow. [3.13] If we separate the concept of light/dark as variables of value from the concept of bright/dull as variables of saturation, then both concepts are clarified.

Figure 3–13 Sometimes colors are mistakenly called dark, when in fact they are pure, high in saturation. The pure yellow is both high in saturation and light in value. Shades of yellow that are darker in value are also lower in saturation.

Systems of Color Saturation— Color Solids

There are several color theorists who made significant contributions to the notion of color attributes. *Color solids* are three-dimensional color notation charts. Several theorists formulated color solids, notably Albert Munsell, Otto Runge, and Wilhelm Ostwald. Each of their color notation systems presented the attributes of color, hue, value, and saturation in an organized framework. Many color theorists saw color solids as the only way to accurately represent all the dimensions of color within a single visible structure.

ALBERT MUNSELL The foremost color theorist of this group was the American Albert Munsell (1858–1918). Munsell presented his color system in detail in his 1905 book *Color Notation*. Munsell developed a color circle based on ten rather than twelve hues.

Munsell's major contribution to color theory was the development of a three-dimensional color tree that illustrated the color characteristics of hue, value, and saturation all at once. Munsell saw the color wheel as a three-dimensional structure in relationship to a white-to-black gray value scale, which served as its central axis. [3.14] In this color system, the pure hues are located in a circle around a nine-step value scale. Each pure hue is at a different level in order to be value-keyed with a corresponding gray. Munsell envisioned each pure hue in a relation-

Figure 3–14 The Munsell color tree schematic. Courtesy of GretagMacbeth, LLC. Photographs provided by Munsell, A Division of GretagMacbeth, LLC.

ship with the inner gray scale in order to simultaneously display the tints, shades, and tones of each hue.

Munsell coined the term *chroma,* a synonym for color saturation. A pure color in Munsell's system is regarded as having a high chroma. A *tone,* a hue + gray, according to his system, is a way of controlling the *chroma* of a color. [3.15] There are many saturation steps from each pure hue to a perfectly neutral gray. In Munsell's color tree, every hue is scaled in various steps to nine white-black gray values. [3.16] The amount of resulting colors makes it clear why Munsell felt it

Figure 3–15 A hue plus gray is a tone.

Figure 3–16 The Munsell color tree displays the three attributes of color in a three-dimensional form at indicating hue, value, and saturation. Photographs provided by Munsell, a Division of GretagMacbeth, LLC. Courtesy of GretagMacbeth, LLC.

Figure 3–17 The Ostwald solid is similar to the Munsell color tree in its three-dimensional structure, and its use of sequential tones.

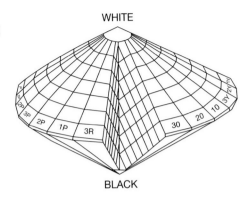

necessary to design a three-dimensional color model. His color tree illustrates a large and complex color system, which allows many variations of each hue to be perceived, created, and organized with relative ease.

WILHELM OSTWALD The work of German color theorist Wilhelm Ostwald (1853–1932) closely relates to the color theories of Albert Munsell. Ostwald's color notation system also emphasizes saturation variety, yet it is even more complex than Munsell's. Ostwald, like Munsell, created a color circle in relationship to a central value scale. [3.17] Ostwald formulated an extremely scientific method of incrementally mixing pigments in order to achieve controlled results. While Ostwald's system has a more solid color structure than the Munsell system, it uses essentially the same concept of pure hues gradated into a series of tones for saturation variety. The major difference between the two systems is that on Ostwald's color solid the hues are aligned in a circle instead of being staggered value by value as they are on Munsell's color tree.

PHILIP OTTO RUNGE Color theorists throughout the twentieth century and even earlier have formulated color solids. An early color solid was developed by the eighteenth-century German color theorist Philip Otto Runge (1777–1810). His color sphere places a twelve-hue color wheel in relationship to a central core of a middle-value gray. [3.18] The hues are gradated in tones toward the gray core. The upper pole of the sphere is white and the lower pole is black. [3.19, page 62] This allows tints and shades of the hues to be presented in relationship to the tones. This sphere predates both Munsell and Ostwald by almost a century and is perhaps a clearer presentation of similar concepts.

JOHANNES ITTEN Johannes Itten was an artist, color theorist, and teacher at the Bauhaus School in Germany. He developed a color study course that addressed the aspects, characteristics, and contrasts of color. In his book *The Elements of Color*, Itten designed a two-dimensional version of the Runge's color sphere in the form of a color star. [3.20, page 63] The color star is essentially a view of the color sphere, cut apart and spread out in two dimensions. The equator of the sphere has pure hues, its inner circle has tints toward a white center and the outer points have shades. A cross

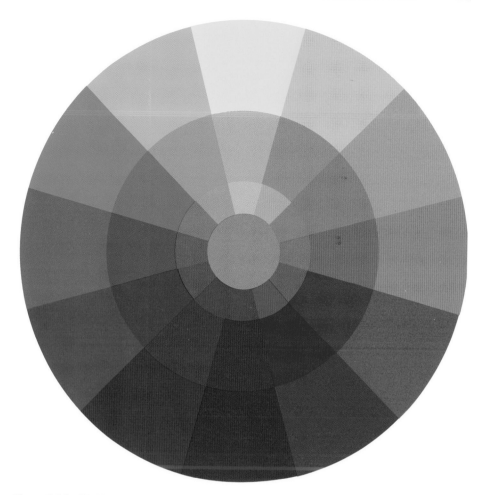

Figure 3–18 The Runge sphere seen sliced in half along its equator; the sphere gradates into lower saturation tones toward a central gray core.

section of Itten's sphere is based on the design of Runge, with colors gradating toward an inner gray.

Methods to Vary Color
Saturation

There are four main methods to manipulate the saturation of a color, using either physical pigments or colors on a computer. The first method is to add neutrals to a hue. The second is to intermix complementary hues. The third method is to overlay combinations of transparent colors. And the fourth method is by experimental hue-to-hue mixing.

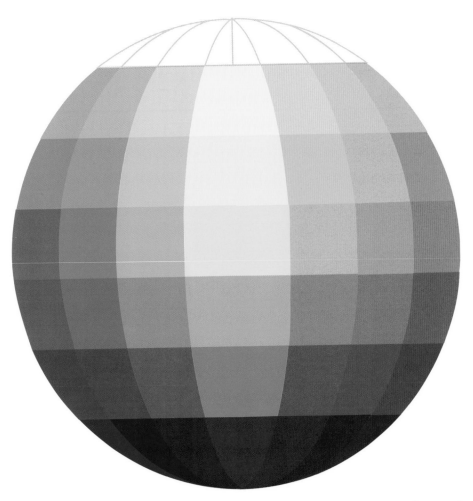

Figure 3–19 The Runge sphere outside view shows the pure hues on an equator that gradate toward white at the top pole and black at the bottom pole.

Varying the saturation of a color can be accomplished simply by adding a neutral to a pure color; that is, by adding a neutral you can create a tint, shade, or tone. As indicated by the color systems of Munsell, Ostwald, Itten, and Runge, tones made from hues have a greater range of subtle color variations than either tints or shades. The chart [3.21] shows a hue mixed with a light-value, a middle-value, and a dark-value gray. Gradating a neutral gray in incremental steps toward a pure hue forms tonal variations. By simply manipulating the hue in varying proportions toward a neutral black, white, or any gray value, we can change both value and saturation. Tones do not substantially change the character of a given color or hue. A color or hue is identifiable even when scaled out to different tonal levels.

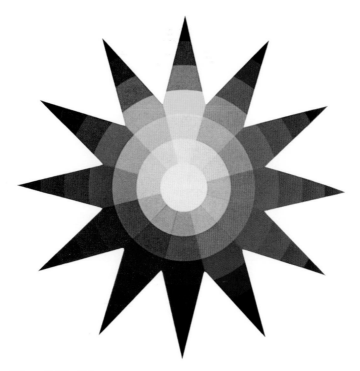

Figure 3–20 Johannes Itten, *Color Star,* from *The Elements of Color*
© 1970 Johannes Itten. Reprinted by permission of John Wiley and Sons.
The Itten color star opened the three-dimensional color solid into a two-
dimensional color model.

Figure 3–21 A simplified tonal saturation chart presents a pure color gradated to light, medium, and
dark gray in a series of tones.

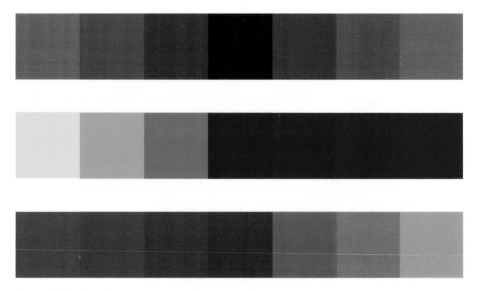

Figure 3–22 Complementary scales: When subtractive complements are mixed together, they lower the saturation of each other, ultimately forming chromatic neutrals.

Another way to affect the saturation of a given color is by mixing a hue with its complement to mute or neutralize the hue. Complements neutralize each other because all three subtractive pigment primaries, RYB, are present in any complementary pair. For example, in the complementary pair of yellow and violet, violet is a mixture of red and blue, thus the pair contains all three pigment primaries, red, yellow and blue. Painters mix complementary hues as a method for muting the intensity of a color. When mixed in the correct proportions, each hue will completely extinguish its complement. [3.22] Complementary mixtures control color saturation, creating neutral colors that are called *chromatic neutrals*. Painters prefer chromatic neutrals because they are chromatically "cleaner" than gray-based tones, particularly when oil paint is used.

Transparent media, such as watercolor, printing inks, dyes, and markers can be used to layer transparent colors on top of one another. A combination of colored layers lowers the saturation of a color. Transparent neutral color layers such as black or gray can be placed over high saturation colors, or complements can be layered atop each other together to reduce the intensity of any given color. [3.23]

When working manually with subtractive colors, intermixtures with other hues may control the saturation of a color, as well as creating many new colors. In hue-to-hue mixtures, subtle color changes result from mixing neighboring hues such as red and red-orange. More radical color changes occur when mixing hues that are spaced farther apart on the color circle, such as green and orange. Saturation changes can occur as a result of trial and error mixing. [3.24]

Figure 3–23 Transparent colors can be lowered in saturation by layering with neutrals or complementary colors.

On a computer, color saturation is variable in the S portion of the HSB color mode. This control makes it easy to use a slider bar or numerical coding to control the maximum-to-minimum saturation of colors. Complementary mixing in CMYK mode, or mixing by adding black or white, can also color lower saturation.

Saturation Keys

The concept of color keys is applicable to color saturation as well as to color value. The terms used are slightly different; color saturation keys are referred to as *high,*

Figure 3–24 Hue-to-hue mixtures can have many combinations to create new colors and vary saturation. In top two rows, red to violet and yellow to green make a chromatic gradation between hues. On bottom row, widely spaced hues on the circle change more in color and saturation, such as blue to YO.

Figure 3–25 Low saturation key colors are colors that are duller or muted.

medium, or *low saturation* colors. Low saturation colors are dulled or neutralized. [3.30] Middle saturation colors are medium intensity or partially muted. High saturation colors are full intensity pure hues or strong colors. [3.26] Some artists prefer to work in a high saturation key. [3.27] Others use mostly low chroma or saturation colors. Still others use *saturation contrast* to draw the eye to certain parts of a composition.

The three attributes of color—hue, value, and saturation—can be manipulated to control and generate a wide variety of colors. When color attributes are applied simultaneously, they open up a full array of color choices. By notation of all the dimensions of color, color solids reflect the almost infinite possibilities of color.

Figure 3–26 High saturation key colors are colors that are very intense or pure.

Figure 3–27 James R. Koenig, *Untitled*, acrylic on canvas. 1973
Collection Catherine C. Koenig. © James R. Koenig 2001. This painting
displays mainly high saturation key colors.

ACTIVITIES

1. HUE IDENTIFICATION AND VARIETY STUDIES

Objective: The objective of these studies is to train the eye to correctly identify
a color according to its base hue on the color wheel. Also, the student should be
able to create and identify many colors generated from this base hue.

A. Hue Identification Study
- Using Color Aid® paper, found color paper, samples from a paint store, or other materials, gather as many varieties as possible of one base hue (any primary, secondary, or tertiary hue), such as violet.
- Go through the assorted colors, identifying the colors one by one. Light colors should be identified on a pure white background and dark colors can be identified against a pure black background. Make sure to identify each color sample one at a time, not as a group.
- All colors should be visually identified has having the same base hue that you have chosen. [3.28, 3.5]

Figure 3–28 A hue identification study on green, presenting widely varied colors all based on a green hue.

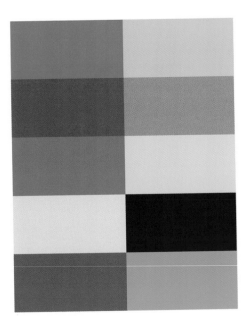

- Try to find as many varied colors as possible, based on your chosen base hue. For example, for green, there should be very muted tones, strongly saturated pure colors, light tints, dark shades, and slightly more yellow and slightly blue green varieties.
- The format is ten 1" x 2" rectangles placed in a 4" x 5" format as shown. The colors should be arranged for maximum contrast.

B. Hue Variation Study
- Make another study in the same format. This time, with paint, mix a varied group of colors based on the same hue. The difficult part of this exercise is to vary the hue as much as possible without jumping into another hue category.
- To mix these varieties, start with any chosen primary, secondary, or tertiary hue. Make various tints, shades, and tones. Try to make some hue-to-hue mixtures, making sure that your chosen hue still dominates the mix. For example, blue with small parts of red or orange, without letting the mixtures go to violet. These mixtures, in turn, can be tinted or shaded.
- Present the hue variations in the same manner as above.

2. VALUE STUDIES

Objective: For the student to understand and manipulate the concept of neutral value and color value.

A. Value Scales: Neutral gray value scale
- For this exercise, there are four value scales.
- The first scale will be a gray scale of ten or twelve steps including white and black.
- Mix at least 15 steps from white to black, painting them on good sketch paper. The paint should be opaque and evenly applied.

- Make the paint swatches approximately 2-inches square.
- Make many more grays than you need, perhaps as many as 15 to 18. Take care that there are no abrupt jumps in value.
- When mixing light values, start with white and gradually add black. When mixing very dark values, start with black and gradually add white.
- When the paint is dry, cut swatches out into 2" x 2" squares. Leave some white edge on each piece and then overlap the pieces in order, creating a color scale.
- Edit the scale down to ten or twelve steps; make sure they are even steps.
- Assemble the swatches, according to the directions, into a scale that consists of ten 1-inch adjoining squares. [3.29]

B. Primary Tint/shade Scales
- Make a value scale using each of the three primary hues: red, yellow, and blue.
- Make ten or twelve-step scales, including black and white.
- A pure primary hue should be included in each of these scales. Make at least six tints and six shades from which to select a scale by mixing a pure hue in steps to black and a pure hue in steps to white.
- When you are making light tints of red, start with white, adding small amounts of red. For the darker tints start with red and add small amounts of white.
- For shades, it is best to start with the hue, such as red, and add small amounts of black in stages, otherwise the black will completely cancel out the hue.
- Do not add both black and white to your hue. This makes a tone, which does not belong in a tint/shade scale. [3.29]

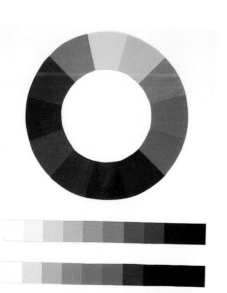

Figure 3–29 Color circle and scales. Student work by Marlene Shevlin.

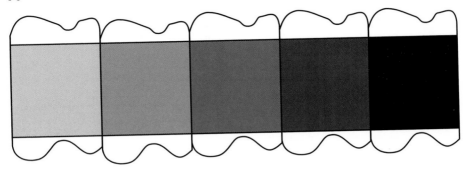

Figure 3–30 A guide for making scales. Use grid paper and overlap swatches, then cut as shown.

- Use the same process of selection as with you gray scale. Cut away the white edge on each piece of color and overlap them in order. If there are large jumps, try to mix a shade or tint to fill the gaps. If two colors look the same, omit one. Select scale down to ten to twelve steps including black and white, finding the appropriate place for the pure hue.
- Assemble scale as in the illustration.
- Make a separate scale each for red, yellow, and blue. Present all scales on a black or white board with the neutral gray scale. [3.29]

C. Scale Assembly Instructions
- The easiest way to assemble scales is by using grid paper as a guide.
- Make sure that each color swatch has one straight edge.
- Use the grid paper as a guide for overlapping swatches at 1-inch increments as shown, gluing them onto the grid paper as you go.
- Glue each swatch onto the grid paper until the whole scale is complete. Then trim the scale strip from the back to 1-inch wide using the grid paper as a guide to give you 1" x 1" squares. Grid paper can be used as a guide for the 1" x 2" pieces as well. [3.30]

D. Additional value exercises
- Make a value scale of ten or more steps using Color Aid® or found paper. In this scale use various hues and colors and try to put them in order sequentially from light to dark.
- Make keyed-value grids. Using found or Color Aid® paper, pick various hues that are as close to the same value as possible. Use the same format as the hue variations to present these studies. grid of all light- or high-value key colors, one of medium- or middle-value key colors and one of dark- or low-value key colors can be made. Looking at colors in a half-lit room will aid this process. [3.31]

3. SATURATION STUDIES

Objective: For the student to understand and manipulate the concept of color saturation. Also, for the student to use a modified approach to the Munsell color system.

- Pick any primary or secondary hue and paint out a swatch of that pure hue.
- Mix three neutral grays, one light value, one middle value, and one dark value.

Figure 3–31 A value key grid of all light value colors.

- Make a simple tonal scale of about five or six steps from the hue to each gray. You will probably have to mix more than five to get even steps. The steps should represent the hue gradating to each gray value.
- The hue will still be recognizable as it moves toward gray, but will lower in saturation and may change in value. For example, an orange will change in value and intensity when dark gray is added to it. Light gray will only make it lose intensity.
- This exercise makes one hue and a family of related tones, representing the saturation variety of one hue.
- Present as illustrated. [3.21]

A. Additional saturation exercises

- Using Color Aid® or found colored paper, make a saturation scale from various colors and hues. The scale should range from the strongest, most saturated colors to the dullest, most muted colors. This scale will represent high-, middle-, and low-key saturation or chroma. Remember to go from bright to dull rather than from light to dark. [3.32]
- Using the same format as the hue variation studies, make a grid of high-saturation key colors, middle-saturation key colors, and low-saturation key colors. Try to equalize the saturation level visually for each grid. This exercise may be done on a computer using the HSB mode in any graphic program. The saturation slider bar should be used to pick colors varying in hue but not in saturation.

Figure 3–32 A saturation scale of different colors arranged in order of their saturation or purity, from intense to muted.

Chapter 4

Color Interaction

Color study traditionally includes the origin and physics of color, the attributes of color, and color systems. The preceding information, however, does not address the phenomena of relative color that is called color interaction. Color interaction is an illusion that occurs in our perception of color. *Color interaction* pertains to the idea that color perception is dependent on color relationships. We rarely see colors as independent entities in reality or in art, because color is often seen and used in groups. Our visual reality is composed of color masses in juxtaposition to each other. Through color juxtapositions, we perceive colors in interconnected relationships. Color relationships are ever-changing, thus affecting the appearance of color. The manner in which color interacts is a mysterious yet fascinating area of color study.

Color Relativity—Chevereul and Albers

Simultaneous Contrast

Because color is a phenomenon that exists in the human brain, personal experience guides our color perception. Each person's subjective concept of red, for example, varies regardless of any international color standards. Our eye receives color differently, dependent on light and color relationships. Our perception of a specific color is also dependent upon its visual context. For instance, the color of pink (a tint of red) flower will appear to be different in sunlight from its appearance in shadow. Changing the color surroundings and lighting conditions for the same pink flower results in several different versions of pink. Which of these pinks is the true color of the flower? There is no pink that is not affected by its color surroundings, illustrating the uncertainty of color and demonstrating that color itself is relative.

Artists have always been conscious of the concept of color relativity. Experienced painters are aware that a color's appearance on the palette is modified when the color is placed in the context of other colors in a painting. In the Renaissance, Leonards da Vinci noted that color perception is dependent on the color interrelationships present in a work of art.

 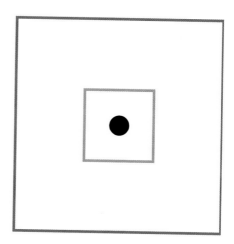

Figure 4–1 Afterimage: Try this experiment to understand the phenomena of afterimage. Stare at the dot in the RO square, and then quickly switch to the blank square. What do you see?

The French chemist Michel Eugene Chevereul (1786–1889) explored the concept of color relativity in detail. Chevereul's work was the supervision of the production of dyes in the manufacture of carpets at a textile plant. In the course of this work, Chevereul often found that a color failed to produce its predicted effect in a carpet's pattern. He realized that the difficulty was not chemical but optical. These problems impelled Cheveruel's research on theories regarding color perception problems and led to a publication entitled *The Principles of Harmony and Contrast of Colors* in 1839. The book presented a systematic foundation for why color perception fluctuates in different color relationships. Chevereul discovered and coined the term simultaneous contrast. *Simultaneous contrast* can be generally defined as the way that colors interact and affect each other. Interaction can lend the same color a varied appearance dependent on its color surroundings. This concept strongly connects to the phenomenon of *afterimage*. [4.1] An afterimage occurs when the eye becomes tired of a given hue and spontaneously creates the visual complement of the hue. For instance, after staring at RO and quickly shifting our eyes to a blank white sheet of paper the eye will spontaneously produce a momentary afterimage of BG. This phenomenon is also known as *successive contrast*, because an afterimage occurs in direct succession to the eye's overexposure to a full saturation color. A more specific definition of simultaneous contrast accounts for the phenomenon of afterimage. In this context, *simultaneous contrast* means that the eye simultaneously "wants" to see the complement of any given hue for color balance. The eye generates the complementary color spontaneously even when the hue is not present.

In his research, Chevereul concluded that this effect is so pervasive that one color will "push" a second adjacent color toward the complement of the first color. This type of color interaction is dependent on the direct proximity of colors. For example,

Figure 4–2 Simultaneous Contrast. Left: The violet appears to be more BV near the YO since YO is the complement of BV. Right: The YO may appear slightly more yellow in relation to the violet since yellow is the complement of violet.

in the illustration, YO causes violet to appear to be more BV; that is, YO pushes violet toward BV because BV is the complement of YO. The YO, in turn, appears to be more yellow because yellow is the complement of violet. [4.2] The effect is most pronounced when one color is completely surrounded by another.

Afterimage

Why do we see an afterimage of a color? Why don't we see it all the time? First of all, an afterimage is usually only perceptible in a controlled or extremely strong color situation. Otherwise, we would be seeing distracting afterimage colors all the time. An afterimage occurs due to fatigue in the hue sensors (cones) in our eye. This forces our eye to revert to the other remaining hues to which our eye is sensitive. So, when the red cones in our eye tire of a strong red, the eye reverts to the two other remaining cones, the green and blue, which, in turn, form a brief sensation of bluish green. Thus, we may think of afterimage as a color overload or reaction. In this experiment, the afterimage is so strong that it actually works in reverse. Stare at the dot in the illustration of circles, then quickly shift to the other dot on the white surface. Can you explain what you see? This afterimage effect is called a *contrast reversal*. [4.3] While we are staring at the orange circles, our eye is filling in the white spaces with blue, although we cannot perceive this. Thus, when we look at the blank square, the white spaces between the orange circles reverse again from a blue afterimage to the complement of blue, making orange shapes.

The effects of afterimage and simultaneous contrast are so pervasive that they can even influence our perception of neutral colors. [4.4, see page 76] All the grays in the illustrations are the same perfectly neutral gray. There are slight visual differences evident in each gray's appearance relative to its the placement on various pure

 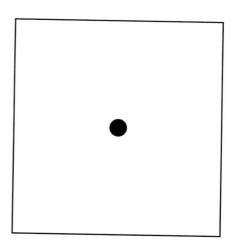

Figure 4–3 Contrast Reversal: Stare at the dot amidst the orange circles, and then quickly shift to the dot in the blank rectangle. What do you see? See the text for an explanation.

hue grounds. Gray on the red ground appears to have a greenish tinge, since our eye "wants" to see the complementary hue red. The same gray on an orange ground displays the most striking effect, seeming to have a bluish cast. Simultaneous contrast causes this color distortion because of our need to see the blue-orange complement in balance. The same gray has a subtle reddish quality on green, a yellowish cast on violet, and an orange tinge on blue. Thus, the theory of color interaction hinges upon the effects of simultaneous contrast and afterimage.

Albers and Color Interaction

Josef Albers (1888–1976) was a German painter, educator, and color theorist. He taught at the Bauhaus School in Germany before World War II. The Bauhaus School was a seminal art institution that melded fine art, design, crafts, and architecture. Albers later came to the United States, where he taught at Yale University. Albers probably would not have considered himself a color theorist in the traditional sense. His educational method was first to visually sensitize students to color before they learned about traditional color systems and charting. Albers significant contribution to color education was presented in a famous book *The Interaction of Color,* published in 1963. In his book, Albers outlines specific color exercises for students, focusing primarily on the notion of color interaction Albers stated that one color could have many "readings," dependent on both lighting and the context in which the color is placed. He felt that an understanding of color relationships and interactions was the key to gaining an eye for color. Albers' ideas were based on the research of Cheveruel as well as extensive classroom experience and experimentation.

Josef Albers also put his ideas about color into his own paintings. In 1949 he began a series of paintings, entitled *Homage to a Square,* which he continued to

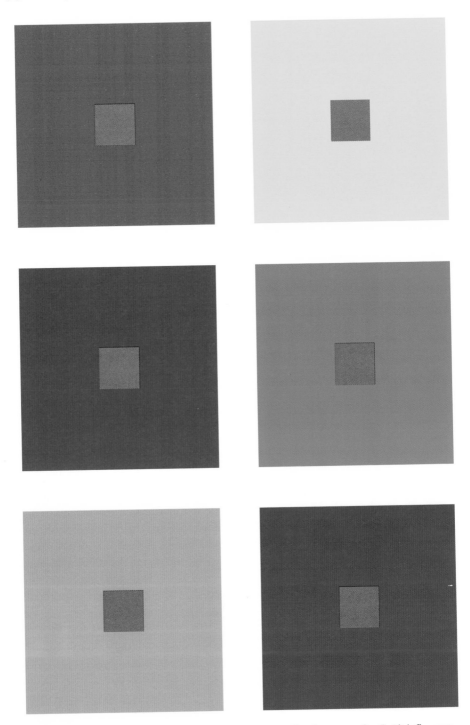

Figure 4–4 Simultaneous Contrast: The complementary effect is so pervasive that it influences even neutral grays. Note that each gray is tinged with the complement of each ground color. For example, the gray on the orange ground appears to be bluish.

work on throughout his life. Throughout this series of paintings, Albers continually explored shifting color relationships between hue, value, color temperature, and saturation, in a quest for ever-changing color harmonies.

Color Relativity—Principles of Color Interaction

Many color classes are based solely on Albers' experiments and studies. Albers' methods are direct, meaningful, and serve to sensitize students to color. Several important factors can be gleaned from *The Interaction of Color*. Streamlining the content of Albers' book aids in the comprehension of his concepts, as well as in positioning his ideas in the larger context of color study.

According to Albers, we rarely see a color that is not affected by or relative to other colors. Even when a color is placed against the pure neutrals of black, white, or gray, the color is affected by that neutral ground. The study of color interaction entails a series of color "experiments" that illuminate our knowledge of how colors operate in relationships. The color transformations that result from these experiments are both striking and surprising.

For color interaction experiments, a relationship between two colors must be unequal, in which one color dominates another. Colors do not necessarily need to be dominated in order to be modified, but dominant color relationships dramatize our perception of color shifts. The ideal setup is a relatively large ground color in proportion to a much smaller area of the color to be affected. The smaller area of color is strongly affected because a large environment of color surrounds it. Colors in interaction studies also need to be directly adjacent to one another without white or black outlines. [4.5] Color interaction is minimized by the containment of outlines.

Colors may interact and are changed in appearance by other colors in accordance with three guiding rules or concepts. These rules are called the Principles of Color Interaction. These principles may function either separately or simultaneously. The rules are presented in order of conceptual difficulty.

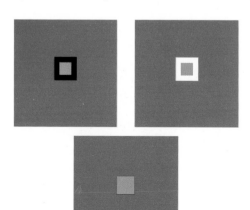

Figure 4–5 Color interaction studies should show direct interaction of adjacent colors. Black outlines seem to constrain colors, while white outlines isolate and expand color.

Figure 4–6 This gray scale illustrates how even achromatic colors can change our perception of value by color relationships. The gray circle inset in the gray scale is all the same value gray, which seems to change in comparison to the surrounding values.

PRINCIPLES OF COLOR INTERACTION

1. Light/Dark Value Contrast
2. Complementary Reaction or Effect
3. Subtraction

LIGHT/DARK VALUE CONTRAST The first principle of color interaction is *light and dark value contrast.* The most efficient way to effect a color change is to utilize the principle of light/dark value contrast of grounds. It is logical that a color will appear lighter on a black or dark ground and appear darker on a white or light ground. A light or dark value environment affects even an achromatic color like gray. The gray scale shown here has a circle of the same gray value running through it. [4.6] Note the radical changes in the appearance of each gray value throughout the scale.

Colors also react in a similar manner. For instance, red on a black ground seems to be both lighter in value and less heavy when compared to the same red presented on a light gray surface. On a light gray ground, red seems to be both darker and denser in saturation. [4.7] Colors appear to be lighter in value on dark grounds due to the comparative relationship between them. Similarly, colors appear to have a darker value on light grounds due to contrasting value relationships. A dramatic ex-

Figure 4–7 Color Interaction: Colors appear to be visually different dependent upon their context. Red appears lighter on black but, heavier and darker on light gray.

Figure 4–8 Value Contrast Principle: This tint of red seems to be lighter on dark blue and darker on light blue.

ample, shown here, is the same pink presented on both a dark blue ground and a light blue ground. [4.8] It is difficult to tell that both pinks (tints of red) are exactly the same; the pink on the dark ground seems to be much lighter. In another example, the green appears to be different from one ground to another, light in value on the dark ground and darker in value on the light ground. [4.9] In this manner, light/dark value contrast controls the perceptible value level of a color.

COMPLEMENTARY REACTION OR EFFECT The second principle of color interaction, called *complementary reaction or effect,* is a bit more complex. This principle exploits the concept of simultaneous contrast, a strong factor in color interaction. Remember that our eye "seeks" the complement of any given color,

 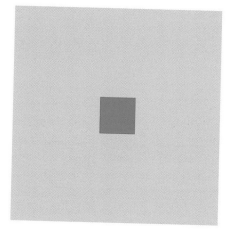

Figure 4–9 In this use of value contrast, the green seems lighter on a dark green and darker on a light value gray.

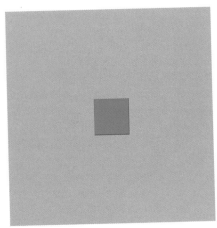

Figure 4–10 Complementary Reaction: Green appears more intense on the red ground when compared to how it appears on gray. This is caused by the complementary effect.

especially high-intensity colors. For this reason, a green on a red ground appears to have a higher saturation or intensity when compared to the same green placed on a neutral gray ground. [4.10] The complementary effect causes a color to "bend" toward the complement of a ground or dominant hue. Our eye causes the high saturation red to make us "want" to see green, because it is a complement of red, for hue balance. This effect enhances the green and makes it appear to be more saturated.

In the second example, YG on a violet ground appears to have a more yellow cast than the same YG on a neutral gray ground. This illusion takes place because when we perceive violet we simultaneously "seek" yellow, violet's complement, so YG is pushed slightly toward yellow. The principle of light/dark value contrast is also in play here. The YG appears to be lighter against the dark value of violet than it is on the paler gray ground. [4.11]

SUBTRACTION The last principle of color interaction is the rule of *subtraction.* This is perhaps the most difficult idea of the three principles to grasp. According to this concept, a strong or dominant color will actually subtract itself from a smaller or less dominant color. For example, a YO on an orange ground seems to be less orange, leaving it more yellow, when compared to the same YO on a neutral gray ground. The dominant color, orange, is subtracting itself from the YO, leaving a visual effect of simply yellow. In comparison, the YO also appears to be more orange against a gray ground. [4.12] The influence of the orange ground is to change YO slightly in hue and lower its saturation due to subtraction. In this manner, subtraction can slightly change a hue as well as the saturation of a color.

COLOR SUBTRACTION EQUATIONS The principle of subtraction can become rather complex. Therefore, we might regard color subtraction as a color equation. The equation, for example: YO – O = Y explains briefly the color change that occurred in the previous example. In a second example, the same BV is placed on both a blue

Figure 4–11 YG appears more intense on violet due to complementary reaction.

and a violet ground. [4.13] The BV in the violet environment looks bluer according to this equation: BV − V = B. The BV on the blue ground is seen as more violet according to this equation: BV − B = V. This study proves that by the careful manipulation of a color's surroundings even the base hue of a color can be altered.

Subtraction may also operate in the following manner. When a green is placed on a dominant blue ground the blue will subtract its own component from the green as follows: G(Y + B) − B = GY. [4.14] This forces the green to appear more yellowish. The same relationship, when inversed, changes the color dynamic. The strong green ground causes us to "seek" red due to complementary effect. This "bends" the blue

Figure 4–12 Subtraction: YO seems to be somewhat yellow on an orange ground due to subtraction. The orange subtracts itself from the YO, leaving more yellow.

Figure 4–13 BV on a blue ground appears to be more violet. The same BV on a violet ground appears to be bluer. Both effects are caused by subtraction.

toward red, making it seem slightly more BV. Thus, even saturated hues can be visually changed dependent on their color environment.

ALBERS' STUDIES To demonstrate the principles of color interaction, Albers' students executed two color study experiments, which are classic in their simplicity, yet illuminate the idea of color relativity.

Awareness of the principles of color interaction aids in execution of the two Albers' color interaction studies. The studies are best executed with colored paper. When choosing the colored grounds one should try to pick colors that are very dif-

Figure 4–14 Examples of subtraction. In this case the colors are in an inverse relationship to demonstrate subtraction. The green on the blue ground seems slightly more yellow; the blue on the green ground seems slightly more violet.

 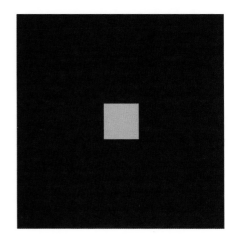

Figure 4–15 Value Contrast and Subtraction. Light violet appears to be more saturated and darker on a yellow ground. The same color looks lighter and less saturated on a dark violet ground due to subtraction.

ferent in both hue and value. This exercise is fairly easy to do. Often, the student has great success with the first study by trial and error without fully understanding the three principles of color interaction. However, for comprehension of color relativity, students should be able to explain why their color experiment works, citing the principles involved. Some colors react more strongly to color surroundings and others resist change. For instance, very saturated or warm colors can be very hard to change. A full saturation yellow, in particular, resists being changed in appearance under many circumstances. In contrast, most low saturation colors change easily. Experimenting with a wide variety of colors insures success.

In the first study, the goal is to *make one color appear to be two colors* by changing the color of the ground or context color. Two examples of the first Albers' study are presented here. The first example exhibits all of the three principles. [4.15] A light violet appears to be darker on the yellow ground because of the light value of yellow. The violet also seems to have a higher saturation (to be stronger violet) on the yellow ground due to complementary reaction. Remember, we "want" to see violet when we perceive yellow, thus, the violet hue is enhanced. The same light violet appears to be even paler on a dark violet ground. It also appears to be duller (lower in saturation). Subtraction occurs here; the strong violet ground subtracts itself from the light violet, lowering its color intensity. Both of these colored grounds have effectively changed our perception of the violet color in two ways, effecting both its value and intensity.

The second classic Albers' study is to *make two slightly different colors appear to be the same* by the illusion of color interaction. Obviously, this is a more challenging study to execute. When choosing two different colors for this study, one may select two value steps of one hue, two slightly different hue variations such as blue

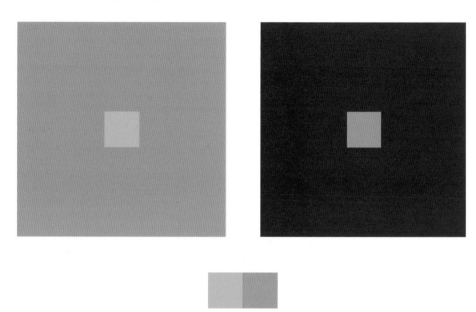

Figure 4–16 Albers' study: Two colors look like one color. The light warmer tint of red appears more RV against the RO ground. The darker RV tint appears to be lighter and is pushed toward orange by the dark blue ground.

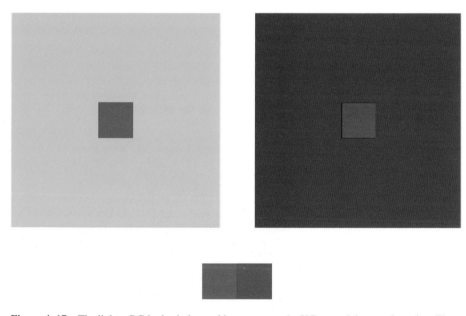

Figure 4–17 The lighter BG looks darker and less green on the YG ground due to subtraction. The blue appears lighter on the dark RO ground and also slightly greener because of the complementary effect.

and BG, or two different saturation levels of the same color. Logic, as well as a grasp of the color interaction principles, makes this study easier to execute.

For the first example, a light and a darker tint of red (pinks) have been chosen. The goal is to visually equalize these two colors by manipulation of ground colors. [4.16] To make the lighter pink appear darker; it has to be placed on a lighter value ground. To make the darker tint of red appear to be lighter it has to be placed on a darker value ground. The lighter pink has a RO cast, so it is placed on a full saturation RO, to subtract some orange and leave it a cooler pink. The lighter pink, in turn, can be pushed toward RO by placing it on a blue ground, bring about the complementary reaction. The dark blue forces the pink to have an orange cast as well as making it slightly lighter in value.

Two slightly different hues can also be visually equalized. [4.17] A lighter BG and a slightly darker blue can be made to look the same by careful experimentation. The lighter BG can be placed on an YG ground to make it darker in value and pull some of the green cast out of it by subtraction. The yellow also pushes the BG toward violet making it seem more like a BV. The darker blue looks lighter and more BG on a dark red ground. This occurs because the red ground brings out any green component in the blue due to complementary reaction.

OPTICAL MIXTURES

The concept of optical mixture is an alternate form of color interaction. In optical mixtures two or more colors can either oppose or blend with each other. *Optical mixtures* of color use tiny amounts of two or more colors, which visually blend to create yet another (third) color. Either pigmented materials or light may form an optical mixture. In light, optical mixtures are responsible for the colors that we see on our television screens and computer monitors. In the four-color printing process subtractive optical mixtures create all the colors. The process primaries, cyan, magenta, yellow, plus black, are printed in tiny dot patterns to mix visually.

The human eye is incapable of signaling rapid fluctuations of light and dark to the brain. Film, for example, has a frequency of 48 individual flashes of light per second. Our eye and brain process these flashes as a continuous moving picture. This optical phenomenon is known as the *persistence of vision*. The idea of optical mixture is related to the notion of persistence of vision. An *optical mixture* is a blend of two or more colors that occurs in the eye and brain and creates a single color sensation. There are two major color theorists who broke ground in the area of optical mixture. Michel Eugene Chevereul, the researcher of simultaneous contrast also explored optical mixtures. Chevereul found that many color mixtures were available from a relatively small amount of colored yarns in textile manufacture. He explained that this occurred because of the optical mixtures produced by color combinations in the fine thread grid (the warp and weft) of woven fabric.

Figure 4–18 A stationary analogous mixing disc.

Figure 4–19 Analogous optical mixture by motion. Analogous colors keyed to the same value will visually mix and become lighter because they mix additively when in motion.

Color Mixing Discs

Research by color theorists of the nineteenth century was specific information directly aimed at assisting artists in the practical use of color. A device devised to demonstrate visual mixtures was an optical mixing disc, sometimes called Maxwell's disc after James Clerk Maxwell (1831–1879), the Scottish physicist. Maxwell used the mixing discs in his research on the light primaries. Chevereul, Goethe, Ostwald, and Albers also did research with a mixing disc. An optical mixing disc is essentially like a toy top with a pattern of two colors in a stripe configuration. The top is spun to see how the colors "mix." When we see rapidly alternating colors in sequence, the colors appear to be continuous. Due to persistence of vision, the two colors seem to be a single color.

Color discs or tops can be constructed and spun manually or on a drill bit to form optical mixtures. For example, a disc that alternates blue and green will produce a color sensation of cyan when rotated. [4.18] The resulting color is an additive rather than a subtractive mixture of the two colors on the disc. Cyan is the additive mixture of blue and green rather than the subtractive pigment of BG. [4.19] Red and blue should result in magenta; green and blue should make cyan; and red and green, should appear yellow when visually mixed by movement. [4.20] In reality, the mixing discs make muted rather than pure versions of these colors. [4.21] Stripes of complementary hues on a cardboard disc or top emulate the experimentation of Nicholas Ogden Rood (1831–1902), an American scientist and artist color theorist that explored optical mixtures. Rood's experiments with color discs verified the exact complements of hues in artist's pigments, as presented in his book *Modern Chromatics* (1879). He experimented with mixing discs using complementary colors to fabricate grays and to pinpoint exact pigment complementaries. Optical mixing discs can also form lower saturation colors when a color is alternated with gray, black, or white.

Figure 4–20 A complementary mixing disc.

Figure 4–21 When moving, the mixing disc appears as a red/green chromatic neutral, tinged with yellow, which is the additive mixture of red and green.

Broken Color

The static juxtaposition of two or more colors can also produce the sensation of a third color. This technique is also called *broken color.* Eugéne Delacroix (1798–1863), the French artist, used color hatching to make new colors from optical mixtures of small marks of color. Optical mixtures can produce a color atmosphere in a painting. The Impressionists, for example, felt that small marks of color juxtaposed to each other in a painting would create a more vibrant sense of light than a flat or gradated tone. Juxtaposition of color was a method used by painters throughout history, but most obviously put to use by the Impressionists and by a Post-Impressionist named Georges Seurat.

Georges Seurat (1859–1891) was a French artist greatly concerned with a new approach to color in painting that he dubbed *divisionism.* [4.22] Divisionism, sometimes called *pointillism,* employed a sophisticated method of creating color luminosity in a painting. The colors that Seurat used, for example, to make a brown, are tiny dots of red and green juxtaposed to each other. The small marks of color, even though they were not physically mixed, generated brown by optical mixture. This brown is similar to the chromatic neutral made from a physical mixture of red and green pigments. However, Seurat created color sensations with pointillism that were lighter in value than physically mixed colors. Optical mixtures seem to occur in a quasi-additive manner, producing both higher luminosity and color saturation.

Optical Mixtures of Pigmented Color

An optical mixture of traditional materials such as pigment, inks, or dyes involves the use of tiny dots, dashes, or marks of at least two colors. [4.23, see page 89] Optical mixtures may create a hue, value, or saturation change depending on what

Figure 4–22 Georges Pierre Seurat, *Evening Honfleur,* 1886. Oil on canvas, 25¾" x 32" (65.4 x 81.1 cm). The Museum of Modern Art, NY. © 2003. Gift of Mrs. David Levy. Photograph © 2003 The Museum of Modern Art, New York. Seurat employed a form of optical mixing by using small dots of color. He dubbed this method "divisionism."

colors are mixed. To understand optical mixtures, the student can produce simple two-color studies. Each color in these studies should occupy an equal amount of surface area. There are several types of color combinations that optically mix, such as two or more hues, two or more saturations of one color, and two or more values of one color. However, for clarity, two specific types of optical mixtures can be assembled.

The first type of optical mixture is called a *sympathetic analogous* mixture. Analogous hues are neighbors on the color circle, causing them to be both sympathetic and harmonious with each other. The color similarity of analogous colors allows ease of visual blending. Theoretically, a wide gap between hues can form an optical mix, such as blue and red to make violet. In a fine pattern, of two colors as in pointillism the optical mixture imparts an effect similar to a subtractive pigment mixture but with added luminosity.

A pair of directly neighboring hues from the color wheel such as YG and yellow can yield a more subtle optical mixture. If a fine mosaic is created with these hues,

Figure 4–23 Optical mixtures of small areas of color. Clockwise, from top left: complementary colors, analogous colors, two hues, and a color and gray.

they result in a visual mixture of a color in between YG and green. [4.24] When manually creating a mosaic from colored paper or paint, it is difficult to form a mesh fine enough to visually blend. The result may become a pattern with too much value contrast. If colors are keyed to the same value level, in this case by lightening the green to the same value level as YG, than this achieves a more convincing visual mix. Value-keyed colors optically blend because colors of a similar value seem to exist on the same spatial plane.

 The second type of optical mixture is quite different. This optical mixture is made from opposing or complementary hues. In a very fine pattern, a complementary pair such as yellow and violet will neutralize each other in the same manner as they would in a pigment mixture. However, if a coarser textured mosaic is formulated,

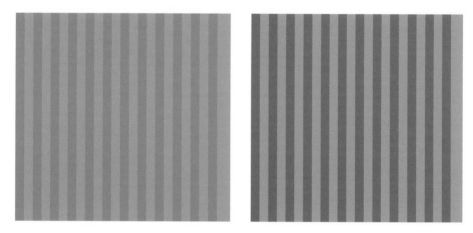

Figure 4–24 If YG and green are to form an analogous optical mixture, they have to be adapted since there is too much value contrast between the hues. Colors that are keyed to the same value level will visually mix more readily, YG and green formulate a color between the two hues.

a phenomenon called *complementary vibration* occurs. Our eye "wants" to see the complementary colors simultaneously for visual balance. However, when we do see the pure complementary hues simultaneously, something unexpected occurs. The complements seem to repel each other causing an illusion of movement or visual vibration. [4.25] Note that this study is difficult to stare at for any length of time! In order to make the opposing hues vibrate, high saturation (pure) hues must be used. Red and green, in particular, present one of the strongest complementary vibrations, the hues being similar in inherent value.

Figure 4–25 A strong complementary vibration is caused by the juxtaposition of pure red and green.

OTHER TYPES OF COLOR INTERACTION

The Bezold Effect

Wilhelm von Bezold (1837–1907) was a German scientist who attempted to create a color system based on perception. Like Chevereul, he was involved in textile production. In the course of his research, he noted that a single color change in a pattern affected the appearance of all the remaining colors in the pattern. In this type of color interaction, the change of a single integral color causes multiple color changes in a design. This is known as the *Bezold effect.* Bezold's theories are practical for artists who usually work with color combinations rather than only two colors as in Albers' experiments. The Bezold effect is most noticeable in a pattern rather than in composition because compositional forces do not interfere with color perception in simple patterns. In Bezold's studies, not only do individual colors shift in appearance, but relationships between colors are also affected. [4.26] For example, notice that the contrast between the orange stripe and the blue triangle seems to be stronger on the left part of the illustration than on the right. Changing the appearance of an entire group of colors is more difficult to achieve than the change of a single color. Individual colors in a grouping seem to change in a distinct manner dependent on specific principles of color interaction. For instance, the

Figure 4–26 The Bezold Effect: Note that the colors and color relationships appear differently from only a single color change.

colors in the illustration do not all change equally; the green has the most dramatic change, while the orange shifts only slightly.

Color Dominance

The Bezold effect is formed by a single color change integral to or dominant in a composition. The Bezold effect runs parallel with the concept of color dominance. *Color dominance* is achieved by letting a single hue, value, or saturation dominate a composition. A dominant color influences all the colors in a composition. When a dominant color is shifted it will change the color dynamics in a composition. Color dominance is easily achieved by allowing a single color to cover the most physical area of a composition. [4.27] In order to understand color dominance, one can also reposition the same set of colors to various locations in identical compositions. One can also change the proportions of the same set of colors in identical compositions. Changes in color proportion and location can shift compositional forces, such as visual weight and balance. The same color palette and composition is used for all of the examples shown.

COLOR TRANSPARENCY

Actual Transparency

Actual color transparency is either the perception or use of transparent materials. *Actual* transparent materials are colored glass, filters, acetates, transparent plastic, and other items. [4.28, see page 94]

Most color perception is a result of either reflection or absorption of various light wavelengths. In our perception of a transparent object, a different phenomenon occurs. Light is *transmitted,* that is, allowed to pass through a transparent object to create a color sensation. Transmission serves to filter light wavelengths. For instance, green glass blocks both blue and red light wavelengths and transmits only green light.

The only traditional transparent art material is watercolor. Transparent films of paint that achieve glasslike effects characterize watercolor. Watercolor creates the effect of volume on a two-dimensional surface because of its many transparent layers.

Transparent media can be used to create *actual transparency* studies with either watercolor or thinned acrylic paint (using no white). Colored washes or glazes are actually transparent films of color. Overlapped shapes can be used in a design to demonstrate direct color transparency. Where colored shapes overlap, films of paint form a visual mixture of the colors involved. For example, yellow glazed over blue produces green. In transparent washes, care must be taken to equalize the washes' color saturation and value. Otherwise, stronger or heavier colors will dominate, reducing the color transparency.

Figure 4–27 Color dominance. One color dominates each composition showing that the dynamic of a composition can be shifted with the repositioning of color. An identical group of colors is used in varying proportions and positions within each composition.

Figure 4–28 Transparent objects transmit a particular color wavelength, blocking other wavelengths.

Simulated Transparency

Simulated transparency is a type of color interaction in which opaque media produces the illusion of an actual transparency. Two opaque colors overlap and seem to "mix" into a third color, which is also an opaque color, creating an illusion akin to colored glass or film. To formulate simulated transparency, the optimal medium is opaque colored paper. Colored paper studies help us to visually imagine the mixtures between two "parent" colors, rather than manually mixing them. [4.29]

For simulated transparencies, any two-color combination can be chosen. We simply apply logic to imagine a subtractive color that is in-between two parent colors. For instance, to create an artificial transparency between two hues such as blue and red we refer to the color circle, where the subtractive mixture of red and blue is violet. Various violets can be chosen to approximate the in-between color mixture. Placing them in a central position between the parent colors, one color will seem to click to form the optimal transparency illusion. An in-between color that simulates transparency cannot be higher in saturation or darker in value than either of the two parent colors.

Simulated transparencies can be created from virtually any color pairing. Some examples shown here are two-value variations of the same hue, complementary colors that form chromatic neutrals, and two different hues that make a third hue. [4.29, 4.30, see page 96; 4.31, see page 97]

Another way to create a simulated transparency is to use opaque paint to mix the color between the two color parents. This is usually more difficult, since, in paint-

Figure 4–29 Student example by Andrea La Macchia of simulated transparencies in a design.

ing, subtractive mixtures of color have a tendency to become darker and less saturated than the parent colors. To alleviate this problem the in-between color can be lightened in value.

Color is a relative visual sensation. This makes it subject to change based on lighting, color environment, surrounding colors, optical mixtures, and transparency. The study of color relationships sensitizes us to the interaction of color.

ACTIVITIES

1. COLOR INTERACTION STUDIES

Objective: For the student to understand that color perception is influenced by surrounding colors. The following are classic Albers' studies of color interaction.

Media: Colored paper

A. Make one color look like two colors.
- Using the concepts in this chapter, take one color and place it on two different grounds to make it appear to be two different colors.
- The proportion should be approximately 6" x 6" or 5" x 5" square for the ground and a 1" x 1" square or a ¼" stripe for the color to be changed.
- The point is to make the same color look radically different by manipulation of various colored grounds. Try many possibilities with colored paper until you get a major color change.

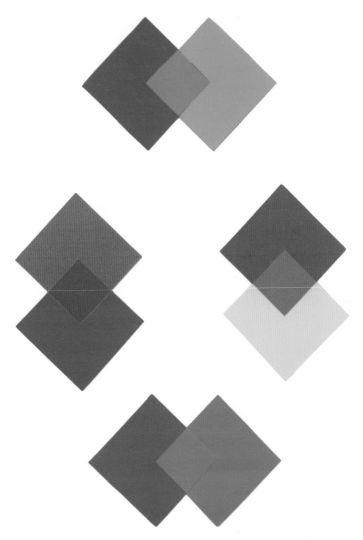

Figure 4–30 Simulated transparencies made with opaque colored paper.
The correct choice of an in-between color must be chosen from the two
parent colors. Simulated mixtures clockwise from the top include two value
levels of one hue, hue-to-hue mixtures, two analogous hues, and
complements that mix to form a chromatic neutral.

- Remember to make the grounds as different as possible. Differences in hues (opposite
 hues), saturation, color temperature, and/or value are needed to truly change the color
 you have chosen.
- When the color interaction is complete, site the principles used that implemented your
 color change. [4.11, 4.15]

Figure 4–31 Student example of a simulated transparency study by Donna Briceland.

B. Make two different colors look like the same color.

- This study is invariably more difficult than the first study.
- Pick two slightly different colors from colored paper.
- The colors may vary in value, for example, a lighter and a darker orange. They also may vary slightly in hue, for example, a green BG and a bluer BG, for example. The two colors might be slightly varied saturations of one color, for example, blue and a tone of blue.
- Now pick two different grounds to try to equalize the two colors that you have chosen.
- Try to use the three principles of color interaction to implement this. Example: If you are using a lighter and darker value of one color, you can put the light color on a light ground and the dark value on a dark ground. Also use subtraction and/or complementary reaction if necessary.
- Save an extra piece of each color used and place it as shown with your study. This will indicate where each color is placed and show the color differences. [4.16, 4.17]

2. OPTICAL MIXING STUDIES

Objective: The student will create optical mixtures, one to make two colors blend visually and one to create complementary vibration. Movement can be used to create additive color mixtures.

Media: Colored paper.

Figure 4–32 Student examples of optical mixtures, left: vibrating complements and right: analogous by Marlene Shevlin.

A. Analogous optical mixture
- Pick a pair of analogous or almost analogous hues (by skipping the in-between hue) from the color circle. Example: Blue and BG *or* red and violet.
- The colors should be keyed to the same value as closely as possible. The value match will create a better optical mixture.
- Make a pattern or a fine mosaic of stripes or dots, a grid, or any pattern using equal surface area for the two colors. This will let them blend visually when viewed from a reasonable distance.
- The result will be two colors that blend optically to create a third color in-between the two. Example: yellow + orange = YO *or* yellow + YO = YYO. [4.32]

B. Complementary vibration
- This visual mixture is the opposite of an analogous mixture.
- Pick any dyad or complementary pair from colored paper.
- Make sure that the colors of the dyad are high in saturation, as shown.
- Create a similar or the same pattern mesh as in exercise 2A.
- You should notice a strong movement or vibration as you look at this study.
- If you view it from across the room you will notice a change in contrast and possibly a neutral color. [4.32] [4.25]

C. Optical mixture discs
- Make several optical mixing discs to show additive color mixtures.
- The discs should be circular, either glued or painted on a toy top or made of a flat cardboard disc to be spun on an electric drill.
- You can use two analogous hues, complementary hues, or black and white. Glue or paint the two colors in an alternating stripe pattern.

- What color sensations do you get when the discs are revolved? How are the results different from what you would expect?

3. BEZOLD EFFECT STUDIES

Objective: These studies are meant to explore the concept of the Bezold effect, multiple color interactions, and color dominance.

Media: Colored paper, paint, or a graphic program on a computer.

A. Bezold effect
- Plan a simple geometric pattern that uses four or more colors.
- Choose two different grounds for your studies that substantially change the appearance of all the colors in the study. Try to choose grounds that are either opposing light and dark values, complementary hues, or colors that are high and low in saturation.
- The design should appear to be very different chromatically from one ground to another.
- Make sure to let the colors in each design interact so that the change in interaction between them can also be noted. [4.26, 6.19]

B. Color dominance study

Media: colored paper, paint or computer graphic

- Pick five or more colors to create two or three studies. Create a simple geometric design or pattern.
- Make two studies using the same color selection and the same design.
- Each study should have one color (from your chosen group) that dominates the whole study. You can also change the location, proportion, or repetition of colors from one study to the next.
- The point is to radically change the appearance of the same design and color grouping by the location and proportion of the colors. [4.27]

4. TRANSPARENCY STUDIES

Objective: The student will work with both actual transparencies (transparent media) and with simulated transparencies (opaque media) to understand the differences between the two concepts.

Media: Colored paper, watercolor or acrylic paint, or a computer graphic program.

A. Actual transparency
- Choose at least four hues or pigment colors with which to work.
- Make a simple overlapping design using geometric shapes on cold press illustration board or watercolor paper. Draw design out in pencil.
- Try to have some areas where at least three shapes overlap.
- Use either watercolor or acrylic paint (watered down and without white) to create washes of each of your chosen colors.

- Make sure all of your colored washes are of approximately equal intensity.
- Carefully fill each shape of your design with the washes. Make sure that you let each layer dry before washing over with another color. Layer color carefully to create transparencies.
- If desired, you may paint background with black paint or leave white.

B. Simulated transparency study
- From colored paper, choose at least four pairs of colors that you want to overlap in a design. Make sure each pair is a different type of color combination.
- Design a simple overlapping structure using geometric or free hand shapes.
- Pick colors that represent the in-between or offspring color between all four sets of parent colors that you have chosen. [4.30]
- Where the components of your design overlap, place the appropriate colors to simulate the illusion of transparency.
- The negative or ground color should be dark or neutral to accentuate the illusion of transparency. [4.31]

Chapter 5

The Materials of Color

INTRODUCTION

Artists and designers have a wide selection of colored materials available to execute color harmony, expression, and design. Media options range from physical materials, like pigments and dyes, to printing processes and light itself. *Physical* color materials are used directly, such as paints, colored drawing materials, and textile dyes. *Process* media is used indirectly through printing, photography, and computer graphics.

PHYSICAL COLOR

Physical color materials are called colorants. A *colorant* is a compound that imparts its color to another material. The word colorant has multiple definitions. A colorant may be formulated from the color component of a natural object, such as a stone. It also may be the colored ingredient of a mixture, like the pigment in a paint. A colorant is also defined as an agent that lends its color to another substance, like a fabric dye.

Pigmented Materials

Pigment is probably the oldest form of colored art material used by man. Cave paintings are made with various earth pigments. A *pigment* is defined as a colored powder that imparts its color effect to a surface, when distributed over that surface in a layer. A pigment is a chemical substance that is capable of reflecting a particular light wavelength to create a specific color sensation. A pigment is a finely ground powder that is insoluble in a binder. [5.1] Pigment must be mixed with a *binder*, also known as a *vehicle*, to become paint. Without a binder, a pigment cannot adhere to a surface, but simply dusts off as a powder. When pigment is ground into or mixed with a binder it does not dissolve, but forms a liquid/solid suspension. Pigment powders are the same from one pigmented media to another. For example, ultramarine blue pigment is always the same composition, whether it is formulated into tempera, oil, acrylic, or watercolor. [5.2] Different binders specific to each type of paint determine the differences in paint character and handling. Each paint media also uses a surface or *support* that contributes to these differences.

Figure 5–1 A pigment is a colored powder that is mixed with a binder to make paint. Shown here are an earth pigment and titanium white pigment.

Most artists' pigments are colorfast. *Colorfastness* is the resistance of a color to losing its original color quality, which means that it will not darken, fade, bleed, or washout over time. Artist's colors have generally high colorfastness ratings, although there are a few colors that are somewhat less permanent.

Pigments will not adversely react with vehicles since they are chemically inert. Pigments are varied in their opacity or transparency levels. Although all pigments are used in every painting medium, transparent pigments such as ultramarine blue is especially effective in watercolor, a transparent medium. Opaque pigments, such as cadmiums all also used in all media, but are particularly appropriate to oils, an opaque painting medium. There are U.S. government standards for labeling pigments; all pigments contained within a color must be listed on the label of the container.

Types of Pigment

There are two categories of pigment, organic and inorganic, which are further divided as follows:

Inorganic:

Earths—Ochres, umbers
Calcined Earths—Burnt Umber, Burnt Sienna
Artificial Mineral Colors—Cadmiums, Zinc Oxide

Figure 5–2 The same pigment, ultramarine blue, is shown here in different binders. From the left: pastel, oil, watercolor, acrylic, and gouache. Notice the differences in color and surface.

Organic:

Vegetable—Gamboge, Indigo, Madder

Animal—Cochineal, Indian Yellow

Synthetic organic—Pthalos, Alizarin, Azo, Hansa, Quinacridone

Before the nineteenth century most coloring agents were derived from natural sources. Many of these sources were difficult to obtain or time-consuming to process. This made bright colors such as blues, reds, and yellows more expensive. The plentiful and inexpensive pigments were the earth colors. Earths are native clays (inorganic) with high metal content such as red ochre, iron oxides, siennas, umbers, ochres, and green earth. Inorganic minerals were more rare, as they were ground natural ores, such as cinnabar, malachite (green), azurite (blue), ultramarine (lapis lazuli), which were essentially ground colored stones. Most surprising to today's artists are the contents of the compounds made from animals. Examples of these are sepia (ink of cuttlefish), crimson (dried lice), carmine (cochneal insects), Indian yellow (urine). Other organic sources included plants, roots, berries, flowerheads, barks, and leaves. Examples are the root of the madder plant to make rose madder, a red; chamomile flowers for yellow; iris or ragweed for green; and an Indian plant, indigo, for blue. Some of these substances are still used for natural dyes but almost all of the organic substances are out of use today as pigmented materials.

In the nineteenth century, pigments and dyes were beginning to be chemically produced. Many of these pigments were dyes fixed to inert inorganic pigments. Examples of these are the lake pigments, reds and oranges. Major synthetic organic pigments that are in use today include pthalos (greens and blues), azos (yellows, reds, and oranges), and quinacridones (reds and violets), as well as many more. Natural pigments from organic sources are much less permanent than the organic synthetics, which are permanent and intense colors. Inorganic pigments are still used today, in particular the earth colors and the artificial mineral colors such as the cadmiums. The amount of pigment colors available today would stagger the artist of the Middle Ages or Renaissance.

Hue colors from the color circle do not always have a single pigment color equivalent. Sometimes there are several pigment color choices; for example, a blue-green can be chosen from several different pigments. Some common pigments that align with the traditional twelve-hue color circle are presented on Table 5–1, which also includes the chemical content of each pigment.

Veihicles and Binders

The definition of a *vehicle* or *binder* is a substance that must support and bind pigment particles together. It also must easily apply a pigment to a surface. A vehicle must dry to a durable film that both suspends the pigment and binds it to a surface support. A *support* is the appropriate surface to which the particular paint medium is applied, whether paper, wood, or canvas. All vehicles or binders have a measure of plasticity, in order to allow paint to flow onto or be paintable onto a surface. The

Table 5.1

CHART OF HUES AND PIGMENTS

Hue Name	Pigment Name	Pigment Characteristics	Pigment Source
Yellow	Cadmium Yellow Medium	Opaque, warm yellow	Cadmium Yellow
	Hansa Yellow Light	Transparent, cool yellow	Arylide Yellow and Zinc White
YO	Cadmium Yellow Deep	Opaque, very warm yellow	Cadmium Yellow Deep
Orange	Cadmium Orange Hue	Semi transparent, YYO	Arylide Yellow and Perinone Orange
	Cadmium Orange	Pure orange, opaque	Cadmium Orange
RO	Cadmium Red Light	Opaque, warm red	Cadmium Red Light
	Napthol Red Light	Semi opaque	Napthol Red and Zinc White
Red	Cadmium Red Medium	Opaque	Cadmium Red Light
	Permanent Red	Semi opaque	Napthol Red and Arylide Yellow
RV	Quinacridone Red	Transparent	Quinacridone Red
	Alizarin Crimson	Transparent, warm RV	Alizarin Crimson
	Cobalt Violet	Transparent, cool RV	Cobalt Violet
Violet	Dioxazine purple	Semi opaque	Dioxazine Purple
	Permanent Violet	Semi transparent	Ultramarine Violet and Dioxazine Purple
	Manganese Violet	Transparent, slightly BV	Manganese Violet
BV	Ultramarine Violet	Transparent	Ultramarine Violet
	Ultramarine Blue	Transparent	Ultramarine Blue
Blue	Cobalt Blue	Semi opaque, cool	Cobalt Blue
	Brilliant Blue	Semi transparent	Phthalo Blue and Ultramarine Blue
BG	Phthalo Blue	Semi transparent, intense	Phthalo Blue
	Cerulean Blue	Opaque	Cerulean Blue, Chromium
	Cobalt Green	Semi opaque	Cobalt Green
	Cobalt Turquoise	Semi opaque	Light Green Oxide
Green	Permanent Green Light	Opaque	Phthalo Green and Arylide Yellow
	Phthalo Green	Transparent, cool, intense	Phthalo Green
	Viridian Green	Transparent, cool	Viridian
YG	Cadmium Barium Green Light	Opaque	Cadmium Barium Yellow and Phthalo Green
	Yellow Green	Semi opaque	Phthalo Green, Arylide Yellow and Zinc White

Figure 5–3 Vehicles bind a pigment to the surface support. Clockwise from top left: linseed oil for oil paint, gum arabic for gouache and watercolor, acrylic polymer for acrylic paint, and beeswax for encaustic.

texture of the binders can range from a thin liquid to a thick paste. Binders include a range of substances: fats, oils, gums, waxes, resins, and polymers. [5.3] The type of vehicle causes pigments to behave in a particular way when light is absorbed or reflected from the painted surface. Pigments are generally darker when a binder is added because the pigment's refractive index (how much light refracts or bends when in contact with the surface) is lowered when a binder is added. Each pigment has a different reflective surface quality dependant on the type of particles involved. Since pigments are derived from a wide range of sources, the binder may cause the pigment to become more opaque or transparent. [5.4] Overall color quality is effected by the following factors: the nature or type of vehicle used, the gloss or matte quality of the paint surface, the type of light on the colored surface, the interaction of colored areas, the transparency or opacity of the medium, and the paint application.

Opaque and Transparent Media

Opaque paint is sometimes called "body color" when it completely covers the surface onto which it is painted. No light comes through the paint film when it is used in an opaque manner. The colors are seen through absorption and reflection of light. Opaque color can also be thinned and used in a transparent or translucent manner. The *undertone* of an opaque color refers to its color when used in a transparent manner or tinted. [5.5]

Figure 5–4 Notice the color differences between left: cerulean blue dry pigment and cerulean pigment in a binder, shown here in oil paint.

Figure 5–5 Body color in opaque paint is the color seen when the paint is applied heavily and used as a mass. Undertone is the color seen when the paint is applied thinly or tinted with white. Shown here from top: Dioxizine purple, Cadmium Red Light, Phthalo Blue, Alizarin Crimson and Permanent Green Light.

In *transparent media*, light can pass through the paint layers to the support below. Watercolor, oil glazes, markers, dyes, and some inks are transparent. Light value colors in transparent media are attained not by the use of white but by thin films of colors that let the white support show through. The effect of transparent colors is due to the transmission and reflection of light. [5.9]

Colorfastness of Artist's Materials

An important consideration facing artists and designers is the permanence of their color materials. We tend to take for granted that all materials sold by the art retailer or those printed from our computer are permanent. This is certainly not always the case. It can be safely said that most pigmented materials are lightfast tested and have permanence ratings. Sometimes the manufacturer will have the permanence rating

listed on the tube or jars of paint. U.S. paint manufacturers are required to supply this information, but since many brands of paint are imported, the ratings must often be found on color charts, in product catalogs, or on website of each company. Note that the permanence ratings only apply if the art materials are properly used. Pastels used on Mylar, or oil paint on glass may present problems that the manufacturer could not anticipate. In the United States, toxicity ratings and the exact pigment content of each color also must be listed on the packaging of artists' colors. Sometimes the opacity and tinting strength is also included. It is best to buy paints that list the true pigment components of each color on the container.

All artists' pigments are rated for lightfastness. Artists' pigments are held to a much higher standard than, for instance, commercial wall paint. Lightfastness tests are done on both full strength pigments and tints of the pigments. The pigments are exposed to approximately 600 hours of sunlight, and then they are checked for fading. Lightfastness ratings range from I to V, I being the highest rating. Paints are also checked for the following: tinting strength, opacity, and toxicity. Sometimes they are checked for drying rate, consistency, and paint composition.

Student and Professional Grade Colors

When shopping for art materials, we are confronted with a dizzying number of options, particularly when buying paint. There are usually two or more quality grades of paint, which may not be evident to the student or novice reading the label. Student grade paints have a slightly lower quality level than artist's grade paints. Student colors are just as permanent as artist's grade paints, but there are some key differences. Student colors are lower in cost, contain somewhat less pigment, use alternate pigments, and have a more limited color selection than artist grade paints. In student paints, there can be pigment substitutions labeled as hues. [5.6] For example, a tube that says cadmium yellow hue indicates that the content is not true cadmium but a substitute pigment, such as hansa yellow mixed with a little white to give it the appearance of true cadmium yellow. A cadmium yellow hue may handle and mix with other colors differently than true cadmium yellow, but otherwise it is a safe, permanent color. Note that student grade paint does not include children's art supplies, which are meant for fun and not tested for permanence. Children's art supplies are not recommended for any serious artwork.

Painting Media

ENCAUSTIC One of the earliest forms of painting media is encaustic. *Encaustic* is pigment mixed with melted beeswax and resin. The colors must be warmed (melted) to be applied. A process called "burning in" finishes off the paint surface. In this process, the paint surface is smoothed with a hot metal implement. Encaustic and waxed-based painting methods were used in Egyptian and Roman art. In Roman art, it was used for funerary portraits. The resulting lifelike effects attest to the skill of

Figure 5–6 Student versus artists grade color. Notice the difference between true Cadmium Yellow Light, artist grade (top right) and Cadmium Light Hue, student grade (top left). Notice also real Cerulean Blue, artist grade (bottom right) and the student grade (bottom left). All the colors are permanent but the student grade paints use alternate pigments.

the unknown artists as well as to the permanence of the painting medium. Some contemporary artists still employ this medium for their work, which results in high luminosity colors and a matte, satiny finish. [5.7]

FRESCO *Fresco painting* is a method of mural or wall painting in which the pigment binds with the support itself. The fresco technique is unique in this regard, not having a traditional binding agent. Pigments are ground in water, and then applied onto wet lime plaster. The plaster must be wet or damp for the binding properties to work correctly. This obviously gives the artist a limited time to work. As the plaster dries, the pigment penetrates into its surface. Pigment powder thus cements

itself to the lime. In Secco fresco technique, specific colors, such as azurite blue, are painted onto dry plaster. Fresco technique has been used from Minoan times (2300–1100 B.C.), most notably seen at the palace of Knossos in northern Crete. In Asia, frescos also adorn the interior walls of Buddhist temples. The fresco technique was perfected during the early Renaissance and was a predominant medium throughout the Renaissance. The most famous example of fresco is the Sistine Chapel ceiling by Michelangelo. [12.2] Artists that employed fresco were limited to mostly earth colors, as plant derived pigments reacted badly with the alkaline plaster. Dried colors of a fresco painting are light in value due to the pigment's reaction to the lime.

EGG TEMPERA Another early Renaissance technique was egg tempera. In the *egg tempera* technique, pigments are first ground in water then "tempered" with egg yolk, which serves as its binder. Egg yolk is a perfect natural binder, being an emulsion of water, a nondrying oil, and lecithin. The oil in egg yolk binds the pigment to a primed wood panel support. The yellow of the egg yolk bleaches, thus not affecting the colors of the pigments. The gesso ground (primer) is a mixture of chalk whiting and sizing, which has a bright white, absorbent surface. As egg tempera dries, the water in the emulsion is replaced by air. This causes more light to be reflected from the bright white gesso surface, lending the paintings a special luminosity of color. The proteins in the egg also harden to create a satiny, durable surface. The disadvantages of this media are the need to continually remix fresh paint with fresh egg and the time-consuming application technique, which employs multiple paint layers. Egg tempera was a primary painting medium of the early Renaissance before

Figure 5–7 Mark Lavatelli, *Red Pine*, 1996. Collection of the artist. Encaustic on panel. © Mark Lavatelli 1996. This contemporary use of encaustic paint illustrates the brilliance of the color enhanced by the medium, which is pigment in a wax binder.

Figure 5–8 Catherine Catanzaro Koenig, *Pendulum*, 1992. Egg tempera on panel. Collection of Brian and Barbara Baird. © Catherine C. Koenig 1992. Egg tempera is characterized by a pale value key and translucency, as shown in this work.

the development of oil. Although its use is not widely used today, several contemporary artists employ it as their primary medium. [5.8]

OIL PAINTING Oil painting is directly developed from egg tempera painting. Early Renaissance artists started adding small amounts of drying oils to the egg yolk binder for more painting flexibility. Oil was also used as a final varnish over egg tempera paintings. Soon artists discovered that pigments could be ground solely into oil to make a new form of a more flexible paint. The main type of oil used for *oil paint* is linseed oil, a natural drying oil extracted from the seed of the flax plant. Oil paint is soluble in gum spirits of turpentine or mineral spirits. The dried oil film serves as a vehicle for the pigment, protecting the particles and binding it to a gesso surface. Other oils, such as, walnut oil, poppyseed oil, lavender oil, and hempseed oil, have been used in the manufacture of oil paints and oil medium (a paint additive).

The artist who is credited with the development of the oil technique is Jan Van Ecyk (1390–1441), a Flemish artist, who was a major contributor to the art of the Northern Renaissance. The advantages of oil paint are numerous. Oils have an ease of manipulation due to their slow drying time. Many paint consistencies can be manipulated with oil, from thin glazes to heavy impasto. Oil is painted on primed canvas, a light, movable support, as well as on a wood gesso panel. In most painting media, the colors change in value from wet to dry, but oil colors retain a similar appearance from wet to dry. Oil color also has an innate richness. Some of the disadvantages of oil are the slow drying time and the need for harsh, toxic solvents. The handling and surface quality of oil paint can be enhanced or changed with the additions of varying types of oils, resins and waxes.

WATERCOLOR *Watercolor* is a transparent painting medium. Its transparency makes it unique among the selection of primarily opaque painting materials. Watercolor came into common use in Western art in the nineteenth century, popularized in England. The optimal pigments for watercolor are those that are transparent by na-

Figure 5–9 Transparent watercolor washes allow the white paper surface to show through the paint film to create tints.

ture, such as ultramarine blue and alizarin crimson. However, many pigments are used for watercolor, even those with a characteristic opacity, such as the cadmium pigments. The pigments for watercolor are ground very finely in a gum arabic (glue) solution. Watercolor comes in both tube form and in small color pan sets. The support for watercolor is paper, which is lightly sized with gelatin to prevent the watercolor from absorbing into the surface too quickly. Transparent washes are colors diluted with water and used in watercolor painting to achieve light value effects. [5.9] Tints are made with thin layers or washes of color that allow the white of the paper to show through. Watercolor actually stains the surface of the paper as it dries. Since pigments are adhered to the paper surface with a delicate binder, watercolors are matted and protected by glass when professionally presented. This keeps the paint surface clean and protects it from the ultraviolet rays of daylight and sunlight. Watercolor is a popular painting medium because it is highly transportable, has only water as a solvent, and cleans up quickly. Although known as a medium associated with beginners and children, watercolor in reality is quite difficult, requiring both a delicate touch, and knowledge of color transparency. Inexpensive children's pan sets of watercolors should be avoided for artists and designers, as they are low in quality and impermanent. Fine brushes and paper are also extremely important for success in watercolor.

GOUACHE *Gouache* or *tempera* is an opaque form of watercolor. Gouache has a gum arabic binder like watercolor, but it has a larger ratio of binder to pigment than found in ordinary watercolor. The paint is also applied more heavily and with less water than watercolor. [5.10] Either watercolor paper or illustration board serves

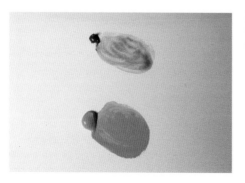

Figure 5–10 A comparison of the transparency of watercolor (top) to the opacity of gouache (bottom).

as a painting support for gouache. Various amounts of chalk or white are added to the pigments to give gouache both body and opacity. Gouache is more intense in color than watercolor since it contains more pigment and is opaque. Tempera painting was used for book illumination in the Middle Ages, for Persian miniatures, and for Asian painting on paper and silk. Gouache is commonly used today for fine art or as designer's color. A lower grade of gouache is called poster paint.

ACRYLIC The two Americans Leonard Bocour and Sam Golden developed acrylic paint in the 1940s, but these paints did not come into common use until the 1960s. *Acrylics* are an emulsion of water, pigment, and a polymer resin. The water component of the emulsion allows the paint to be water soluble, one of its main ad-

Figure 5–11 Acrylic is the first paint using a synthetic binder, polymer resin. A versatile medium, acrylic is capable of a wide variety of effects. Clockwise from top left: a tint, body color, a transparent wash, and a texture made with acrylic gel, all with dioxizine purple pigment.

Figure 5–12 Oil sticks, pastels, and colored pencils are dry pigmented colored drawing materials. From the top: chalk pastel, colored pencil stick, and oil pastel.

vantages. When acrylic dries, the water evaporates; leaving an extremely strong polymer film that binds the pigment into the paint film and onto the painting support.

Acrylic paint has many advantages; it can be thinned with water, thus eliminating the need for solvents. It can be used in an opaque, transparent, or translucent fashion, and can range in application from impasto to watercolor-like washes. [5.11] Acrylic paint dries quickly, allowing repainting almost immediately. It can be painted onto many surfaces, primed or unprimed, including canvas, paper, board, wood panel, and plastics. Additives for acrylic paint can create a variety of paint surfaces: gloss and matte mediums, gels, modeling pastes, and so forth. The disadvantages of acrylics are changes in color and paint quality that occur when the paint drys. Acrylic dries too quickly for some artists, not allowing enough time for paint manipulation.

DRY COLOR-DRAWING MEDIA For color drawing, there is a wide selection of dry color-drawing media, including colored pencils, chalk pastels, pastel pencils, oil pastels, oil sticks, and wax crayons. Color-drawing media all use a paper surface as a support. [5.12]

Colored pencils are colored sticks encased in wood casings. They are made from pigments mixed with clay, a synthetic resin, and wax. They are also available in a water-soluble composition, and are called watercolor pencils. The lightfastness of colored pencils is questionable since some pencils have dyes rather than permanent pigments. A good artist's grade of colored pencils should be used for finished fine art or illustration. Colored pencils can be translucent or opaque depending on the

application onto the drawing paper support. The colors may be built up in layers or used lightly, letting the grain and whiteness of the paper show through. They are a convenient way to make both quick color plans and finished drawings.

Wax crayons have the same binder as encaustic paint, but they are used as a dry media on paper. They are essentially pigments or dyes mixed with paraffin wax to make colored sticks. We usually think of crayons as a child's art material, but there are also wax-based colored drawing sticks for artists on the market.

Chalk pastels are dry pigments with a very minimal glue binder called gum tragacanth. The chalk pastels are made of a glue solution of precipitated chalk and pigment. These ingredients are mixed together then formed into sticks and dried. Since this is an opaque medium, tints are made in premixed color sticks with various additions of white pigment, and shades are made with the addition of black pigment. Pastels are best used on a medium textured paper surface. A toned paper ground (for example, a sepia-colored paper) is sometimes used to bring out the sparkling quality of the colors. Pastels are easily blended with the hand or a paper blending stick. Their portability makes them a good painting tool for working outside. Pastels can be lightly sprayed and fixed, but are delicate and should be always professionally displayed under glass.

Oil pastels are colored sticks that are made of pigments or dyes in an oil/wax binder. Oil pastels do not dry, but retain a somewhat sticky surface. They can be drawn onto paper and blend easily into each other. They also can be dissolved or blended with mineral spirits or turpentine. Be aware that there are many inferior grades of this material on the market. For permanent work, only use those graded as artist quality.

Oil sticks are actually oil paint in stick form. The sticks form a skin but stay wet inside. They should be used on a primed ground as oil paint, and can be blended with turpentine and oil paints.

Inks and Dyes

DYES *Dyes* are soluble colorants. Dyes transfer color by being dissolved in liquid and then staining or absorbing into a given material or surface. The lightfastness of dyes is variable, they are not all as lightfast and stable as artist's pigments. There are two major sources for dyes: natural (animal or vegetable extracts) or synthetics. There are some common sources for dyes and pigments. Some fiber artists who prefer natural dyes use natural dyeing agents such as indigo, cochineal, and madder, which are older organic pigments that are no longer in use for paints.

The number of dyes used for textiles is enormous, over 10,000. Some types of synthetic fabric dyes are fiber-reactive dye, disperse dye, vat dye, and procian dyes. Since natural dyestuffs will only adhere to natural fabrics, synthetics are widely used, especially for commercially produced fabric. Procian dyes, while offering a large range of bright and permanent color for textiles, are highly toxic.

DYES IN ART MATERIALS Dyes are also used in various art materials. Most felt-tipped markers, for example, are filled with dyes rather than pigmented materi-

Table 5.2

CHART OF PIGMENTED MATERIALS

Media	Binder	Additive	Solvent	Support	Opacity	Property
Encaustic	Wax	Gum		Wood panel	Translucent	Must be heated to paint with
Fresco	Lime plaster	None	Water	Lime plaster on wall	Translucent	Must be painted on wet or damp plaster
Egg tempera	Egg yolk	Oil	Water	Panel with gesso	Translucent	Must be painted thin in layers
Oil	Linseed oil	Resins, oils, or waxes	Gum turpentine or mineral spirits	Primed wood or canvas	Opaque or transparent	Slow drying from glazes to impasto
Watercolor	Gum arabic	Gum arabic	Water	Watercolor paper	Transparent	Thins with water
Gouache	Gum arabic		Water	Watercolor paper	Watercolor	Opaque water color
Acrylic	Polymer resin	Polymer medium or gel	Water	Almost any	Opaque or transparent	Fast drying any thickness
Chalk pastel	Gum tragacanth		Dry Media	Paper	Opaque	Dry blends easily
Colored pencil	Wax and clay		Dry Media	Paper	Translucent	Smooth or textured
Oil pastel	Wax and oil		Turpentine	Paper	Translucent	Blends easily
Oil stick	Linseed oil		Turpentine	Paper or canvas	Opaque	Like oil paint

al. In order for the colors to flow properly through a fiber point, it has to be a liquid dye. Markers are convenient when used for execution of architectural renderings, quick compositions for graphic design, and so forth. Markers are available in a wide range of colors for these purposes. Markers are a transparent medium used to create

layered effects. Alcohol-based markers can blend into each other easily. Water-based markers can be layered with less blending. Both types of markers bleed and absorb into the paper surface to stain the paper with their dyes. Markers, whether water-or solvent-based, should not be regarded as permanent art materials for fine art or design. There are a few markers that use pigmented ink, mostly black, which should make them more lightfast. There are also "paint" markers, which contain an enamel paint that is released to flow by a pump mechanism. All markers are questionable as to permanence and should be subjected to informal light testing before use for permanent work.

Dyes are also used as coloring agents for both ink jet printers and photography.

INKS Ink is a term for a large variety of art materials. *Inks* refer to both physical materials and process materials. There are drawing inks, printing inks, process inks for commercial printing, and printing inks for fine art printing.

India ink is a pigmented ink that has been in use for several hundred years. [5.13] India or China ink was originally in a stick form that was ground and mixed with water to make a black, permanent ink. India ink refers to a black waterproof drawing ink made with carbon black combined with a shellac binder and used on paper. India ink is different in composition from writing ink for fountain type pens. Writing ink is dye-based and water-soluble. There is also a selection of colored inks that can be brushed on or applied with dip pens. Inks that are dye-based are of questionable permanence. Other dye-based materials that are subject to fading are the liquid "watercolors" in dropper jars. These are appropriate for graphic design, but because they are dye-based, they may fade or change color. Pigmented colored inks can be applied by a brush, pen, or air brush (a spray painting device). Pigmented inks are higher in colorfastness than dye based inks.

Figure 5–13 India ink is a combination of carbon black and a shellac binder.

The permanence of some questionable materials can be tested at home for color and light fastness. Swatches of all the questionable materials can be put on a paper or board, complete with labels. Half of the board should be covered with a heavy black paper. Placement in a south-facing window for a month or more should indicate any fading that will occur. The black paper is then removed to compare exposed with unexposed areas.

PROCESS MATERIALS

Color Photography

Color photography applies principles of the tricolor theory and is interplay between the additive and subtractive color systems. Color photography was first introduced in 1907. The color image was created by a series of films exposed with separate color filters to make three color images. Color film today is made of three light sensitive layers. Each of these layers records one of the primaries of additive light: red, green, and blue. Each image is actually recorded as a black and white using silver halide, which is subsequently washed away in processing. This leaves three dye colors: the three subtractive process primaries of cyan, magenta, and yellow, one color on each of the three-layer film emulsion. Dye couplers, color formers that are activated in the film development process, form the dyes.

The photographic process involves the additive color system, with an additive color circle as its reference. [5.14] The secondary colors of light are the three subtractive process primaries, cyan, magenta, and yellow, which are the complements to the additive primary colors. When color film is exposed to a subject, the light hits each layer of film, and the additive primaries of red, green, and blue change in color to their complements. The complements of additive colors are cyan (from red), magenta (from green), and yellow (from blue). In film, the red sensitive layer records as cyan, the green layer as magenta, and the blue layer as yellow on the developed negative. [5.15] The yellow filter is destroyed in film processing. Also note that the color black in an image does not expose any emulsion and white exposes all three. Black is open on the negative, thus it is a combination of cyan, magenta, and yellow. White is black on the negative, thus blocking all color development in these areas on the positive print. Color films have an orange mask on the developed negative that corrects the color in the final print.

The photographic positive is made on special color print paper that also has three layers of light sensitive emulsions. These are in reverse order when compared to the film. The top layer is cyan, the middle, magenta and the bottom layer is yellow. To make the print, the negative is projected through an enlarger either sequentially to red, green, and then blue light or to a balanced white light. In photographic printing, it can be a problematic process to balance the colors. Special care must be given to balance cyan, magenta, and yellow. Since both the negative

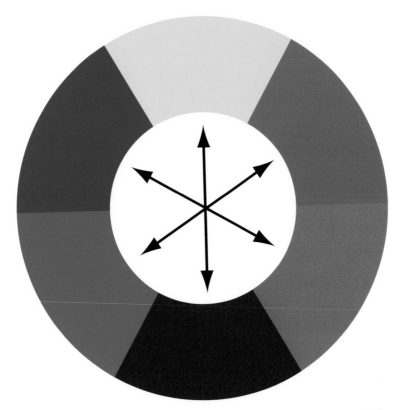

Figure 5–14 The photographic color circle is identical to the additive color circle. The complements determine how each color filters another in photography.

Figure 5–15 How light is filtered to produce a color on a photographic negative.

and the positive print are formed from dyes, color photography is subject to fading. Care must be used in protecting framed images with glass, especially glass that controls ultraviolet rays.

Color Printing

Color printing refers to two types of printing processes: first, processes used for *commercial reproduction* of type, text, and image; and, second, processes used by artists for *fine art printing*. Printing always refers to the transfer of image from a special surface (a plate, block, or stencil) by ink onto paper. Printing process can be roughly divided into four major areas, relief printing, intaglio, screen-printing, and lithography. There are fine art and commercial processes within each area.

RELIEF PRINTING *Relief printing* utilizes the raised and recessed areas of metal plates or wood blocks to form a printed image. Types of relief printing include woodcuts, wood engravings, and letterpress for commercial work. To make a relief print, ink is rolled onto the raised areas and a lightweight paper picks up the inked areas by the pressure of a press or hand. [5.16] Raised areas of the block or plate are printed and recessed areas remain white as unprinted areas. Any number of colors can be used, but each color means a separate print run from different block surfaces. For wood relief printing, either oil-based or water-based inks are applied to the block with a rubber roller. Amongst the finest examples of wood block printing are the Japanese woodcuts, which have been refined to a high art form.

Letterpress is a form of relief printing that uses a photosensitizing process to etch a metal plate. After etching, raised areas remain, which are alternately inked and printed by machine. Letterpress was in use until the 1960s, when other, more efficient printing procedures replaced it. It is still used primarily by small printing companies for high quality bookwork.

INTAGLIO PRINTING In intaglio printing, metal plates made of steel, zinc, or copper are used. These plates are etched by acid or hand engraved to form recessed areas. The plate is fully inked, and then wiped by hand or scraped by machine to force the ink into the recessed areas of the plate. The inked plate is then run through an etching press, equipped with heavy rollers and the image is transferred onto a

Figure 5–16 A cross section of a relief-printing block. The raised areas (red) print, and the recessed areas do not.

Figure 5–17 In a silkscreen print, a stencil on the screen controls the areas to be printed.

dampened sheet of paper. The recesses can be either line or textured areas. In fine art processes, such as etching, the heavy oil-based pigmented ink is applied to the plate by hand, and then wiped. Intaglio processes include dry point, etching, metal engraving, aquatint, photo etching, and the commercial process of gravure. Gravure printing is often used for large printing jobs, the costs being too high for smaller jobs. In the gravure process ink is rolled onto the plates and then scraped by a thin steel blade to force ink into the recessed areas. Gravure printing of photographs is considered a superior method due to the higher contrast that it provides.

LITHOGRAPHY Lithography was developed in the nineteenth century. Lithography was used for art printing, as its process was quicker than that of either etching or engraving. In *lithography*, an image is drawn with a grease-based material on a specially ground stone or metal surface. The printing process involves oil and water, which resist mixing. A thin film of water keeps the ink on the oil-sensitized areas of the surface and away from other surfaces. *Offset lithography* is a primary means of commercial printing for books, magazines, and art reproductions. The offset process uses a thin metal plate to offset the image onto a rubber mat, which is then printed onto paper. Both etching and lithography use heavy oil-based pigmented inks that have a sticky consistency.

SCREEN PRINTING *Silkscreen* or *screen-printing* involves a special fabric screen that employs a handmade or a photosensitized stencil method to produce prints on paper or fabric. The screen is a fabric that is stretched over a simple wooden frame. [5.17] The prints are made by using a squeegee to force ink through the screen. To produce a print, open areas of stencils allow the ink to pass through the screen to a sheet of paper underneath. Silkscreen is manually produced both for artists' prints and for larger commercial production. There are also semiautomatic presses, which

are hand-fed with paper. Fully automatic machines print large editions of posters. Screen-printing ink adheres to many surfaces, including plastic, paper, metal, glass, and fabric.

Color Reproduction

Commercial color printing utilizes two main processes to reproduce color, namely, color separation or flat color.

COLOR SEPARATION The first photomechanical color separation was produced in 1893. Color separation is a process of isolating the component colors of a full-color photo, painting, or illustration for reproduction purposes. Three photographs of an artwork are shot, each through a separate color filter. The filters are meant to calibrate exactly to each wavelength of the three light primaries. Reproduction quality is dependent on the quality of the filters used. Each photo records one-third of the color information, which is similar to the color photographic process discussed previously.

- The red filter removes red and leaves green and blue, making cyan.
- The green filter removes green and leaves red and blue, making magenta.
- The blue filter removes blue and leaves red and green, making yellow.

Each photo thus results in the process complement of each additive color. [5.18]

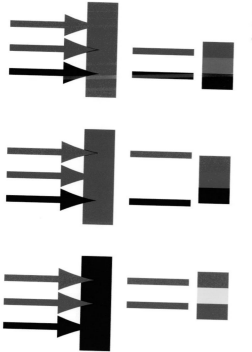

Figure 5–18 How colored filters for the four-color printing process (CMYK) separate colors.

Figure 5–19 Color separations are over-printed in stages as shown, at right starting with yellow and ending with black, for four-color commercial printed matter, as shown above.

In the four-color process, printing inks are transparent, which means that color mixing occurs by color layering and open white paper represents white. Cyan, magenta, and yellow mix in various intensities to produce most colors; C and Y forming greens, M and Y making oranges and reds, and C and M producing violets and blues. Unlike photography, in commercial printing, cyan, magenta, and yellow alone are not adequate to reproduce a full color continuous tone image. A fourth photo with a neutral filter allows black to be added to sharpen, darken, and define the image. [5.19] Thus the four-color process is called CMYK, standing for cyan, magenta, yellow, and black or "key."

FOUR-COLOR PROCESS The four-color process of printing is actually a pattern of tiny dots, which are round, elliptical, or square. By their density, these dots form variation of both value and color saturation for the final image. Screens that create these dots vary according to the desired resolution of the printed image and the type of paper onto which it is printed. *Halftones* are a pattern of dots used for reproduction of a continuous tone image. These dots are called *Benday dots* after their inventor, a New York printer named Benjamin Day. Benday dots gradate in size to suggest light or dark areas of the image by optical mixtures. While the dot pattern remains consistent, dots in dark areas are larger to cover more white paper. Dots are smaller in light value areas so that the white paper optically mixes with a small amount of color to produce tints. Gradation of the size and overlapping of dots produces the illusion of a smooth value, hue, or tonal gradations. The screen pattern of

85 dpi 150 dpi 300 dpi

Figure 5–20 An example of 85, 133, and 300 dpi (dots per inch). Dpi determine the resolution and clarity of printed matter.

dots or *dpi* (dots per inch) can be finer or coarser depending on the desired resolution of each printing job. The combination of CMYK dots in various sizes and overprinting colors forms optical mixtures to give the illusion of a wide array of colors. The first step in this process is a photographic or digital *color separation*. Each separate color of CMYK is screened to create a dot pattern.

The dots are graded in lines per inch. [5.20] These can be roughly sorted in quality as follows:

- Newspapers 85 lines per inch
- Magazines 133–150 lines per inch
- High-quality art reproductions 300 lines per inch

The four-color process is printed in layers in this order: first yellow, then magenta, then cyan, and then black. [5.19] The screens are placed at different angles to avoid a wavy effect called a *moiré pattern* that can occur in the final reproduction. When more color accuracy is desired, up to eight colors can be used for process printing.

To insure color consistency, printers use color control bars called SWOP, which stands for "specifications web offset productions." The variations in the colors of CMYK inks dependent on the manufacturer, and this information is important to know at the outset of a job. Today, computer scanners are used to produce most color separations. Original art is put through a scanner that uses a high intensity light or laser to separate the colors. Color filters are built into the scanner, which then converts the image into a four-color separation. The resolution of the scanner can be set according to the resolution and paper that are desired for the final print of the image.

FLAT COLOR Flat or spot color is a solid printed color area selected for some one- to three-color printing jobs. The colors are chosen from a PANTONE MATCHING SYSTEM ® or process color chart. The PANTONE MATCHING SYSTEM ® system has upwards of 1,000 spot colors. Choosing colors from the PANTONE ® chart allows the printer to exactly duplicate a particular color choice.

The materials of color range from the traditional pigmented materials that artists have always used, to sophisticated process tools of ever-increasing complexity. These tools allow the artist and designer to communicate more widely with color than ever before.

ACTIVITY

COLOR TESTING

Objective: To learn about the permanence and paint quality of a variety of colored art materials.

A. Lightfastness tests

- Make a test strip on a small piece of board. Make marks of colored markers, colored inks, computer printed color, writing pens, paint markers, or colored pencils on the board. Use colors that are both pigmented and made from dyes. Try many different colors and coloring materials.

- Make sure that each item is labeled. Cover half of each mark with black paper.

- Put the test strip in a sunny, south-facing window for at least one month.

- Remove black paper and note any fading or color changes.

B. Paint tests

- Using acrylic, gouache, and watercolors test the paints for opacity by painting a strip of each color on black paper or on a black strip of paint.

- Paint out a thick swatch of each color, and then test the undertone of some of the colors by spreading each pigment out thinly next to each thick swatch. [5.5]

- Try adding the same amount of white to two or three different pigments. Be careful to use the same amount of white for each color. How do the tinting strengths of each pigment compare?

Chapter 6

Computer Color

INTRODUCTION

The advent of computer design has caused a rapid development in electronic color. Computer graphics are ever-changing due to simultaneous advances in computer hardware and software. Generalized information about computer color modes and the characteristics of graphic software programs is provided in this chapter. It should be noted that manufacturer's manual is always a necessary reference for operating specifics when working with any type of graphic computer software. Support books, specific to each version of the programs also can be vital in order have success with graphic software programs. This chapter provides a broad guide to common color modes that exist within a number of graphic programs. Graphic software is helpful to the color-study student because it demonstrates the concepts of color theory discussed in preceding chapters.

Computer color opens a vast new territory of color to the artist and designer. The computer is capable of producing 16 million colors. Despite this number, a computer still cannot generate all the colors that we perceive in reality. Color selections available by a simple click of the mouse are staggering, so a basic knowledge of computer color can assist us.

COMPUTER COLOR BASICS

The computer is the primary tool used in creating most graphic design. It is also a tool for drafting, animation, illustration, typesetting, page layout, photo enhancement, web design, video, painting, and drawing. Due to the emphasis of this book, the focus will be on the basics of color seen both on a display monitor and on printed computer-color work.

Graphic design is accessible to a wider range of people due to the advent of the personal computer to create both printed matter and web design. Web design can be as important as printed publications for companies and organizations. Personal computers have revolutionized the graphic design process because of the ease and speed with which they can be used. Computers are readily available for in-house design at the office level. For small-run publications, authors can design their own artwork for

publication. The availability of layout programs, inexpensive printers, and photo-copying machines has revolutionized the graphic design process, along with making color publication less expensive. Color is used in both small-run and large-run publishing due to inexpensive ink jet printers, graphic software, and color photocopies.

A home computer studio consists of a standard computer set up: computer, scanner, monitor, printer, and design software. The computer should have adequate RAM or memory because graphic files need a lot of memory. With this equipment, a graphic designer can do virtually all prepress work for publication.

THE COLOR MONITOR

The computer display monitor has an illuminated screen, the surface of the screen is a grid, each unit of which is called a pixel. The word *pixel* is combination of the words picture and element; hence a pixel is a "picture element." On a traditional monitor each pixel has tiny spots of *phosphor,* a chemical that can emit light. Pixels are arranged in rows called *rasters.* The number of pixels or the fineness of the pixel grid measured in *ppi* (pixels per inch). Ppi determines the resolution of the monitor screen. At the rear of traditional cathode ray tube monitor (CRT) screen is a device called an *electron gun,* similar to that used in a video screen on a TV. The electron gun fires beams of electrons at each pixel in a particular order. Each dot is either illuminated on or off during this process. In color monitors, each pixel contains at least three separate spots of phosphor, one for red, one for green, and one for blue. Three electron beams can activate these spots individually or simultaneously, one corresponding to each color (RGB). While computer screens have higher color saturation than TV screens, the RGB range in a CRT monitor is smaller than the true range of spectral colors (RGB from light) in reality. A color limitation occurs because on CRT monitors, colors created by phosphor are not as pure as true spectral hues. A display screen's limited color range (in relationship to the color range of what we actually perceive in reality) is called a color *gamut.* A traditional CRT monitor has trouble accurately representing such colors as a pure cyan, magenta, and yellow, the printing process primaries. In an inverse manner, the luminous quality of color on the computer screen cannot be exactly duplicated in print or by pigments.

Flat screen monitors are called liquid crystal display monitors or LCDs. LCD monitors are used on laptop computers, and are also available in a larger format for personal computers. The LCD flat monitors are attractive and compact. LCDs are significantly different from CRTs. LCDs display in one optimal resolution, have a smaller viewing angle and a lower radiation emission, have no flicker or distortion, and use less energy. In LCD monitors a light source filters through the liquid crystal, bending and twisting light to display colors and images. LCDs use pure RGB filters so the color distortion of phosphors does not exist, making the colors true RGB color with more saturation and brightness.

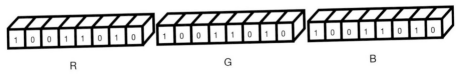

R G B

Figure 6–1 Bit or pixel depth determines the number of colors that can be displayed on the computer screen. Each bit is either on or off in combinations which determine the overall color of each pixel. Shown here an eight-bit depth that makes 256 colors, and a 24-bit depth that can form 16 million colors.

All computer monitors display colors by actual additive colored light. Essentially a color monitor is a painting and drawing with light.

PIXEL DEPTH

To grasp the concept of pixel or bit depth in reference to computer color, we should have a basic understanding of how a computer operates. A *bit* is the smallest unit of information used by the computer. It is equivalent to a single electronic pulse, which can be either on or off. One (1) is the numerical code for on, and zero (0) is the number code for off. This is the basis of the *binary system,* a two-number system that is the code for all the information contained in a computer. Pixels turn on or off dependent on the coded information sent by the computer to the monitor. Older computer monitors had one-bit pixels, which meant that a pixel was either on (illuminated) or off (darkened). The illuminated areas of the screen were either white or green, and could display text, line art, or simple shapes. Two-bit screens were subsequently developed, which meant that each pixel was capable of holding two bits of color information. Two bits per pixel means that a monitor is capable of four colors: black, white, and two gray values. Thus, the higher the bit number, the more colors that can be displayed on the screen. An eight-bit pixel can display 256 colors or grays because two to the eighth power mathematically forms 256 distinct combinations of color information. Each bit also has "depth" or different levels. For example, on a four-bit monitor, the four on and off signals can be arranged in 16 different ways. The colors that we see due to *bit depth* are dependent on the arrangement of the bits in various layers. [6.1] The manner in which bit numbers relate to the number of colors displayed on the screen is as follows:

 1-bit 2 colors, black and white
 2-bit 4 colors, black and white and 2 grays

4-bit 16 colors
6-bit 64 colors
8-bit 256 colors
24-bit 16 million colors

Most computer screens now have 24-bit color or *true color,* because of more memory per pixel. True color is photographic quality color on the screen display. Twenty-four-bit color has eight bits of memory for each of red, green, and blue. When exponentially calculated, 24-bit color leads to over 16 million colors, which is the number of different combinations of color information that are possible. Because a lot of code goes into 24-bit color, this information uses up a large amount of memory space in a file on the computer's hard drive or disc.

BITMAP AND VECTOR-BASED PROGRAMS

There are two major ways in which images are created and manipulated on a computer. They are called either bitmap or vector-based modes.

Bitmap images use pixels to create areas of color on the computer screen; they are also called *raster* images. Bitmap images are built from pixels that fill the computer screen in horizontal and vertical rows. Painting programs and photo-image editing software are bitmap-based graphic programs. Bitmap software is effective for photo images because of the need for continuous tones. Painting programs are bitmap-based because computer painting requires blended colors and gradations. Bitmap software uses pixels to define image areas, so when images are enlarged they lose definition as the pixels that form each image become visible. The enlargements leave jagged edges on the final products. Bitmap programs have a fine mosaic of pixels. [6.2] A pixel mosaic uses an optical mixture by the location and the color of each pixel to create tones and gradations that form images. A bitmap program controls pixels rather than lines or shapes. Bitmap images are *resolution dependent,* meaning that the image resolution depends on the display monitor and the scale of the pixels themselves. *Resolution* refers to the number of dots or pixels per unit used to reproduce or create artwork. Although the computer itself can manipulate pixel resolution, on a larger screen the individual pixels may become more evident. This is called *pixelation.* Higher resolution uses a greater number of pixels, which gives an image a smoother, finer-grained appearance.

Vector-based programs are based on line drawing. Defined by math objects called vectors, *vector* images describe shapes according to their geometric plan. Vector programs use mathematical locations or points to form lines and shapes, which then formulate images. The advantage of a vector-based graphic program is that the images are *resolution independent;* that is, the images can be enlarged or reshaped without losing their clarity. [6.3] A vector-based program is more precise than a bitmap program and allows more flexibility for change. The file sizes of vector art

Figure 6–2 Pixels or rasters can become evident when a bitmap image is increased in size.

Figure 6–3 A vector image maintains a crisp outline despite its size since it is based on a computer line drawing.

tend to be smaller than bitmap or raster-image files. Vector programs are a good choice for type, logos, and clean-edged work. Vector programs draw with on straight lines, freehand lines, and Bezier curves (curves plotted by anchor points). Vector programs also include a limited amount of painting capability to create softer effects. Vector images cannot be seen with complete accuracy on a monitor because images are displayed in a pixel format. A good printer converts vector lines into dots, thru a process called rasterizing. A low-end ink-jet printer cannot rasterize so it will print the image as seen on the screen display. A high-quality printer will help improve the final product printed out.

TYPES OF GRAPHIC SOFTWARE

There are several major types of graphic software available for drawing, painting, image editing (for photography), page layout, and drafting. All of these programs are designed for static art, but there are also programs designed for space and time media, such as software for video and computer animation. Drawing software is vector-based and has drawing, limited painting, and type-setting capability for both graphic design and illustration. Bitmap-based painting programs have the capability of simulating the effects of traditional drawing and painting media. Image-editing software is designed for manipulating photographic material, which is scanned in or loaded from a digital camera. Photo software uses pixels to provide the continuous tones needed for photographic imagery. Page layout programs assist the graphic designer in the layout of print-ready materials, both illustration and type. Drafting programs are used for architectural drafting and perspective presentations.

Computer Tools

Every graphic program provides the artist with a workspace (called the paper or art board), a toolbox, and a huge range of colors. Toolboxes of different graphic programs contain some items in common, which are activated by clicking or dragging with a mouse. Some graphic tools are for image creation and others have image-editing capability. [6.4]

The two charts shown, Tables 6–1 and 6–2 (see pages 134–135), provide a brief description of some of the common image-making and editing tools found in graphic software. [6.5] Graphic software is updated on an almost continual basis, making the tools ever more sophisticated and with added functions. [6.6, see page 133.]

Graphic software operates in layers that can be thought of as clear layers of acetate, each containing a part of the final design. One or more layers are used to create any given artwork; each layer has objects "stacked" in order of their creation. Objects can be moved forward or back in this stacking process or moved from one layer to another by cutting and pasting. For most of the computer activities in this book, a single layer is adequate.

Figure 6–4 A sample toolbox from Adobe Illustrator®. From top to bottom, left to right: Selection, direct selection, lasso, direct lasso, pen, type tool, ellipse and circle tool, rectangle and square tool, paintbrush, pencil, rotate, scale, reflect, free transform, blend, column graph, gradient mesh, gradient, eyedropper, scissors, hand, zoom. As the bottom square indicates the fill (solid) color and the open square is the stroke (outline) color. Screen capture from Adobe Illustrator® is a registered trademark of Adobe Systems, Inc. in the United States and other countries.

Figure 6–5 Some examples of drawing or painting tools. Clockwise from top left: Pencil tool, brush tool, scatter brush, and pen tool.

Figure 6–6 Some painting effects that are available. Clockwise from top left: roughen, scribble and tweak, inner glow, and drop shadow.

Computer Color

There are several color modes available within each graphic program. Each color mode should be understood in relationship to its color range, mode of operation, and function. Otherwise, the color selection process can be overwhelming. In any case, having 16 million colors at our disposal is true color power. The major color modes are RGB, CMYK, HSB or HSV, Web-safe color, and sometimes a mode called Lab color, which is the computer version of CIE color.

RGB COLOR Both the computer monitor and scanner utilize the *RGB color mode.* Since the computer monitor displays color information with light, it operates in the additive RGB light color mode. Each set of color information, red, green, and blue, is called a channel. Each channel of RGB color is eight-bit. Since there are three colors (RGB), this makes a total of 24-bit color. Each channel is capable of making 256 variations on each colors (red, green, and blue). The possible combinations of three sets of 256 provide us with the choice of 16 million colors in the RGB mode.

The RGB color can be selected in several ways. We can select hues from a spectral band or color circle that is displayed in this mode. A hue band has higher

Table 6.1

COMPUTER GRAPHIC TOOLS

Tool	Function
Selection	An arrow that allows selection of an item. An item must be selected in order to work on it. A selection box can be dragged around numerous items or shift/click will allow selection of more than one item.
Pencil	A pencil tool allows drawing of free hand lines or shapes. This requires some control with the mouse or stylus. Some programs can vary line texture and pressure. Line weight is easily adjusted. Some programs can simulate fine art media such as charcoal, ink, and pastel.
Brush	The brush tool is for freehand drawing and painting. Brush options can control brush size, texture, and shape. Some painting programs also have options of various tranparencies, water, dry brush, etc. A scatter brush can repeat a motif or pattern along a painted path. There is usually an airbrush or spray can linked with the brush too, which can spray a fine stipple of color. An art brush will bend an object along a path.
Shape	The shape tool has preset shapes that can be formed by dragging from a corner or the center of the shape. The set shapes include squares, rectangles, ellipses, circles, and others. Other polygons can be made with a polygon tool. Shapes can also be drawn with the pencil or pen tool.
Eraser	The eraser tool can erase areas down to white or to a previous color area. It can also change or modify an object.
Pen	The pen tool is used for precise straight lines and curves. The curves (Bezier curves) are built from anchor points, which indicate changes in direction. Straight lines can be bent at anchor points, which are clicked to set. The lines made by the pen tool are called paths. They can be open or closed to make shapes. Directional guidelines control the curve of each path.
Type	The type tool allows type to be placed anywhere in the design, inside and out the object (area type), in a text box, on a path. The type can also be enlarged, distorted, rotated, as with any other object.
Fill	The fill tool can fill an area with color, texture, or a gradient. Its icon can be either a paint bucket or an eyedropper. An eyedropper selects a color from an object and applies it to another object.

saturation colors in the center, which blend gradually to lighter values of hues on one edge and darker values on the opposite edge. The spectral band allows us to choose colors instinctively. The option of red, green, and blue sliders is also available in the RGB mode. [6.7, see page 136] Since RGB color represents light, the sliders display RGB color mixtures in an additive fashion, which may be surprising at first. When all the sliders are pushed up to 100% the RGB colors mix to white and when all the sliders are set at 0% the mixture is black.

The RGB mode is used for web graphics, art that will be viewed exclusively on the monitor, or for any light-based medium. Scanners use the RGB mode like a

Table 6.2

COMPUTER EDITING TOOLS

Tool	Effect
Zoom	The zoom tool allows the view to be magnified or moved back from the object.
Lasso	The lasso tool allows the selection of a group of objects to modify or move.
Blend	The blend tool can make shape or color blends between objects.
Scale	The scale tool can enlarge or shrink objects.
Transform	The transform tool allows geometric edits to selected objects, including rotation, reflection, shear, extruded, or applied perspectives.
Hand	The hand tool allows the art board to be moved around freely to change the viewing and work areas.
Feathering	Feathering can soften transitions between foreground and background objects.
Filters	Filters encompass a large range of effects that can be used on images. Artistic filters can give an image the effect of traditional art media such as pastel, impasto, brushstroke, etc. There are also larger arrays of textures that can be applied to objects. Various other effects can include distorting, blurring, sharpening, sketching, and pixelating.

camera, capturing the red, green, and blue color information from the scanned image. The RGB mode should not be used for the creation of printed material because it forces the computer to convert the RGB color to CMYK mode and color information can thereby be lost. The gamut or range of RGB color is larger than the range of CMYK. When a conversion from RGB to CMYK occurs and a color is out of gamut (range) for printing, the computer warns us that the selected color is not printable. RGB color can also be selected from a color picker box, which shows a chromatic gradation between additive colors.

WEB SAFE COLOR *Web-safe color,* also called a web-safe palette, is a selection of 216 red, green, and blue additive colors that are common to eight-bit color palettes. This allows web images to be viewed on eight-bit or higher monitor display screens.

CMYK COLOR MODE The computer *CMYK color mode* correlates with subtractive process printing colors. CMYK has sliders that represent percentages of cyan, magenta, yellow and black, used either singly or in combinations. [6.8] Not every color monitor is able to display pure CMY colors exactly, but using this mode translates perfectly for printed color artwork. The CMYK mode should be used for art that is to be sent out to a printer for publication. A process color swatch book is an important reference for this process because colors seen on screen are different from the final colors printed at the printer. The monitor displays color in an additive mode, forming brilliant luminous color that cannot be exactly emulated in print with the process colors. Tints in CMYK mode are formed by low percentages of colors;

Figure 6–7 RGB band and sliders. The RGB slider and spectrum represent the additive color mode of light mixtures seen on the computer screen or from any light-based medium. Screen capture from Adobe Illustrator® is a registered trademark of Adobe Systems, Inc. in the United States and other countries.

Figure 6–8 CMYK sliders used to mix a red. The mixed color appears on the left in the fill color indicator box. The open square is the stroke or outline color, which can also be set to any color. Screen capture from Adobe Illustrator® is a registered trademark of Adobe Systems, Inc. in the United States and other countries.

Figure 6–9 CMYK sliders form a tint of red by lowering the magenta and yellow percentages. Screen capture from Adobe Illustrator® is a registered trademark of Adobe Systems, Inc. in the United States and other countries.

Figure 6–10 To make shades of a color with the CMYK mode a color is mixed, then a percentage of black (abbreviated as K for "key") from the bottom slider is added to darken the value of a color. Screen capture from Adobe Illustrator® is a registered trademark of Adobe Systems, Inc. in the United States and other countries.

for example, a 10% magenta is a light tint of magenta. [6.9] To form shades, percentages of black (K) can be added to a color. [6.10] Secondary and tertiary colors are mixed by the combinations of *CMY,* cyan and yellow for green, magenta and yellow for orange, and cyan and magenta for violet. Varied percentages of CMY combinations control both the value and hue cast of a color. [6.11] Neutrals can be formulated from varied percentages of black to make grays. Complements can also be mixed together by manipulation of the sliders. For instance, an orange can be first formed from yellow and magenta, and a percentage of cyan can be added to the orange to make chromatic neutrals.

HSB OR HSV COLOR MODE The third major color mode is *HSB* or *HSV color.* The H controls the hue selection, S controls saturation, and V or B varies value or brightness. HSB is utilized by manipulating sliders, a hue box, or a spectral band display. The HSB color mode directly parallels the three attributes of color, so it can be also a means of understanding color notation systems. Sliders control hue selection, value, and saturation, but all three controls also operate as a unit. [6.12] For instance, if saturation is set at a low percentage the whole spectral band in the hue selector appears to be low in saturation. Subtle differences between colors can be chosen from either an enlarged spectral band or a Color Picker box that displays a gradation between a hue, gray, black, and white. [6.13] This color mode is the most instinctive for people who are comfortable with traditional subtractive materials such

| C 49 M 11 Y 0 K 0 | C 49 M 11 Y 0 K 15 | C49 M 11 Y 0 K 50 | C 100 M 58 Y 0 K 21 |

| C 0 M 0 Y 100 K 0 | C 15 M 0 Y 100 K 0 | C 50 M 0 Y 100 K 0 | C 50 M 30 Y 100 K 0 |

Figure 6–11 CMYK percentages: The top row shows a tint, on the left, with black gradually added to create tones; the last color is a higher saturation of the same color. The second row shows a chromic gradation from yellow into green by the addition of cyan. The last color on the right shows YG with magenta added to simulate a complementary mixture.

Figure 6–12 HSB sliders mix a light value, a low saturation green. H controls hue, S controls saturation level, and V or B controls the value or brilliance of a color. Screen capture from Adobe Illustrator® is a registered trademark of Adobe Systems, Inc. in the United States and other countries.

as paint. HSB is not a standardized system, and therefore, for printed work, the computer must convert color information into CMYK and some color information can be lost in this process.

COLOR LIBRARIES Color libraries further expand the color choices contained within graphic programs. *Color libraries* are large groups of preset colors for spot color reproduction. Spot colors are used for an exact color match or for color reproductive processes when only one to three colors are desired in addition to black. A printed swatch book is used as a reference to accurately visualize how the colors will print, since they will appear differently on the monitor. Various color libraries

Figure 6–13 HSB color picker can also show many saturations and values of a single hue. A color may be selected from any part of this gradated box. Screen capture from Adobe Illustrator® is a registered trademark of Adobe Systems, Inc. in the United States and other countries.

Figure 6–14 The standard color swatch box is on screen both for color selections and to store any other colors that are in use. Screen capture from Adobe Illustrator® is a registered trademark of Adobe Systems, Inc. in the United States and other countries.

may be contained in graphic software, which can display the color swatches on the screen. Most of these color libraries have upwards of 1,000 colors from which to choose. The PANTONE MATCHING SYSTEM® is the best known of these and libraries is the most commonly used color library in the United States. Commercial swatch books can be purchased from each color library company. Swatch books are used either to choose spot colors or to find equivalent CMYK percentages to match each color if the colors are to be printed in four-color process. Even when colors appear differently on the screen display than on the swatch books, when printed they should match perfectly to the swatches. Swatch books show color samples printed on either coated or uncoated paper stock.

Swatch Palette

Most graphic programs have a swatch palette that consists of commonly used colors, textures, and gradients. Colors that are selected from a color library or mixed from any color mode can be dragged and added to the swatch palette for maintaining a group of colors while designing. [6.14] Swatch options can be chosen to see any particular chosen color in a gradient form.

USING COMPUTER COLOR

Although graphic software can be intimidating because of its many options and sophisticated applications, it is can be fairly simple to use if some time is spent reading the manual and following tutorials. Simple design/color-studies applications of graphic software need not be difficult. Basic exercises are a quick way to execute color studies and to familiarize us with graphic software.

To Pick and Apply Color

Colors can be chosen from any of the aforementioned color models and/or libraries. Bear in mind that a color mode is selected dependent on whether the work is to be

Figure 6–15 Gradients can be customized by dragging any colors to the small squares below the gradient strip. The squares also operate as sliders to modify the gradient. Screen capture from Adobe Illustrator® is a registered trademark of Adobe Systems, Inc. in the United States and other countries.

printed or viewed on the display monitor. Studies made for a color class can be either printed out or saved on a disc to be viewed on a monitor.

Computer color may be selected either by numerical percentages or by using sliders to choose a color visually. Colors to be used multiple times in a design should be dragged and saved to the swatches palette. Any closed form (fill) or line (stroke) can be easily filled with color by choosing a color and filling the selected object with the paintbucket or eyedropper icon or by simply dragging to or clicking on a color for a selected object. Colors may be changed quickly as a study is produced, as colors may be immediately reselected and refilled into selected areas. If the stroke (outline) option is set to zero or off, the color will fill a selected shape completely to its edges. There is an enormous advantage to creating color studies on screen because we can view alternate color options and combinations with ease. Working electronically is an effective and efficient tool for conceptualizing color harmonies.

GRADIENTS *Gradients* are gradual blends of one color to another, or from a color to a neutral. Gradations blend from left to right, top to bottom, diagonally, or from the center of an object. There are some preset gradients on the swatches palette, but gradients can also be customized. [6.15] A gradient fill is created with the gradient palette or tool by dragging colors from the swatch palette to the gradient bar, then manipulating the gradation itself by sliders on the bar. Gradations can be customized by color, direction, and amount of gradation. [6.16]

TRANSPARENCY The transparency option palette allows the use of an opacity slider to control the transparency of a color from 0% opacity (completely clear) to 100% opacity (completely opaque). When using transparent color, new colors are formed when shapes overlap. A transparency mode can also allows overlapping color areas to mix in a number of different manners. Individual objects or groups of objects can be set for transparencies with varying results.

Computer Color Printing

INK JET PRINTERS Computers used for artwork at home use a color printer, which is usually an inexpensive ink jet printer. Ink jet printers use the CMYK process colors in cartridges that are applied to the paper by high pressure or heat. Color

Figure 6–16 Various gradients. From top to bottom: white to black, a hue shaded to black, white tinted to a color, a complementary blend from blue to orange, chromatic gradation from red to yellow.

quality can be improved by printing on glossy photo paper. A dot pattern creates color blends and gradations.

A giclée printer is a high-end ink jet color printer. It sprays CMYK process inks onto paper in a much slower process, that yields richly colored printed materials.

LASER PRINTERS Laser printers are high-resolution printers that use laser technology to define an image. A heat process melts toner powder onto the paper. Laser printers utilize CMYK process color to create colors images either in layers or all at once.

DYE SUBLIMATION PRINTERS Dye sublimation printers convert solid dyes into gases that are then applied as colors onto paper. This process does not use dots as laser and ink jet printers do, but forms continuous tones. Dye sublimation printers are a good way to print out high quality photo images directly from the computer.

Computer processes uniformly use dyes as their colorants, meaning that the lightfastness of the printed products are dependent on the quality and permanence of the dyes. Some printers are capable of using pigmented inks for permanent art.

COLOR MANAGEMENT

Two major drawbacks to using computer color are that color gamut ranges vary from one color mode to another and inconsistencies may occur between colors on a screen display and the actual colors as printed on paper. Color management is a way of stabilizing color variation between devices in order to provide more consistent color. The limitations of color gamuts may affect such things as RGB and CYMK modes

Figure 6–17 Comparative gamuts of RGB and CMYK superimposed upon each other. Note the colors that can be made with CMYK and colors that are not available to RGB. The overlapped areas indicate colors that are common to both modes.

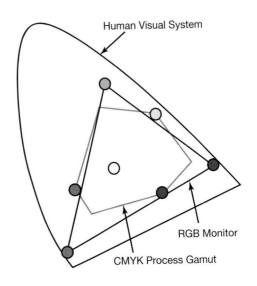

because each mode may have a number of colors that cannot be reproduced by the other system. [6.17] Color variations also occur among different monitors, printers, scanners, and papers.

Color matching problems arise from all of these variables. A *color management system* or CMS translates color in a precise way between the computer devices. Color management employs an objective manner of defining colors, namely CIE color. CIE color is based on a perceptual color model. Color information is translated by a color management system into the appropriate color selections in each color mode. Color monitors can also be calibrated with special software to standardize color settings and make screen display colors more accurate. Some graphic programs have color management settings for web graphics and U.S., Japanese, or European prepress.

Another tool for color consistency is viewing printed color under consistent lighting. Graphic design light booths can be set up for viewing color in balanced light. Adequate and consistent lighting is also helpful in areas where monitors are used in a design studio.

Computer color gives the artist more color choices than ever. A working knowledge of the color options contained in each graphic program is the foundation for successful manipulation of computer color.

ACTIVITIES

Objective: For the student to use the various computer color modes: RGB, CMYK, and HSB. The student will also learn some computer operations by making some simple color studies, using fills, blends, and gradients.

1. RGB, CYMK, AND HSB EXPERIMENTS

- Use RGB sliders to create white, black, gray, cyan, magenta, and yellow.
- Use the CYMK mode to make red, blue, and green. Use the sliders to make at least five light tints and five shades of different colors. Low percentages make tints and colors with percentages of black make shades. Mix complementary colors to make some neutrals.
- From the HSB mode, pick at least two different hues. Manipulate value and intensity, to make 10 to 12 variations on each hue. Place the colors on the swatches palette. Use the colors in two grid studies, a grid for each hue. The grids may have 4 x 4 square units making 16 squares, or 5 x 5 units making 25 squares. Repeat colors as desired. Use the rectangle tool and duplicate to make squares. Use the grid on your artboard as a guideline for placement. [6.18]

2. COLOR BLENDS

- Make complementary blends using the gradient tool. Lay out a rectangle of yellow and violet leaving a space in between. Drag the pure colors to the gradient bar to form a gradient between the two colors. Do the same for the blue/orange and the red/green dyads. You can also use the gradient tool for tint and shade blends. [Figure 6.16]

3. BEZOLD STUDIES

- Make a simple pattern with at least five colors. Use shape tools: a pencil tool for freeform shapes or a pen tool for structured shapes (either rectilinear or curvilinear) for parts of your design. The whole study should be filled with color. Make sure that you save your colors on the swatch palette.
- Duplicate the study on the same artboard. Use the same colors, but locate them in different parts of the study. Make a third design using the same colors and design, this time each area should have a gradient. [6.19]

Figure 6–18 HSB study. Variations on any two hues are mixed in HSB mode, saved as swatches, and then placed into a grid.

4. COMPUTER PAINTING

- Make a study using the paint options on your program or painting program.
- Pick five colors for your study and place them on the swatches palette. Use paint effects exclusively to make this study. Vary the brushes; use the airbrush, the blur, and the eraser tools. Make a study that is textural and does not look like it was made on the computer. [6.20]

Figure 6–19 Bezold effect studies are fast and simple when made with the computer. Copy and paste an original study and simply change colors and/or gradations to modify the overall appearance of color interaction.

Figure 6–20 Computer painting made with vector or bitmap program to experiment with drawing and painting tools, effects, and filters.

Part Two

DESIGNING WITH COLOR

Chapter 7

The Elements of Design

INTRODUCTION

Design elements, alternately called *art elements,* are the basic building blocks of art. *Design elements* are the visual tools utilized to create two-dimensional and three-dimensional art. Color is the most complex and variable of the all the design elements, as demonstrated in Part I. Each design element has its own distinct visual characteristics. A list of design elements includes line, shape, space, value, scale, and texture. Design elements provide us with a series of choices in the visual components of art. Design elements are a portion of the *form* component of art, the purely visual characteristics of art. The artist's challenge is to appropriately select formal design elements to address the subject, theme, and function of an artwork.

THE ABSTRACT CONCEPTS OF DESIGN

Wassily Kandinsky, in his book on art and design entitled *Point and Line to Plane,* 1947, compiled a list of abstract components of art and design that are the basis for all art elements. Kandinsky identified the four major ingredients of art as point, line, plane, and volume. [7.1] A *point* is defined as either a dot or a location in space. A point may be visible or invisible, of any size, and refers to a specific location in a composition. A *line* is a connection between two points, and can be thought of as a point or dot moving through space. A *plane* is a shape with height and width, but no breadth or depth. A plane is two-dimensional and flat, having any type of outer edge or contour. A *volume* is a plane that has been pushed back into or advances forward in space. A volume has three dimensions, height, width, and depth. In the following discussion of design elements, parallel concepts to point, line, plane, and volume will emerge.

146

Figure 7–1　The abstract components of design: point, line plane, and volume.

THE PICTURE PLANE

The *picture plane* is a formal rectangular or square unit used to contain a two-dimensional composition. Not all art is presented within a traditional picture plane, but the format of the picture plane is a given entity of art and design. The picture plane format aids in structuring our study of composition. By working within the confines of a picture plane we can begin to master compositional forces. A picture plane is the compositional window into which we see an artist's vision.

DESIGN ELEMENTS

Line

A *line* is a pathway, the closest distance between two points, the elemental mark, and a moving point. Lines and edges define our visual sense. We identify objects by innately scanning the contour of each object. Line represents the edge of a form, distance, a continuum, and a connector. Line is the trail left by pulling the point of a pencil or pen. *Line* is strictly defined as a mark whose length is greater than its width. The term *linear* refers to line or line quality.

　　　The variables of line are its width, direction, quality, position, and expression. As defined, a line's length must be greater than its width, but its width can range anywhere from slight to massive. The direction of a line is infinite and ever-changing. We tend to think of line as straight, so special attention must be put into variety of line direction. Line directions include straight, curved, zigzag, meandering, squiggled, angular, massed, spiraling, and overlapping. *Line quality* refers to the texture, media, weight, hand pressure, personality, and speed of a line. [7.2] An exploration of line quality may begin with simple word associations. The following list contains linear objects along with descriptive adjectives for the character of each line:

Figure 7–2 Line Direction. Line can vary in any directional path: straight, curved, squiggle, zigzag, scribble, etc. Line quality varies with hand pressure and media handling.

Object	Adjective
Tree branches	gnarled
Wire	taut
Leaf veins	branching
Highway lines	straight, curved, dotted
Circuitry	angular
Facial lines	fine, spreading
Wrinkles in fabric	undulating, smooth
Pipecleaners	fuzzy
Barbed wire	jagged

A similar descriptive list suggests appropriate media that will produce a large range of distinctive line marks:

Tight and delicate—ink
Bold and heavy—charcoal
Fast and blended—charcoal and graphite
High contrast—black ink with white chalk
Blurred and bled—ink into water wash
Personal lines—made from words, letters, shapes

Line position refers to a line's direction in relationship to the picture plane. Horizontal, vertical, and diagonal are the three major line positions. [7.3] Vertical direction suggests height, up and down, north and south. Horizontal direction suggests flatness, east and west, the ground, and the horizon. Diagonal lines can be in any direction, varying by 360 degrees. A diagonal can be an angle of any degree, radiating any direction, or be a stationary 45° angle. Diagonals form a compositional dynamic that suggests movement, speed, rotation, and convergence.

A line can also move through space three-dimensionally, either receding or advancing into the picture space, by convergence or gradation of width. An *actual line* is a physical line in three-dimensional space, for example, a wire or thin piece of wood in a sculpture. An *implied line* points to another line as its logical continuum, creating an invisible connection. [7.4] An implied line is a conceptual line that forms bonds between the parts of a composition.

Shape

When a line closes upon itself it forms a shape. A *shape* is a two-dimensional closed form or *plane*. [7.1] A shape can have any contour, height, and width, but no depth. A shape has mass or area defined by its edges. It can be outlined or solidified by being filled with a value, a texture, or a color. Shape is almost infinite in its variations.

There are several categories of shape. *Geometric shapes* are our standard shape vocabulary: circle, square, rectangle, ellipse, triangle, diamond, and pentagon. [7.5]

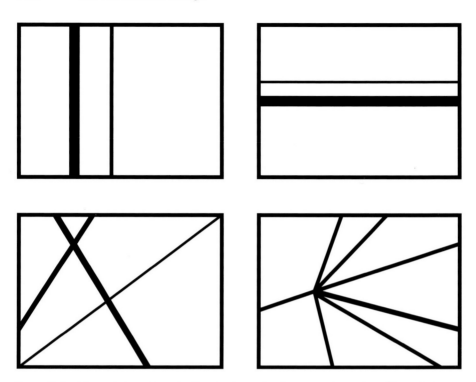

Figure 7–3 Line position refers to its direction in relationship to the picture plane. The main line positions are vertical, horizontal, and diagonal (also shown as "radiating" diagonals).

Figure 7–4 Line Continuity Study, student work by Kelly Mordaunt. Implied line forms a mental and visual connection between the parts of the composition.

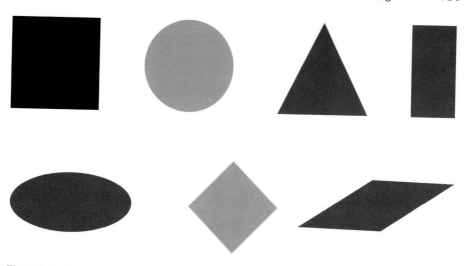

Figure 7–5 Geometric shapes are the standard shape vocabulary: circle, square, triangle, rectangle, oval, diamond, and trapezoid.

Figure 7–6 A rectilinear shape is formed from straight edges or contours.

Since geometric shapes form the archetypal shape vocabulary, they also serve as the building blocks for other types of shapes.

A *rectilinear shape* is made up of straight edges. Rectilinear shapes are angular in structure, and may be based on sections of squares, rectangles, triangles, or a combination of ruled lines. [7.6] A *curvilinear shape* is built primarily from curved edges. The contours of a curvilinear shape are derived from circles, ellipses, or freehand curves. [7.7] Curvilinear shapes have a sense of movement or continuity.

Art and design cannot be created in a vacuum. Art is always derived from and inspired by our surroundings. There are several categories of shapes that are reality based: namely organic (nature made) and mechanical (man-made). *Organic shapes* are those that are inspired by—but not a direct depiction of—nature. [7.8] For example, an organic shape could be derived and synthesized into a simplified shape from a flower, shell, or leaf. Mechanical or *man-made* shapes are inspired by man-made

Figure 7–7 Curvilinear shapes are formed from curved edges.

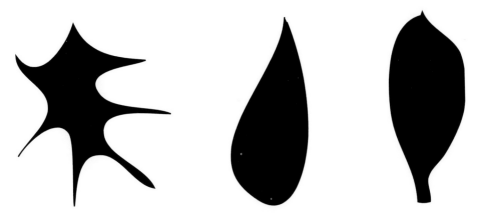

Figure 7–8 Organic shapes are those reminiscent of natural forms.

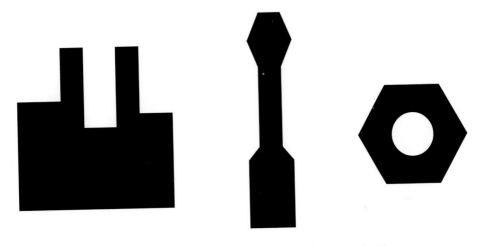

Figure 7–9 Man-made or mechanical shapes are those inspired by man-made objects.

Figure 7–10 Symbolic shapes are associated with cultural meanings.

objects, technology, architecture, tools, and so forth. [7.9] Everyday objects are potent sources of ideas for shape invention.

Symbolic shapes are those with cultural associations. A symbolic shape stands for an idea, such as a cross, a heart, a stop sign. [7.10] Symbols should be used with care in art because of their strong associations with specific ideas. The viewer receives a thematic message from symbolic shapes in an artwork.

Shapes can be invented and individualized with infinite variety. An *invented shape* is a unique shape formulated by an artist. [7.11] Any category of shapes can be a source for shape invention. Some students find it is easy to develop invented shapes, but others have a difficult time with shape invention. There are several strategies that aid the process of shape invention. *Addition* is a process of overlapping multiple shapes in order to synthesize composite shapes. [7.12] The process of *subtraction* also utilizes shape overlaps as a guide. Shapes are then sheared or subtracted in order to make new shapes. [7.13] By the process of *intersection,* shapes are overlapped, and a common residual area is extracted to produce a shape. [7.14] These strategies streamline the process of shape invention.

When a shape is placed in a picture space it takes up more mass or physical area than a line. This factor gives shapes an interdependent relationship with the picture plane. The area that a shape occupies is called the *positive space* or *figure* in a

Figure 7–11 Invented shapes can be made from any of the shape creations processes, or simply by instinct.

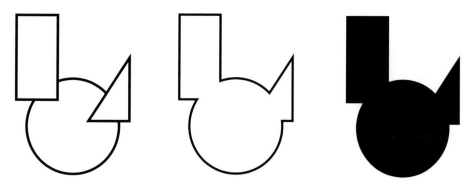

Figure 7–12 The additive process forms new invented shapes by overlapping and combining a group of shapes.

Figure 7–13 The subtractive process uses overlapping to create new shapes. In this case, the overlaps cut away to form a new shape.

Figure 7–14 The process of intersection uses only the area where two or more shapes intersect, which is sometimes called a residual shape.

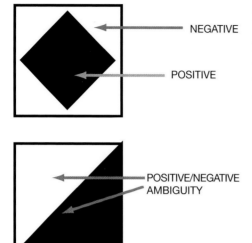

Figure 7–15 The relationship of shape to background. The shape is referred to as the positive space or figure and the background is called the negative space or ground. When this relationship is unclear, this creates positive/negative ambiguity or figure ground reversal.

composition. The area that surrounds the shape is called the *negative space* or *ground*. [7.15] When designing with shape, we need to be sensitive to both positive and negative spaces. The negative space, in some instances, can itself become a shape. When it is uncertain which compositional areas are positive and which are negative, this is called *positive/negative ambiguity*. [7.16] Positive/negative ambiguity is sometimes also called *figure/ground reversal*. Compositions with figure/ground reversal cause our eye to shift to the positive and then to the negative and back again. Positive and negative ambiguity sensitizes us to the manipulation of space in a picture plane.

Space and Form

Two main formats of art are either a two-dimensional or a three-dimensional structure. Three-dimensional work, such as sculpture or relief uses *actual* or *real space* and form. On a two-dimensional plane, however, space and form are created as illusions. *Space* in two-dimensional art hearkens back to the Renaissance notion of the picture

Figure 7–16 Figure ground reversal occurs in this pattern. Student work by Mimi Fierle.

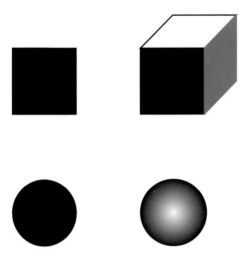

Figure 7–17 A shape is a plane with only two dimensions; a form is a volume with three-dimensions or the illusion of three dimensions.

plane as a window that views a three-dimensional world. Guidelines for creating illusionistic space are based on our visual experience of the world. Gravity, weight, scale, value, perspective, and color all factor into the illusion of three-dimensionality.

FORM A shape realized in three dimensions is called a *form* or a *volume.* To represent a convincing spatial illusion on a two-dimensional plane, flat shapes must first be transformed into volumes or forms. A plane or flat shape may be changed into a three-dimensional form or volume by the addition of the third dimension of depth. A flat rectangular shape, for example, can be made into a planar form by adding breadth or thickness. A curved or irregular shape acquires volume by gradated values called *modeling.* [7.17]

SPACE *Actual* or *true space* is used only in three-dimensional art such as sculpture and architecture. Illusionistic *space* is an art element with a high degree of complexity. To create an *illusion of space* on a two-dimensional plane, we must emulate the principles and distortions that the human eye sees in reality. Methods to create space range from simple to complex as follows: overlapping, diminishing size, vertical location, form and modeling, linear perspective, and atmospheric perspective.

The three levels of space are called *foreground, middle ground,* and *background.* The *foreground* contains the objects and space closest to the viewer. The *middle ground* contains objects and space that appear to be a medium distance away from the viewer. The *background* contains the objects that appear to be farthest away in space along with the distant space itself. Spatial levels can be thought of as three parallel planes of glass in layers that recede from the viewer. [7.18]

Ways to Create Space

The simplest method to create space on a two-dimensional plane is *overlapping,* that is, the visual placement of one object in front of another. Overlapping is a simple but extremely effective mode of constructing spatial depth. [7.19]

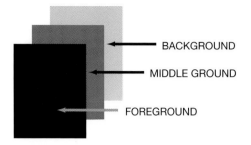

Figure 7–18 The three levels of space can be conceptualized as three parallel planes.

BACKGROUND

MIDDLE GROUND

FOREGROUND

Objects that are further away from us in space seem to recede in size. Because of our sense of size permanence, we instinctively know that objects are not actually smaller, but that the scale change is an illusion. The illusion of depth or scale in a picture plane can, therefore, be fashioned by *diminishing size,* by which objects become smaller as they recede into a larger surrounding space. When overlapping is combined with diminishing size, a stronger spatial illusion occurs. [7.20]

A large open space defined by a *horizon line* instantly implies a space with both gravity and depth. By adding a horizon line to a picture plane, the bottom section of the composition suggests ground and the area above the horizon line suggests sky. Objects placed in this imaginary space can be given gravity by resting them on the ground plane. Objects with gravity have to be correctly placed to form a spatial illusion. Placement in the "ground" area of the picture plane give an object a sense of gravity and location in space. Higher or lower vertical placement in relationship to spatial depth is called *vertical location.* [7.21] Vertical location means each object has a *base line,* which is located closer to the horizon line as the object recedes in the "space" of the picture. Vertical location emulates what we see in reality; objects placed closer to us are lower in our field of vision. Objects in the middle ground are thus located sequentially nearer to the horizon line as they recede. Objects in the background are placed higher in the picture plane, in relation to the horizon line, the farthest point in illusionistic space. Objects in the sky plane also must be correctly placed to enhance a spatial illusion. Objects in the sky area

Figure 7–19 Overlapping is the simplest way to imply a three-dimensional space.

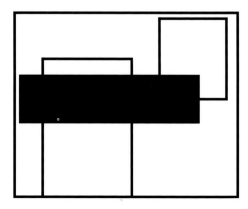

Figure 7–20 Overlapping combined with diminishing scale or size creates a stronger spatial illusion.

of the picture plane are larger at the top of the sky, becoming systematically smaller in scale as they are placed lower toward the horizon line. Vertical location in ground and sky planes is mirrored above and below the horizon line, which represents the farthest point in space. Objects meant to be weightless or floating are not subject to vertical location and can be placed anywhere in the picture plane.

Linear Perspective

Linear perspective is a system formulated during the Renaissance for accurate depiction of space. Perspective demonstrates how volumes appear to become smaller as they recede spatially, emulating the illusion formed by our eye. *Linear perspective* employs lines and vanishing points to represent diminishing sizes and recession

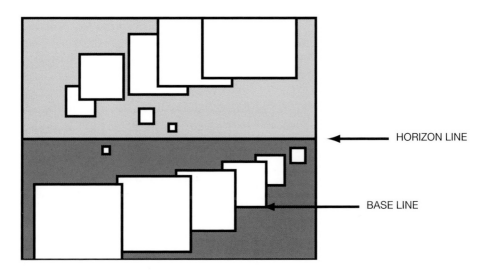

Figure 7–21 Vertical location refers to the placement of objects in a lifelike spatial situation. The objects in the foreground are lower in our field of vision; their base lines are lower in the picture plane. Note that this placement is mirrored in the sky area.

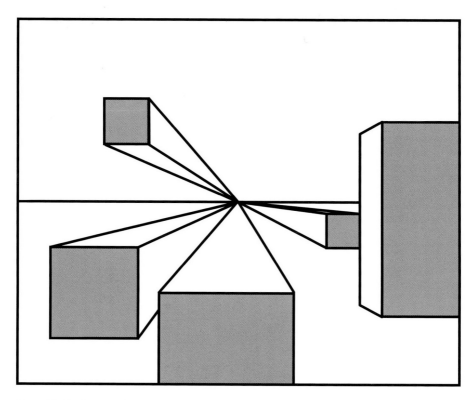

Figure 7–22　In one-point perspective, each object recedes to a single vanishing point that is always located on the horizon/eye level line.

of objects in space. Linear perspective defies logic. For example, we know that a box's dimensions are consistent in height, width, and depth, and are independent of its location in space. Objects, however, do appear to recede in scale toward points, which are called *vanishing points*. In one or two-point perspective, a vanishing point is placed on the horizon or eye-level line, which represents the farthest point in space. The *eye-level line* represents the viewer's height in reference to the objects. As objects recede into the background they also appear to become closer together and diminish in width. Guidelines for each object converge at vanishing points. *One point perspective* is the system used for objects that are placed perpendicular to our viewpoint, meaning that a flat surface of the object faces us. [7.22] In *one-point perspective,* each object's guidelines recede to a single vanishing point, to make, for instance, the front dimension of a box or a wall larger than its rear dimension.

　　Linear perspective can be generalized into two areas, exterior and interior perspective. *Exterior perspective* guides the depiction of objects in an open space. Exterior views depict either objects seen in a landscape setting or the outside surfaces of architectural objects. *Interior perspective* guides the depiction of interior spaces. Inside or interior perspective depicts an interior view of buildings or rooms in an architectural space.

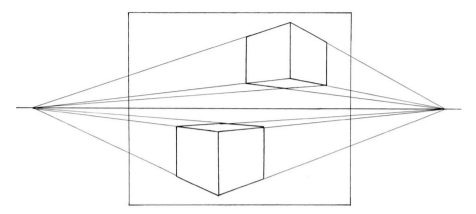

Figure 7–23 In two-point perspective, each object recedes to two vanishing points located on the horizon line.

Two-point perspective represents a view of objects or interiors that are located at an angle to our vision. For example, a box or building with its corner closest to us is depicted by two-point perspective. [7.23] An interior viewed diagonally is also represented by two-point perspective. Objects in two-point perspective are delineated with two sets of lines receding toward two vanishing points, which are located on the eye-level or horizon line.

ATMOSPHERIC PERSPECTIVE Atmospheric perspective is yet another way of creating space on a two-dimensional plane. The concept of *atmospheric* or *aerial perspective* identifies distinct differences that can be discerned among foreground, middle ground, and background objects in space. In reality, objects that are in the foreground have more detail, stronger light/dark value contrast, and brighter colors than distant objects. As objects recede spatially, they lose detail and become less distinct. Objects also tend to lose value contrast and color saturation as they recede into space. [10.16] When we view distant mountain ranges, for example, they tend to be lighter, grayer, or bluer than closer mountains. The atmosphere between the distant object and the viewer causes this illusion. For the artist, contrasting color, value, and detail is an effective way to depict space.

The artist can enhance a three-dimensional illusion by placement of objects in the extreme foreground. Large-scale objects in the foreground, which seem to obstruct our view, dramatize a spatial illusion. [7.24]

Scale

Scale is alternately referred to as either an art element or a design principle. *Scale* is the relative size of objects in an artwork. Scale can either represent depth or serve to organize dissimilar objects. Objects with similar scale will appear to visually unify.

Figure 7–24 Objects in the extreme foreground enhance a spatial illusion. Student work by Simone Theriault.

Value

Value is the range of light to dark steps of achromatic or chromatic colors. Value is a powerful tool for the compositional depiction of space, light, and form. Contrasting values can be controlled to impart volume to a flat shape by using light and dark areas or by using gradations of light and dark. A round, curved, or nonplanar form is given form by a smooth, even value change, called a *gradation.* A gradation bestows a curved object with volume by emulating the play of light across it. In contrast, an illuminated planar, flat-sided form has abrupt value changes defined by the edges of planes. [7.17]

Spatial depth illusion is most effective when represented by volumetric, modeled forms. Spatial illusion can be further enhanced by an overall value gradation. A value system that depicts space is simple and operates as follows: When a background space is predominantly light (in daylight) the foreground objects should be dark in value, gradually becoming lighter as they recede into space. [7.25] An alternate method is for foreground items to have strong value contrast, gradually becoming lighter and less contrasting as they recede into space. A similarly powerful illusion can also be established in an opposite value system. If the background is very dark (as at nighttime), the foreground objects should be light and gradually become darker as they recede into space. [7.26] The alternate method is to give the foreground objects strong light/dark value contrast, gradually letting them become darker and less contrasting as they recede into space.

Figure 7–25 A spatial value study. Note that the objects seem to recede into space as their values get lighter and have less contrast. Student work by Mimi Fierle.

Value can also be placed in an arbitrary fashion for variety, balance, or to highlight an area of interest in a composition. Placing values arbitrarily will help us understand which values recede, advance, or draw our attention in a compositional context.

Texture

Texture is the characteristic surface quality of an object, rough, fuzzy, gooey, and velvety are all words that describe texture. Texture is based on our tactile sense of

Figure 7–26 In this spatial value study, values recede into a dark background. Student work by Graysya Bush.

Figure 7–27 Texture experiments are ways to either depict or invent textures. Student work by Simone Theriault.

touch, but we also experience texture visually. The everyday visual environment informs our sense of texture; we usually know how something will feel solely by visual perception.

Actual or *physical texture* is real texture used in a work of art. Chiseled stone, polished metal, or sand added to paint are all examples of actual textures. *Simulated textures* are accurately rendered textures that create the illusion of being real textured surfaces. Illusionary texture makes use of an artist's rendering skills to exactly duplicate a texture visually on a two-dimensional plane.

Like line and shape, textures can also be individually invented. *Invented textures* are derived from visual ideas or descriptive words. [7.27] Adjectives that describe textures can help us create them: rough, smooth, fuzzy, glossy, and so forth.

Textures can be invented by media experimentation, applying media in unusual ways. Paints or dyes can be applied with sponges, toothbrushes, or pieces of board, or by using drybrush, impasto, or imprinted objects. Combinations of media can be used. Scraping off or erasing can be used to make visual textures. Actual textures can be made by building up surfaces with crumbled paper, pieces of board, tape, or modeling paste. Additions can be made to paint, such as sand. Patterning is also gives the illusion of texture because of the repeated images, marks, and motifs. [7.16]

Transferred texture is texture that is rubbed and assimilated from a surface. A thin paper stock is laid over a textured surface, and then rubbed with a wax

crayon, conte crayon, or graphite. The paper then picks up the texture underneath the paper. A similar effect can be obtained with paint by scraping; this method is called *frottage*.

Textures are a wonderful tool for adding visual variety, physicality, and interest to a composition. Since texture engages our tactile and visual sense and can be a particularly compelling part of an artwork.

The design or art elements are the basic visual tools used to create art. Each visual element has its own characteristics and complexity. Art elements are part formal study as well as a starting point for the comprehension of compositional forces.

ACTIVITIES

Note: All these studies are executed in the achromatic colors of black, white, and gray, so the student can focus solely on the design elements.

1. LINE EXPERIMENTS AND CONTINUITY STUDY

Objective: The student will explore the design elements of line through experimentation with line direction, width, quality, and media.

Media: Black, white, and gray media. Cut papers on 15" x 20" illustration board. Leave 2" to 3" border, and center the composition.

- Make various line experiments with black, white, and gray media (such as ink, graphite pencil, charcoal, gray and white chalks, and black markers) on white paper.
- The experiments should vary widely in direction, line quality, width, and media.
- Using the line experimentation examples that you have made, put together a variety of types of line into a collage.
- The lines should be connected, forming a collaged composition that has single or multiple pathways, using the principle of continuity (see Chapter 8) for unity.
- Try to connect all lines and make smooth transitions between thick and thin lines. Seen from a reasonable distance, the lines should seen to be drawn onto the board. Lines may go "off" the picture plane area. [7.28, 7.4]

2. INVENTED SHAPES

Objective: The student will make a variety of shapes: rectilinear, curvilinear, organic, and invented.

Media: Ink or marker on board.

- Make a vocabulary of shapes to be used for subsequent designs.
- Make at least five examples of rectilinear and curvilinear shape.
- Next, make at least five shapes of your own invention. These shapes can be reminiscent of organic or man-made forms or simply individualized invented shapes. Fill the shapes in with black marker or ink. [7.11]

Figure 7–28 Student line continuity study by Priya Patel.

3. POSITIVE/NEGATIVE REVERSAL PATTERN

- Using the concept of positive/negative ambiguity, design about ten in 2" square units. Each unit should have a shape that easily reverses between figure and ground. To increase your success, design these units next to each other. [7.29].
- The shapes can be invented or be additive or subtractive combinations of several shapes. The units can have equal or unequal amounts of positive and negative space.
- Choose two units to make a pattern, alternating each unit in a grid system. The overall effect should be a unified repetitious structure.
- The pattern may use simple alternation of units, or the units may be mirrored, reversed, or changed in direction. Use tracing paper to aid in this process.
- Use a tracing of the pattern to transfer it onto a board. The final pattern should have figure/ground reversal. Overall image size should be 8" x 10" to 10" x 12" on a larger board, leaving at least a 2" border. Choose size based on what works best for the pattern.[7.30] [7.16],

4. VALUE SPATIAL STUDY

Objective: To sensitize the student to spatial issues. The student will use value and spatial rules to create a spatial illusion.

Media: Black and white and mixed gray acrylic paint on illustration board. Picture area: approx. 8' x 11" to 10" x 14", with 2" border.

- Make an abstract design to demonstrate the illusion of depth, using linear perspective, overlapping, size contrast, value contrast, and/or atmosphere perspective.

Figure 7–29 Sample pattern units for positive/negative reversal.

Figure 7–30 Positive/negative reversal pattern. Student work by Branden A. Kautz.

- Use one of the shapes you have invented. Make it into a form by modeling, giving it depth and making it appear to be a solid volume.
- Set your forms in an illusionary space: an imaginary interior, an open space with a ground and sky, or as floating shapes in space.
- Use several grays, black, and white to emphasize the volume of forms and depth. As forms recede into space, make the values gradually less contrasting and closer to the value of the background. Values may be light in foreground and dark in background or vice versa.
- Plan your composition with value drawings before executing. [7.24, 7.25, 7.26]

Note: A ten-step gray scale must be completed previous to executing this painting. Use the gray scale as a reference for your final painting.

5. RECOVERED DESIGN (PROJECT ORIGINATED BY BRIAN DUFFY)

Objective: To develop the picture plane through the use of chance and intuition. To examine the effects of actual and implied texture.

- This project will have and almost urban archeological quality about it. It is reminiscent of old billboards along the highways, which have been neglected and weathered. Layers have been torn way from these billboards, making an interesting abstract composition.
- On a 15" x 20" board center and rule a 6" x 9" picture plane. In this area randomly glue 10 to 20 layers of color magazine images with a glue stick. Each layer can have one or several images. Areas of large type with images can also be used. Let the images overlap the edges.
- After several layers are applied, trim the edges, and then continue layering. Avoid too many representational areas.
- When all the layers are completed use a hand sander, an electric sanders, rasps, files, and knives to scrape, tear, sand, and gouge sections of the surface to reveal portions of the layers below.
- As you remove layers look for relationships which appear and affect the overall composition. You may add collage areas to aid the continuity of the composition.
- Trim composition and mat with white board. [7.31]

Figure 7–31 Recovered Design, Texture study. Student work by Jennifer Kopra.

Chapter 8

The Principles of Design

INTRODUCTION

Design principles are theoretical guidelines for the placement of design elements in either a two-dimensional or three-dimensional compositional space. Design process is composed of two major steps. First, there is the selection of the art elements we wish to use: line, shape, space, texture, and value and/or color. The second step in design process is the placement of the selected design elements in a picture plane, three-dimensional space, or other visual structure. The *design process* is thus the selection and placement of elements in a piece of art, guided by the compositional principles of design.

The design principles of unity, balance, emphasis, rhythm, or movement each pertain to different aspects of structuring a visual space. Design principles are necessary because the options for the placement of visual elements in a two-dimensional picture plane are virtually infinite. Imagine this visual problem: A series of compositions that contain only one design element each—one black shape on a white ground. Ground rules for this compositional problem are the following: the shape, a half circle, may only be used one time per composition and the only variables are placement and/or scale. How many different compositions can be made within these strict limitations? This illustration [8.1] shows that there are many options available even within a limited visual structure. Compositional solutions seem to go on infinitely, into an endless series of options, which can overwhelm the artist. Imagine a composition with every compositional choice available: every design element—line, space, shape, color, and texture—along with any placement structure factored into the visual equation. How do we know which compositions are the most visually effective? Design principles serve to provide perimeters for both the implementation and the evaluation of design. Unlike mathematical equations, design principles are theories meant to effect, not constrain, design alternatives.

ORDER AND CHAOS

Each area of human knowledge has its own rules, guidelines, theories, and information. Human nature requires visual order, structure, and harmony, causing us to

168

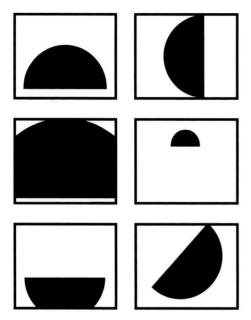

Figure 8–1 Design is about choices and possibilities. Shown here are several compositions made with a shape that has been used just a single time per composition. Only scale and placement have been varied. How many different compositions can be made within these limitations?

seek order in the visual information received by our eye and processed by our brain. When we cannot discern some measure of visual organization, we perceive only chaos. In art and design, there exists a fine balance between the order and chaos of visual information. Visual art engages the right side of our brain, which operates by intuition rather than logic. For this reason, some design choices are made simply because they "feel" right. The process of making art by instinct should be cultivated. Instinctive art is unencumbered by rules and can be thought of as actively using chaos. If our instincts are not grounded in solid knowledge, however, we are simply experimenting by trial and error. Artistic instincts are more effective when supplemented by knowledge of design theory, visual sophistication, and manual and technological skills. Compositional order is visually stable, but an excess of visual order can also form mundane and unstimulating design. In design, the balance between order and chaos may be shifted either toward order or chaos, or it may centered between the two.

GESTALT THEORY IN DESIGN

Gestalt is an interdisciplinary theory that has applications to psychology, therapy, memory, and visual perception. Three German psychologists, Max Wertheimer, Kurt Kofka, and Wolfgang Kohler, founded Gestalt theory in 1910. The word *gestalt* can be roughly translated from the German as *configuration*. Gestalt theory is based on

the idea of a whole that is inseparable from its parts. The whole of human experience and perception is thus acknowledged to be greater than the sum of its parts. Gestalt psychologists were interested in how human beings visually perceive and mentally organize information. Gestalt theory has significant applications for art and design because it involves the study of human perception—the eye as a receptor working in conjunction with the brain. Perception of a visual configuration, pattern, structure, or wholeness in art is the core of *Gestalt.* Gestalt defines the impulse that compels our inner search for visual structure and organization.

At the heart of Gestalt theory is an analysis of how the elements of a visual structure interact to form a whole unit. Max Wertheimer wrote about visual perception in his essay *Theory of Form* (1923). In this essay, Wertheimer asserted that our innate need for visual order causes us to perceive elements in cohesive groups. *Similarity* of scale, color, shape, or any commonality of art elements creates visual groups. Visual groups cohere because we perceive objects with similar visual characteristics as belonging together. [8.2] Dissimilar objects can be visually grouped simply by being close to each other—by being in *proximity*. We also percieve compositional order through the visual devices of simplicity, called

Figure 8–2 According to Gestalt theory, we tend to see objects in logical groups according to different criteria. In the top composition we may see the squares as one group and the circles as another. Objects of a similar scale, value, or in proximity, may also form groups. In the bottom composition, objects of the same value or shape form groups.

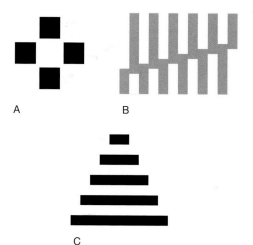

A　　　　B

C

Figure 8–3　Gestalt theory also suggests that we "fill in the blanks" visually when looking at art. Each visual structure can read as (a) four squares or a cross, (b) rectangular shapes in a pattern or a diagonal based shape, (c) lines or steps.

economy and *continuity,* which refers to the visual connection of elements in a composition. According to Gestalt theory, the manner in which parts of a composition interact effects our perception of them. Our mind forms visual connections, to logically "fill in the blanks," even with a small amount of visual input. [8.3] Gestalt psychology establishes organizational theories that bolster the principles of design.

Design Principles—Unity

Unity is a design principle that has conceptual parallels with Gestalt theory. *Unity* is how a composition holds together, the way that parts of a composition visually cohere. In a unified composition, the interaction of elements forms a configuration so interdependent that it holds together visually. Unity is alternatively referred to as visual *harmony:* Compositional components must harmonize in order to integrate. Unity is considered to be the most important design principle because visual harmony is essential for a successful piece of art. The compositional elements are unified by two principal methods: either by thematic unity or by visual unity. *Thematic unity* is use of a single unifying idea or theme in a piece of art. For instance, if the theme of an artwork was love of a pet dog, pictures of the dog could be collaged together, along with his leash, pictures of his favorite chew toys, pictures his favorite people, and a label of his favorite dog food. Although this collage might have thematic unity because of a single idea used throughout, it may or may not have visual unity. *Visual unity* is the method by which we harmonize or visually "glue" together a composition. Visual unity is dependent on a visually coherent selection and placement of elements in a composition. The following are some simple guidelines that will aid in formation of visual unity.

Ways to Create Unity

REPETITION The first way to achieve visual unity in a composition is through the use of *repetition*. Repeating any art element or concept enhances cohesion in a design, due to our innate recognition of similar visual elements. When we perceive repetition in design, our mind interprets it as a pattern or configuration. Nature is full of repetitive elements, so we see repetition as a meaningful visual structure. Repetition of visual elements is evident in the natural world—in the patterns of tree branches against the sky or the repeated textural markings on a shell.

To unify a composition, one or more art elements can be repeated—line, form, shape, value, color, and texture. For instance, a shape, such as a triangle, may be repeated to give automatic unity to a design. Conceptual design elements, such as position, direction, or scale, can also be repeated in a composition. [8.4] For example, the same direction can unify otherwise disparate elements in a design. Perfect repetition of art elements produces a configuration called a *pattern*. A pattern repeats the same formation endlessly in any direction. A pattern has perfect unity, but inspires limited interest compositionally due to its predictable nature. [7.30]

VARIETY Like too much organization, too much repetition in a design can be visually dull and monotonous. To make repetition more visually exciting, it can be paired with a design principle called variety. *Variety* is the differentiation or variation of an element in a repetitious visual structure. In a repetitive design with vari-

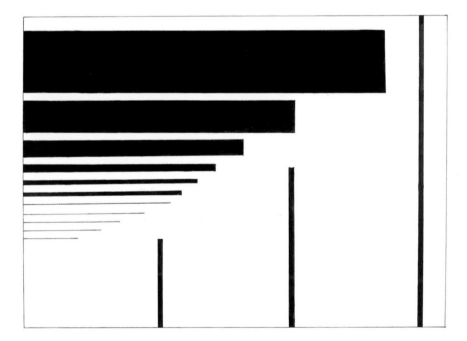

Figure 8–4 Repetition of direction. In this case verticals and horizontals visually hold together different line widths. Line position/proximity study. Student work by Allyson Carreon.

Figure 8–5 This composition has repetition of position and shape, with variety of value and scale. Student work by Liza Palillo.

ety, a visual element such as line is repeated, but some aspect of the element is varied—different line widths and positions spark visual interest. Examples of repetition paired with variety include the repetition of shape and scale with variety of position, the repetition of position with variety of shape, or the repetition of shape with variety of value and scale. [8.5] A highly repetitious composition uses order; a more varied composition leans toward chaos. A high degree of variety is more difficult to unify, but will appear to be more instinctive. Conversely, a high degree of repetition is easy to unify, but more difficult to make exciting.

SIMILARITY Similarity is a concept that corresponds to repetition. According to Gestalt theory, when we perceive *similarity* in a design, our eye picks up a pattern or configuration of similar elements. For instance, even though squares and circles function together compositionally, we may see the squares as a separate grouping from the circles. In another instance, elements of similar value may form visual groups. [8.2] The same idea applies to similarity of scale or position. An innate visual grouping of any common visual characteristic adds to compositional unity.

CONTINUITY An excellent method to achieve visual unity is through continuity. *Continuation* or *continuity* is a visual pathway through a composition. A pathway can be physically connected or have an implied connection (such as an implied line) between elements of a composition. [8.6] Continuity is especially helpful in connecting disparate elements of a highly varied composition. A line of continuity

Figure 8–6 Continuity is a visual path through a composition, which serves to unify.

provides a "roadmap" that allows a viewer to move through a composition. Any type of pathway can be applied for continuity—smooth and flowing or jagged and circuitous. Continuation holds the objects in a visual pathway together, either in an obvious or subtle manner.

PROXIMITY *Proximity* is a method of visually organizing elements into groups in a composition. According to the Gestalt concept, when objects are grouped together, they seem to relate visually. [8.7] Negative space around elements may aid us to see them as a group, or the whole composition can be filled with the grouping. By using proximity, disparate elements in a composition can be united. Our eye sees proximity groupings as cohesive units because of the physical closeness of their positions.

Guidelines for achieving unity can be used singly or in conjunction with each other to produce compositional harmony.

ECONOMY

Economy is a design strategy that uses a minimal amount of visual information. Economy is related to the concept of *minimalism,* in which "less is more" visually. Extreme economy of means or elements sets up a compositional challenge for the

Figure 8–7 Proximity is using the close positioning of elements in artwork to unify and organize a composition. Shape, Emphasis, Study. Student work by Alicia King.

artist. Economical compositions are, however, often visually arresting and bold due to extreme simplicity and clarity of thought. [8.8] Economy is an effective means of paring down the design process to its barest elements.

DESIGN PRINCIPLE—EMPHASIS

The design principle of *emphasis* pertains to the establishment of a specific area of interest in a composition. Emphasis is synonymous with the concept of a *focal point* in art. A focal point is not as essential to design as unity, but an artist may want to

Figure 8–8 Economy is the use of a minimal number of elements to structure a composition. Student work by William L. Otis, Jr.

emphasize a specific place in an artwork to enhance a particular image or theme. A composition with a focal point must provide the viewer with visual clues to direct the eye to the area of focus. Several points of emphasis in a composition can all be of equal importance, or one point can be primary, one secondary, and so on. The following are methods to establish a point of emphasis in design.

Ways to Create Emphasis

CONTRAST The first way to create emphasis in design is to develop some type of visual contrast. Our eye naturally focuses on whatever portion of a composition visually stands out as being different, unexpected, or contrasting within the entire composition. A *contrast* must visually oppose its surrounding environment in some sense. For example, a light value shape in a predominantly dark composition constructs a point of contrast. Any art element may be purposely contrasted with its surroundings—line, shape, color, form, texture, and so forth. For example, a dark shape may be contrasted with a light line environment, a textured area contrasted with an area of solid shapes, a three-dimensional form contrasted with an environment of flat shapes, or a flat shape contrasted with a three-dimensional environment. [8.9] Design concepts such as scale, position, and complexity may also be contrasted to identify a focal point. For example, a light value complex form in a darker and simple environment, a large simple form in an environment of complex textures, and a diagonal placement of a dark shape in an environment of light vertical lines all present this type of contrast pairs. A point of visual contrast is also called an *anomaly;* an unexpected change in a visual structure. [8.10] An anomaly draws our eye because it is an unpredicted departure from the pictorial structure.

ISOLATION A straightforward method of producing a focal point is use of the concept of *isolation.* To isolate an area or specific item in a composition, it must be physically separated from other elements in the design. This can occur in one of two ways. First, a compositional object may be isolated in a large area of negative space, set adrift, so to speak. [8.11, see page 178] In this type of isolation, the *negative space* operates as a buffer to keep isolated element(s) from interacting with the other parts of the composition. Second, surrounding an element within a shape or area isolates an element by *enclosure,* which is akin to circling or outlining the object. [8.7] The methods of isolation by using negative space or enclosure produce a solitary element that becomes a visual point of attention in a composition.

DIRECTION *Direction* is the usage of the directional forces of shapes, lines, position, or forms to create an area of emphasis. Direction also employs implied lines that operate as visual forces or pathways, which guide our eye to specific areas of interest. Our eye can be directed to a point of emphasis in either an obvious or subtle fashion. Elements that are nearly touching in a design form a type of visual tension. Visual tension strongly focuses attention to a particular area of a composition.

A focal point may be located anywhere in the picture plane. It is risky, however, to position a point of emphasis directly on an edge or close to a corner of the picture plane. Either of these placements can result in a balance problem or may

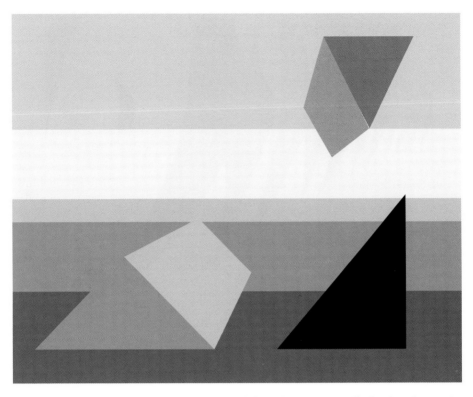

Figure 8–9 Emphasis through contrasting shape with form. Our eye goes to the flat shape because it contrasts with the space of the composition.

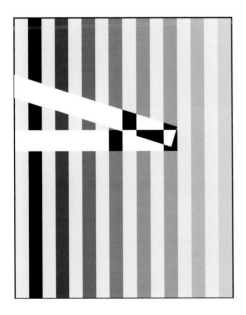

Figure 8–10 An anomaly in design is an unexpected element that stands out as a departure from the visual structure.

Figure 8–11 Emphasis is created by isolation. Shape, Emphasis, Study. Student work by Merrill Rose Stephens.

Figure 8–12 The directional force in a composition can create emphasis and tension points.

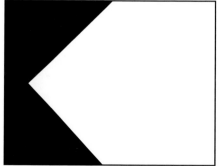

inadvertently lead the viewer outside of the composition. Conversely, a focal point should not be consistently placed in the center of the composition. [8.12] The center of a picture plane has the highest stability, but also can be a predictable location for a focal point. Since taking risks is an integral part of good design, locations of focal points should vary.

•

DESIGN PRINCIPLE—BALANCE

The design principle of balance is an essential component of any work of art. *Balance* is the equal distribution of visual weight in a piece of art. We all have an inner sense of visual balance, weight, and symmetry because of the movement and symmetry of our bodies. Awareness of our own balance and weight occurs as we walk, ride bicycles, carry heavy objects, and so forth. To achieve balance in design, we must first understand the concept of visual weight. *Visual weight* is the relative visual impact or importance of art elements and their characteristics in a composition. Art elements or art concepts have disparate visual weights. Complexity, texture, dark value, and large scale all have innate visual weight. [8.13] Visual contrasts that attract our attention have visual weight, such as the contrasts found in different values, scales, positions, and or spaces. [8.14] Art elements that contrast with their visual environments, such as a textured area within a smooth area, a dark element within a light-value environment, and a modeled form within lines, have visual weight.

For the analysis of balance in a picture plane, an axis can be placed in the center of the picture plane to divide the composition into two halves. A picture plane subdivided by an invisible axis vertically, horizontally, or diagonally helps us to assess visual weight on either side of the axis.

Symmetry

Symmetry is formal balance, or perfect balance, vertically, horizontally, or diagonally on either side of the central *axis* of a composition. [8.15] In a symmetrical composition, elements on each side of the central axis are perfectly equal. When compositional

Figure 8–13 Elements with visual weight include those with dark value, complexity, large scale, and texture.

Figure 8–14 Contrasting elements carry visual weight. As shown here: (a) value contrast, (b) scale contrast, (c) position contrast, and (d) shape/form contrast.

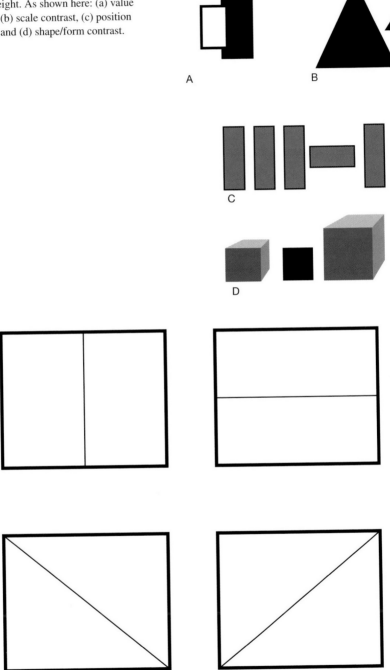

Figure 8–15 The picture plane can be divided vertically, horizontally, or on either diagonal to assess balance. The central line is called an axis.

Figure 8–16 Symmetry is formal or perfect balance.

elements are mirrored on either side of the axis, the axis is called the *line of symmetry.* A line of symmetry is the center of formal balance in either two-dimensional or three-dimensional designs. We all have an inner sense of symmetry, as our bodies are essentially symmetrical in form, which makes symmetry feel "right" as perfect balance. However, symmetry can be static and predictable if applied consistently as a compositional structure, since it is a stable visual structure that yields balance easily. [8.16]

Asymmetrical Balance

Asymmetrical balance, also known as *informal balance,* is the balance of elements that have unequal visual weight. Using asymmetrical balance sensitizes us to comparative visual weights. We must carefully consider the placement of unequal elements in the picture plane. Asymmetrical visual compositions can be equalized by the thoughtful placement of visually heavy elements. In this manner, the visually "light" half of a composition can be weighted to compete with the "heavy" half of a composition. Sensitivity to elements and contrasts with visual weight aids in our mastery of compositional asymmetry. In this example, a large-scale simple element is balanced by a dark value complex element. [8.17] Here, a dark value complex line element is balanced by a focal point established by direction and isolation. [8.18]

Placement in the picture plane also is a factor in an element's visual weight. Elements located near the bottom of a picture plane seem heavy. The same elements become lighter when placed at the top of the picture plane. [8.19, see page 183] This visual sensation is a result of our intuition about the gravity of objects.

Crystallographic and Radial Balance

Other forms of compositional balance include *crystallographic balance,* which is a pattern or subdivision of the picture plane, such as a grid, to achieve balance.

Figure 8–17 Asymmetry is also called informal balance. Here, a dark, small-scale complex shape balances a large-scale, light element.

Figure 8–18 Balance by direction. The heaviness of the left side is balanced by the directional force to the right.

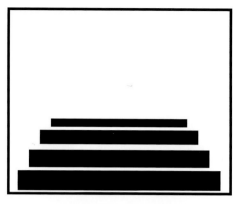

Figure 8–19 Objects at the bottom of the picture plane innately have more weight due to our sense of gravity. Notice that the elements can be made lighter in visual weight by moving them upward in the picture plane.

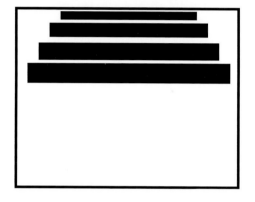

Crystallographic refers to an interlocking crystal-like formation that integrates the positive with the negative parts of the composition, forming positive/negative ambiguity. [8.20]

A simple form of balance is *radial balance,* which employs radiating or emanating forms from a given point or area. The "vortex" of radial balance can be located virtually anywhere in the picture plane and still maintain compositional balance. [8.21]

Figure 8–20 Crystallographic balance is based on some type of interlocking structure.

Figure 8–21 Radial balance. All the compositional forces radiate from one or more points. Movement Montage. Student work by Cathy Van Galio.

Instinct plays an important part in all art, particularly in the design principle of balance. We sometimes innately "feel" that objects are misplaced, too heavy, complex, dark, and so forth. The guidelines outlined here are meant to supplement our visual instincts, not replace them.

DESIGN PRINCIPLES—MOVEMENT AND RHYTHM

Movement

The design principles of movement and rhythm are separate yet interconnected concepts. *Movement* is both *literal* and *suggested* motion in a work of art. There are also art forms that use *actual movement,* such as kinetic art and video. In installation art, for example, the viewer's actual movement through the art piece may be a factor in the impact of the piece. Artists also employ various means to depict motion in a static piece of art.

Frozen motion expresses movement by the image of an animated object, such as a human body, caught in motion, our mind's eye filling in the "before" and "after" of the narrative. Motion can also be expressed by *blurring,* which suggests action or speed, as in a photograph of a moving object. Superimposed *sequential views* of an object moving through space also yield an illusion of movement.

GRADATION A gradation or gradient also indicates movement. A *gradation* is any type of gradual visual change that suggests motion. The sequence of a gradation is a primitive form of visual animation. [8.22] Scale, shape, color, position, texture, value, and color can all be gradated. A gradation implies movement because it sim-

Figure 8–22 A shape gradation suggests movement. Student work by Michelle Priano.

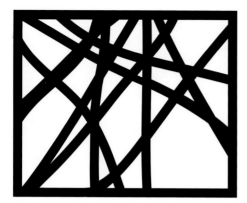

Figure 8–23　Repetition as well as diagonals suggests movement.

ulates time: before, during, and after—are all contained in one composition. Our eye follows a gradation to its logical ending, as it presents us with a logical progression. A gradation can also lead the eye to a focal point.

DIAGONALS　Diagonals suggest directional force in a composition because they convey an innate sense of movement. [8.23] Diagonals that radiate from a given point, for example, move our eye both into and out from that center point. On the other hand, compositions based on horizontals and verticals, like a grid, have a high degree of visual stability.

Rhythm

Rhythm is a concept that corresponds to movement but has some distinct differences. *Rhythm* is a *visual* quality of movement, a pulsation in our eye's perception of a work of art. Visual rhythm thus describes the manner in which our eye moves through a composition.

Rhythm is a term describing the essential beat and time structure of music. When an artwork possesses visual rhythm, it has a visual beat or repeating element that creates movement. A repetition of a similar direction, for example, might cause our eye to move through a composition in a systematic way involving our kinetic sense.

Two main types of visual rhythm are *staccato* and *legato,* terms that are borrowed from music. *Legato* rhythm in music is a sustained or unbroken sound, smooth and connected. Visual *legato* rhythm is a smooth unbroken path through a composition. [8.24] *Staccato* rhythm in music is a percussive on and off sound or beat. Visual *staccato* rhythm is a broken on and off configuration of separate repeated parts, a visual beat. [8.25] *Alternating rhythm* is achieved by alternating two or more rhythmic structures that interact together in a composition. The alternating structures may be either interlocking parts of *staccato* and *legato* rhythms or layers, each with a different type of rhythmic structure.

Progressive rhythm employs a radiating or gradating progression to express rhythm. [8.26] Progressive rhythm correlates with radial balance, because forms

Figure 8–24 *Legato* rhythm is a smooth fluid rhythm.

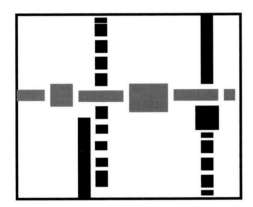

Figure 8–25 *Staccato* rhythm is an on and off broken rhythm.

Figure 8–26 Progressive rhythm emanates or gradates from a given point. Student work by Alicia King.

emanate from one or more points. A visual analogy for progressive rhythm is a rock thrown in a pond, ripples emanating in circles from the splash point of the rock. A gradation also forms progressive rhythm because it represents a visual chain of events. We follow a gradation, compelling our eye to move through a composition. A gradation sequence sets up a visual rhythm because gradual changes seem to encapsulate time.

Compositional excellence is achieved by the simultaneous engagement of manual, intellectual, and visual processes. Design principles are guidelines for visual structures, each principle emphasizing a different approach to composition.

ACTIVITIES

1. LINE POSITION PROXIMITY STUDY

Objective: For the student to understand the relationship of line position to the picture plane. Unity through the repetition of direction, line width, and continuity should be considered. Proximity of line groups can also be put into use.

Media: Marker on hot press illustration board.

- Using only straight ruler lines of different widths, make a composition of vertical, horizontal, and/or diagonal lines. The lines should divide the picture plane.
- The concepts of unity to be used are repetition (of the line element), proximity, and variety. Lines can be grouped in several areas, adding areas of interest. All positions vertical, horizontal, and diagonal lines can be used, but you may want to select only two or three choices. Diagonals can vary by 360 degrees, but be careful to use some position repetition to organize the composition.
- There may be heavy black lines showing little white space, or the lines can be white against black. The main concept is to create a unified composition with as much variety as possible.
- Do several thumbnail sketches first, then draw one choice up to size on tracing paper and transfer it onto a board.
- The final piece should be accurately inked with marker. [8.27][8.4]

2. SHAPE EMPHASIS STUDY

Objective: The student will use invented shapes to create a visual point of emphasis in a composition. A structural manipulation of positive and negative areas will produce a strong composition.

Media: Cut black shapes on white illustration board.

- Create a shape with an interesting contour that is invented, or pick one from the group of shapes that you invented for Chapter 7 Activity. The shape may be curvilinear, rectilinear, or a combination of both.

Figure 8–27 Line Position Proximity Study. Student work by Amy Claroni.

- The shape should be varied in scale either by drawing it in different sizes or by changing the scale on a photocopier.
- Cut several shapes of different sizes out of good black paper. Use the shapes to make a collage, creating a point of emphasis at the same time. Carefully design the positive and negative compositional space.
- A point of emphasis can be established by the use of isolation, direction, scale contrast, position contrast, and so forth.
- The composition can be varied by the reversal of shape, overlapping, and cropping. Try to use only asymmetrical balance for this study. [8.28][8.11][8.7]

3. ECONOMY STUDY

Objective: To use and understand the concept of economy in a figure ground relationship.

Media: Cut out white shapes on a black ground made with black paper, all presented on illustration board.

- Use the same shape as in number 2 (above) to create a study that explores the concept of economy.
- The shapes of different sizes should be white shapes on a black ground for this study.
- Create a study using extreme economy of means. In this piece you should use five or less repetitions of the shape. The shape may be of any scale.
- The composition should be well designed, with thought put into the placement of the few shapes and figure/ground relationship.
- This study should be substantially different from the shape emphasis studies. [8.8]

4. TEXTURE EXPERIMENTS

Objective: To experiment with media to make simulated, invented, physical, and transferred textures.

- Use black, white, and gray media to make invented textures. Make a list of descriptive words for textures, such as: bumpy, jagged, stippled, to inspire textural variety.
- Carefully make some of the textures into patterns. Make others by experimenting with media. Imprinting some objects, using various materials dipped into ink, such as string, wire, and sticks.
- Try painting and scraping away layers of acrylic paint. You can make frottage from objects by laying lightweight paper on a textured object, painting with heavy paint, and then immediately scraping away the paper to transfer texture.
- Build actual textures by gluing small objects to a surface and painting them. A physical surfaces can be built up with layers of paper, tape, modeling paste, impasto paint, self-drying clay, foam core that is carved, and styrofoam, and so forth.
- Use paper to make some transferred textures by placing the lightweight paper on a textured object, such as heavy wood grain, coins, and ridged vents, and rub the paper with a graphite stick or a wax crayon. [7.27]

5. TEXTURE PHYTHM STUDY

Objective: The student will use experimentation with texture, to create a rhythmic visual structure in order to understand the design principle of rhythm.

Figure 8–28 Emphasis study. Student work by Darlene Mastrangelo.

Media: Mixed media in black and white and gray. Paint, drawing media, and textured surface, on illustration board.

- Use the concept of rhythm to create a composition. Keep in mind the use of repetitive elements to keep the eye moving throughout the composition. You may use *legato, staccato,* alternating, or progressive rhythm.

- Parts of this composition are to be made with various textures in black white and gray media. You can use the invented textures that you made for number 4 (above). Or you can use actual textured surfaces, transferred textures, and patterns.

- The textures should be inset into your rhythmic structure. Some textures can be repeated to emphasize visual movement within the piece.

- The final study will be a collage that has a rhythmic design and uses some combinations of textures in all areas of the composition.

- The piece may be made in a traditional picture plane or have an alternative shape. [8.29][8.26]

6. MOVEMENT MONTAGE

Objective: To design and create the illusion of movement.

Media: Cut photocopies on board

- Find several images from magazine photos that strongly suggest motion, frozen motion, or blurring. Or the nature of the form should suggest innate movement.

- Make ten back and white photocopies of one of the images.

Figure 8–29 Texture study. Student work by Amberly Strzalka.

Figure 8–30 Movement Montage study. Student work by Priya Patel.

- Make a montage using all ten photocopies in whole or in part to express the design principle of movement. You may overlap or cut apart the image, or use the whole image.
- The final piece should be an abstract version of the original image using the repetition of the image to convey an overall sense of motion.
- The motion study can break free of the traditional picture plane format and be a defined or irregular shape. [8.30][8.21]

Chapter 9

Color Schemes
and Harmonies

INTRODUCTION

The goal of a color scheme is to provide *color harmony,* meaning a combination of color "notes" which are visually pleasing when presented together. Color schemes are guidelines for the selection of harmonious colors. A color scheme provides an artist with a framework for choosing base hues, which are then varied by value, saturation, or proportion, to form a set of harmonious colors. A color scheme is meant to be flexible, its guidelines are subject to the personal preferences of the artist or designer. Color harmonies free the artist or designer from routine color choices and provide a starting point for an exploration of color groups.

Standard formal color schemes are all based on programmed hue selections from the color circle. Each scheme uses the layout of the color circle as a guide for each particular type of color harmony. Formal color schemes were developed to aid in the selection of harmonious groups of colors for particular artistic purposes. Even within the restrictions of a color harmony, there is freedom of color choice by variation of hues and proportion of colors in a composition. Each type of color harmony has its own personality, but color schemes can be customized to an artist's preference and intent. Formal color circle-based color schemes are standard, but an artist can apply informal color schemes with looser guidelines.

Formal color schemes/harmonies are classified in three areas: simple color harmonies, opposing/contrasting harmonies, and balanced harmonies. *Simple harmonies* are color schemes based on a small number of neutrals or hues. *Opposing/contrasting harmonies* have their foundation in the concept of opposite hues or hue temperature contrasts. A *balanced color harmony* is a color chord with hue selections that are spaced apart on the color circle.

The following color schemes are formal/standard harmonies commonly used in fine art and design. Color schemes with the most color repetition are highly harmonious because such schemes lead to visual unity. As general rule, color schemes with fewer hues lead to greater color harmony. A wide array of hues makes color harmony more difficult to achieve.

SIMPLE COLOR HARMONIES

Simple color harmonies are based on neutrals, a single hue, or a group of neighboring hues. The advantage of a simple color harmony is its high degree of color harmony; its disadvantage is less color variety.

Achromatic Harmony

An achromatic color is a neutral containing no hue. A chromatic color is a color that contains a distinct and discernable base hue from the color circle. An *achromatic color scheme* uses only achromatic colors: black and white and a full value tonal range of grays. [9.1] Achromatic colors also can be chromatic neutrals from complementary mixtures or muted earth colors with black and white. Achromatic schemes are very harmonious and must have light/dark value contrast for variety. An achromatic harmony is characteristically subtle and quiet in nature. Cubist paintings utilized achromatic harmony to depict planar forms. [12.8]

Monochromatic Harmony

A *monochromatic color scheme* is built upon a single hue selection from the color circle. Hue variation demonstrates the many color alternatives available in a monochromatic color scheme. A blue monochromatic scheme, for example, may include pure blue; slightly warmer or cooler blues; tints, shades, and tones of blue; and blue intermixtures with other hues. By remaining within the blue range, the resulting group of colors is very harmonious. [9.2] The disadvantage of this color scheme is the lack of hue contrast; it has only value and saturation contrast. Monochromatic

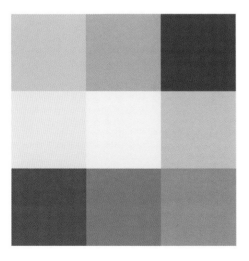

Figure 9–1 An achromatic harmony is an example of a simple harmony. It uses colors with low or no chroma.

Figure 9–2 A monochromatic harmony has variations on a single hue, such as blue. The hue variations on blue, for example, could include slightly more BG or BV versions of blue, along with tints, shades, and tones of blue.

color schemes are extremely unified, set a strong color mood and convey the personality of each individual hue. Pablo Picasso's blue period, for example, is characterized by his almost exclusive employment of blue variations. The painting *La Vie,* for example, sets a color mood by its monochromatic palette, which is in sympathy with its somber subject matter. [9.3]

Figure 9–3 Pablo Picasso (1881–1973; Spanish, produced in France), *La Vie,* 1903. Oil on canvas. 196.5 x 129.2 cm ©2002 The Cleveland Museum of Art. Gift of The Hanna Fund 1945.24. Picasso's blue period was characterized by his dominant use of a monochromatic blue color scheme to enhance the melancholy subjects of the paintings.

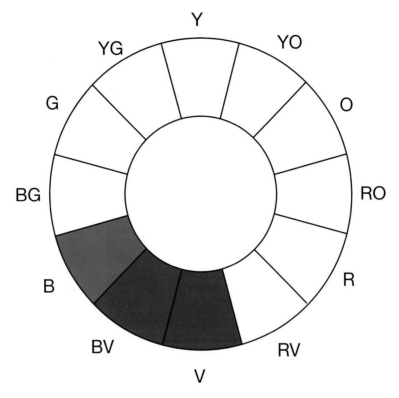

Figure 9–4 Analogous harmony is formed from an adjacent group of two to three hues from the color circle.

Analogous Harmony

An *analogous color scheme* is based on the concept of a color family. Analogous hues are two or three neighboring hues from the color circle. An analogous color scheme begins with two to three hue neighbors as its basis, for example, blue, blue-violet, and violet. [9.4] Analogous harmony is an expansion on a monochromatic system, providing the artist with more hues than other simple color schemes. Most analogous harmonies are low in hue contrast, the exception being a harmony of yellow-orange, yellow, and yellow green. The hues of any analogous color scheme may be intermixed, tinted, shaded, toned, and slightly modified with other hues. [9.5]

Simple color schemes can be thought of as "layman's" color harmonies because they are safe, harmonious, and likable. Clearly, each simple color harmony has its own distinctive personality. An achromatic scheme is cool, neutral, peaceful, or has high value contrast. Monochromatic or analogous schemes are very harmonious and emphasize visual unity. However, any one of these color schemes may be used in an atypical manner to produce unusual effects.

Figure 9–5 A group of analogous harmonious colors based on R, RO, and RV, along with tints, shades, and tones of these hues.

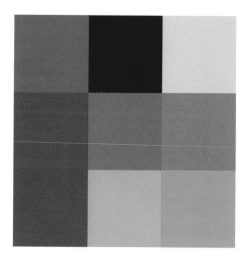

CONTRASTING OR OPPOSING HARMONIES

Opposing or *contrasting color harmonies* maximize hue contrast. These color harmonies tend to generate a lot of visual excitement.

Complementary or Dyad Harmony

A *complementary* color scheme is a perfectly balanced opposing pair (or dyad) from the color circle. Complements are hues positioned directly across the color circle from each other. [9.6] Commonly used dyads have one primary and one secondary hue as follows: blue and orange, red and green, and yellow and violet. There are also three tertiary dyads: red-orange opposing blue-green, red-violet opposing yellow-green, and blue-violet opposing yellow-orange. Complementary pairs neutralize each other when mixed. When placed together, full saturation complementary hues will cause a visual effect called complementary vibration.

A complementary pair as a color scheme produces a great deal of visual contrast and interest. A dyad can also be the starting point for a soothing group of neutral or partially neutralized colors called *chromatic neutrals.* A complementary harmony includes pure hues, such as yellow opposing violet, and then tints, shades, or tones, and their intermixtures (chromatic neutrals). [9.7] Color proportion of one complementary hue to another may be equally balanced or one hue may be chosen to dominate a composition.

The complementary color scheme is the yin/yang of color harmony, expressing polar opposites through color, yet balanced by its foundation on the three subtractive primaries. A complementary harmony, although it emphasizes contrast, may

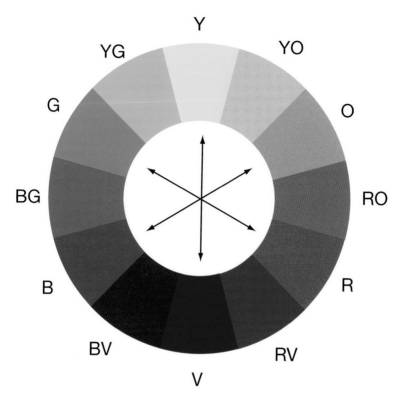

Figure 9–6 Complementary harmonies are based on opposing hues on the color circle. Red–green, orange–blue, and yellow–violet are complementary pairs.

Figure 9–7 A complementary harmony using the red–green complement in a line study (computer illustration). Student work by Michelle Brzezowski.

range from subtle to vibrant, expressing color harmony or movement by complementary vibration. Pure complementary hue pairs are characteristically vibrant and visually "loud" but also can be muted and enriched by the quality of chromatic neutrals. Our visual reaction to complementary pairs connects to the concepts of afterimage, color balance, and physical complementary vibration.

Cool/Warm Color Harmony

Cool/warm color harmony is a four-hue color scheme that is more loosely structured than most color schemes. Cool/warm contrast emphasizes differences in color temperature. The cool side of the color wheel ranges from violet to green. The warm side spans from red to yellow. [2.15] Borderline hues that are not definitively cool or warm are red-violet and yellow-green. RV and YG are the chameleons of color temperature, which means that they are considered either warm or cool colors. A warm/cool color scheme is composed of one pair of neighboring warm colors and one pair of neighboring cool colors. Since RV and YG are mutable temperature hues, they can be either cool or warm depending on how they are paired with other hues. RV is cool when paired with violet and warm when paired with red. YG is cool when paired with green and warm when paired with yellow. For instance, orange and yellow-orange as a warm pair and violet and red-violet as a cool pair forms a cool/warm color scheme. [9.8]

The advantage of this scheme is its extreme flexibility, because any two cool/warm pairs create a scheme, regardless of their placement on the wheel. For example, if desired, a cool/warm group could be red, red-violet, violet, and blue violet. This particular version of cool/warm harmony is also an extended analogous grouping, but technically correct for a cool/warm scheme. This flexibility gives each cool/warm scheme a contrasting yet varied personality. A cool/warm color scheme has more contrast when the cool and warm hues are not physically mixed together. Intermixtures of cool/warm hues may make low saturation colors, or too many colors to visually unify in a composition. To vary the scheme, cool or warm hues may be tinted, shaded, or toned without canceling out the cool/warm contrast. [9.9] The cool or warm pairs can be mixed together (cools with cools or warms with warms) to form intermediate colors between the hues for more color variety. For example, a color between yellow and yellow-orange may be mixed to widen color choices. A cool/warm scheme leads to a freer color harmony because hue selection is not solely based on hue positions from the color wheel. This gives the artist more flexibility.

Double Complement Harmony

A *double complementary* scheme is a four-hue contrasting color scheme, which employs two adjacent complementary pairs. [9.10, see page 200] A double complementary harmony softens and expands the opposing complementary color contrast, for example, green and yellow-green opposed to red-violet and red. A double complementary harmony may be applied in varying manners: pure hues, intermixtures

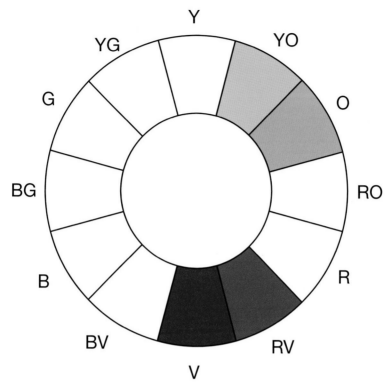

Figure 9–8 A cool/warm harmony uses a pair of any two adjacent cool hues with a pair of any two warm hues.

Figure 9–9 A grid study of cool/warm color harmony based on Y and YG opposite RV and V. No intermixtures between warms and cool colors are used, but hues may be tinted, shaded, or toned. Warm/Cool Grid Study, Student work by Andrea La Macchia.

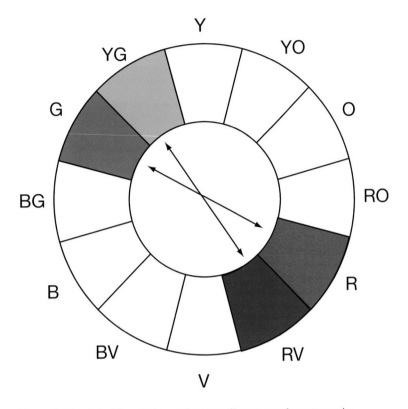

Figure 9–10 A double complement has two adjacent complementary pairs.

between complements, and tints, shades, and tones of any of these. This harmony is a more structured version of a cool/warm color scheme; emphasizing a contrast of opposing hues. [9.11]

Figure 9–11 A double complementary harmony based on RV–YG and R–G. Hues can be mixed in almost any way within this scheme.

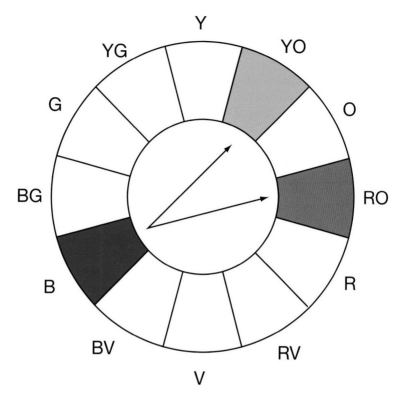

Figure 9–12 Split complementary harmony is an expansion on a dyad, although it uses the two adjacent hues rather than the actual complement.

Split Complementary Harmony

A *split complementary* harmony can be considered either a contrasting harmony or a balanced harmony. A split complementary scheme is a three-hue color harmony based on an opposing dyad. A split complementary harmony begins with a true dyad but instead of using a single direct complement, the two hues surrounding the actual complement are selected. An example of a split complement is violet opposing yellow-orange and yellow-green. This harmony is based on a narrow V configuration inscribed in the color wheel as shown. [9.12] By starting on the opposite side of the color circle, the split complement of yellow is red-violet and blue-violet. This color scheme is traditionally viewed as a softened complementary scheme or a modified triadic harmony.

Hue intermixtures, tints, shades, or tones can be used to vary colors in a split complementary harmony. Intermixtures between all three split complementary hues lead to a lot of different colors, so if a very harmonious and unified effect is desired, only pure hues and their tints, shades, and tones should be chosen. [9.13] Split complementary harmonies characteristically have color balance, a pleasing

Figure 9–13 A split complementary harmony starts with three hues, along with their tints, shades, and tones. Shown here, a computer illustration line study based on red, BG, and YG. Student work by Bonnie Sue Bacon.

color chord, and a strong color personality due to their visually arresting combination of contrasting hues.

BALANCED COLOR HARMONIES

Balanced color harmonies have a wider, balanced selection of hues from the circle, sometimes referred to as *color chords*. Color's analogy with music refers here to "color notes" that have a pleasant "color sound," like a musical chord. Two types of balanced harmonies are triads and tetrads. Both of these color schemes have a geometric figure as their basis, which is inscribed inside the color circle. A triangle defines a triad harmony, and a square or rectangle delineates a tetrad.

Triadic Harmony

An equilateral triangle inscribed in the color wheel leads us to three equidistant hues, which form a *triadic* color scheme. The triad is a classically balanced color harmony used by many artists and designers. [9.14] The are four distinct triadic choices beginning with a primary triad of red, yellow, and blue and a secondary triad of violet, orange, and green. [9.15] There are also two tertiary triad harmonies: RO, YG, and BV; and RV, YO, and BG. All of the triadic color chords are extremely harmonious. A triadic harmony has the advantage of being a highly varied in hue, yet balanced.

The triadic scheme is most harmonious when used simply, by selecting only pure hues, their tints, shades, and tones, and by omitting intermixtures between hues. [9.16, see page 204] Artists have used triads extensively, particularly the primary triad even before the triadic scheme was considered a formal harmony. The modernist painter Piet Mondrian used the primary triad almost exclusively for its purity and distinct hue contrast. [12.9]

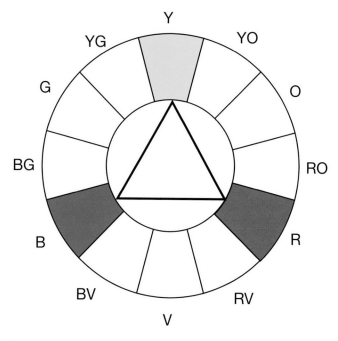

Figure 9–14 A triadic color harmony is based on a triangle inscribed in the color circle for hue selection. The primary triad is shown here.

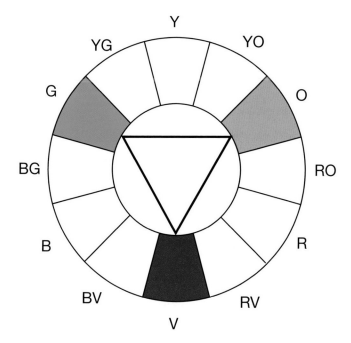

Figure 9–15 The secondary triad.

Figure 9–16 A color harmony based on the secondary triad. The hues are tinted, shaded, and/or toned but not intermixed.

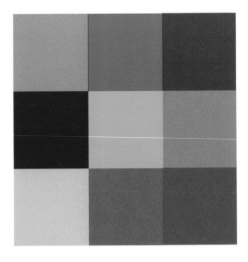

Tetrad Harmony

A *tetrad* is a balanced four-hue color scheme, which is more complex than other color harmonies. Tetrads are defined by either a square or rectangle inscribed in the color circle. The three tetrads created by squares are: Y, V, RO, BG *or* YO, BV, R, G *or* O, B, RV, YG. [9.17] Square tetrads harmony employ two complementary pairs, which are more widely spaced on the circle than those of the double complementary scheme. The four hues in a tetrad create a contrasting yet balanced group of colors.

A traditional tetrad is based on a rectangle inscribed in the color circle to obtain the following four-hue combinations: YG, RV, YO, BV *or* Y, V, B, O *or* G, R, Y, V. [9.18] Since tetrads have wide hue selections, they are a somewhat less harmonious than the schemes with a smaller number of hues. When using a tetrad, other methods of forming color harmony should be employed, such as value or saturation keys to gain greater color harmony. The advantage of a four-hue color system is its hue variety and flexibility. A broad range of base hues is more difficult to unify but can be exciting in its diversity.

KEYED COLOR HARMONIES

Color keys can be tools for both color unity and the creation of unique harmonies. Value keys and saturation keys can be instrumental in harmonizing a large range of colors. Color keys visually connect a wide variety of hues by use of a common color attribute, such as all dark values. [9.19, see page 206] A consistent saturation level may effectively harmonize a large number of colors, for example, by making the colors all the same level of high or low saturation. Color keys harmonize because common color characteristics equalize the diversity in color, forming a visual tapestry.

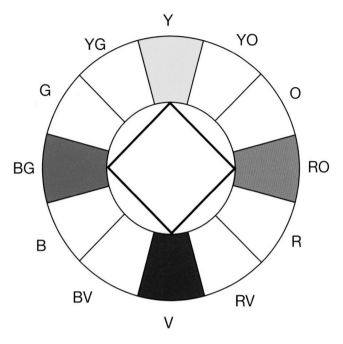

Figure 9–17 A tetrad harmony based on a square inscribed in the color circle.

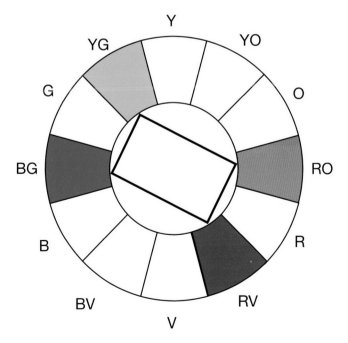

Figure 9–18 A tetrad harmony based on a rectangle inscribed in the color circle.

Figure 9–19 A light, medium, or dark value key allows a large number of colors to harmonize.

INFORMAL COLOR HARMONIES

Informal color harmonies are those with flexible rules. The artist can customize color guidelines to meet the particular color need of a subject, theme, or function of an artwork. Informal color schemes are much less structured than formal harmonies, being based upon general color characteristics rather than programmed hue selections. The following is a simple list of possible informal color harmonies. The rules here are flexible and meant to formulate many possible color combinations.

SIMPLE COLOR SCHEME: A color scheme based on variations from any two to four hues. Hues may be tinted, shaded, or toned to create a group of colors.

HIGH-SATURATION COLOR SCHEME: All high-saturation key hues and colors form this color scheme. Any number of hues or colors can be used as long as they are pure and intense. Sometimes this scheme is called a high-key color scheme. [9.20]

Figure 9–20 A high-saturation key harmony is all high intensity, pure, or almost pure colors.

LOW-SATURATION COLOR SCHEME: A color scheme of all low-saturation key hues and colors, made by the addition of black or varying amounts of gray to make tones. One or two purer colors can be added for contrast.

NEUTRAL WITH ACCENTS: Achromatic black, white, grays; nearly achromatic earth colors, chromatic neutrals, and very low saturation tones are selections for this color harmony. One or two stronger color accents can give the harmony some interest and variety.

LIGHT VALUE KEY COLOR SCHEME: Any number of hues keyed to medium light or very light values are in this color scheme. This is also called a pastel color scheme. Darker or stronger colors can be used for contrast.

DARK VALUE KEY COLOR SCHEME: The same as above but with very dark values. Made with shades, complementary mixtures, or dark tones. [9.19]

LIMITED HUE SATURATION CONTRAST: Any one to three hues can be used to create a wide variety of saturations by using sequential tones. Adding different amounts of gray into a pure hue can do this. There should be high saturation versions of each hue as well. [9.21]

CHROMATIC GRADATION: A color scheme from hues with some distance between them on the color circle; pure hues, as well as subtle gradations between hues are used, for example: yellow, green, and blue. This achromatic scheme consists of Y, YYG, YG, G, GGB, BG, B, and variations. Chromatic gradation is most effective when presented in a sequence compositionally, since it is a logical progression. [9.22]

VALUE GRADATION: Any two to four hues and their light to dark value gradations make another orderly color scheme. Approximately five value variations on each hue makes the scheme more effective, especially when value gradations are in order as an integral part of the harmony.

Figure 9–21 A limited hue saturation contrast scheme can be based on several hues that vary in tonal saturation. This can be made with mixtures of hues in different proportions along with various grays. Student work by Molly J. Hughes.

Figure 9–22 A chromatic gradation is a progression of colors that connect adjacent hues from the color wheel by using in-between colors. Shown here a gradation from Y to YG to G to BG to B.

TRIAD VARIATION: Two of the three hues chosen from a triad forms a strong harmony, for example, orange and green or green and violet from the secondary triad. [9.23]

Formal and informal color schemes or harmonies are the first step in exploring color combinations. Color schemes have rules that seem rigid, but in fact are flexible and amenable to change and manipulation by the artist. Color schemes furnish a stable base for formulating a broad range of color harmonies.

Figure 9–23 Becky Koenig, *Union,* 1999. Oil on canvas, 60" x 48" Collection the artist. © Becky Koenig, 1999. The selection of two colors from a triad, such as blue and yellow from a primary triad, creates an informal color harmony.

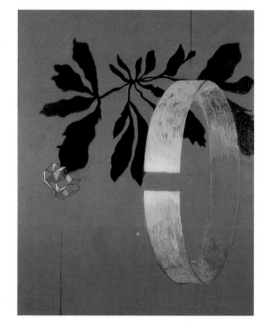

ACTIVITIES

All of these compositions combine color harmony with design principles and elements for developing mastery of color design.

1. MONOCHROMATIC LINE STUDY

Objective: The objective of this study is for the student to work with line as a division of the picture plane. The student will use the line in varied directions (horizontal, vertical, and diagonal) and vary the line width. Unity by color, continuation, and line proximity should be explored. The student will also gain an understanding of the use of a monochromatic color system.

Media: Collaged paper or computer illustration on board.

- First, make some plan drawings, 10" x 10" or 10" x 12", using a ruler. The drawings should use straight ruled lines in any combination of three directions (horizontal, vertical, or diagonal) to divide the picture plane. Lines may end or crop out of picture area. Try to create unity by using the idea of continuation of the lines, either literally or implied.
- Pick out a monochromatic color scheme out of Color Aid® paper or found colored paper. Try to get as much variation on the hue as possible, for example, for blue, use its tints, shades, and tones.
- Using colored pencils or markers, color the areas of your sketch with your chosen colors or photocopy your sketch and try the color scheme in multiple layouts.
- Inset colors into your design, by cutting out the lines or letting lines of color show between adjacent shapes.
- You can also execute this study on computer. Pick out colors and save them to your swatch palette first. Try various color arrangements in the design. [9.24]

2. INVENTED SHAPE COMPLEMENTARY STUDY OR SPLIT COMPLEMENTARY STUDY

Objective: The goal of this study is for the student to use a unique invented shape as a basis for a composition using figure/ground ambiguity, scale contrast,

Figure 9–24 Computer illustration of monochromatic line study. Student work by Jennifer Kopra.

Figure 9–25 Invented shape split complementary study. Student work by Laura Shoemaker.

and overlapping shapes. A complementary or split complementary color scheme will be utilized and explored.

Media: Acrylic paint on board.

- Create at least ten invented shapes. Make sure they are not overly complex. The shapes can be curvilinear, rectilinear, or organic.
- Photocopy or draw your shape in multiple sizes. Design your composition to the desired size by tracing. Overlapping is encouraged.
- Try to make all areas of the equally composition interesting. Color will be used in all positive and negative areas.
- The composition can be completed filled with positive shapes if this doesn't become too complex. Then erase any unnecessary lines to simplify composition.
- Pick either a complementary color scheme or a split complementary scheme.
- If you pick a complementary color scheme, for example, RO and BG, you may use intermixes, between the complementary colors. The color harmony choices are: pure complementary hues, intermixtures between the complementary hues and tints of any of these hues or mixtures. Make a swatch sheet of possible colors.
- If you choose to use a split complementary system (for example, yellow, blue-violet, and red violet), you can use the pure hues, tints, shades, and tones.
- Work out a color placement plan with markers or colored pencils on a trace or a photocopy of the composition.
- Transfer drawing to illustration board and paint in all areas with flat color according to your chosen scheme or plan. Leave no white areas. [9.25]

3. WARM/COOL GRID STUDY

Objective: The student will use the design principle of unity by use of repetition and continuity, also emphasizing variety. The student should explore the idea of a theme and variations on several geometric shapes. The color scheme is a warm/cool color harmony.

Media: Acrylic paint on board.

- Start this study by making a 10" x 10" grid using 2" increments. This can be drawn on sketch, trace, or grid paper. This grid has five 2" squares, both horizontally and vertically.
- Pick two or three geometric shapes to start with from the following: circles, triangles, squares, rectangles, and diamonds.
- Use these shapes as starting points for designing each square increment in your grid. Divide each grid unit into variations on chosen shapes.
- Make the sides of each grid unit integral parts of the design, with positive and negative spaces equally interesting.
- The composition should use the principle of unity by repetition and continuity, yet it should have variety, not be a too consistent pattern.
- The design of a grid unit may be repeated, if position or color is changed, for variety.
- When designing the grid use continuity. Connect one part of the composition to another. Some grid lines can be eliminated in the process, but the study should be visibly based on a grid.
- After drawing several plans for this design by hand or on computer, the colors should be chosen.
- A warm/cool color scheme will be used, emphasizing warm/cool contrast. Pick a neighboring pair of warm colors, for example, yellow and yellow-orange. Pick a pair of cool colors, for example, blue and blue-green.
- Remember that if RV or YG are chosen, you must decide whether these colors are warm or cool. RV is cool if paired with violet and warm if paired with red. YG is cool if paired with green, but warm if paired with yellow.
- Use the pure hues such as Y + YO, mixtures between Y + YO and tints of any color. Warm and cool colors should not be mixed together as this will diminish the contrast.
- A color swatch sheet can also be used to make color decisions.
- Transfer the design onto illustration board and paint, leaving no white areas. [9.26][9.9]

Figure 9–26 Warm/cool grid study. Student work by Molly J. Hughes.

Figure 9–27 Triad masterwork study based on a painting by Rene Magritte. Student work by Laurie Stahrr.

4. TRIADIC MASTERWORK STUDY

Objective: The objective of this study is to familiarize the student with the compositional structure of a particular museum quality artwork. The student will learn to analyze composition forces within the work. The textures, paint application, and surface of the work will be studied and reproduced. A triadic color scheme will be used to change the color message or theme of the work.

Media: Acrylic paint on illustration board.

- The student will look through art history books or survey some art history sites on the Internet to pick a color work that he or she wishes to study.
- The artwork should be a museum quality work by a well-known artist.
- First the student should make a drawing from a good reproduction of the original work. The reproduction should be in color and a good size.
- A triad harmony should be chosen that is quite different from the original color scheme of the painting. Before painting, plan ahead of time where the colors should go.
- Remember, the point is to change the color system of the original as much as possible, while exactly emulating all the textures and the shapes as precisely as possible.
- The triadic system should be used. For example, red, yellow, and blue, along with tints, shades, and tones. Use no intermixes of the hues.
- The final piece should resemble the original in composition, but send a different color message. [9.27]

Chapter 10

Designing with Color

INTRODUCTION

Color, as the most potent design element, wields strong influence on the unity, emphasis, balance, rhythm, and illusionistic devices in art. Thus far, each color concept and design issue has been explored separately for clarity. In reality, a designer or artist works with design elements, design principles, and color simultaneously as a unit. In this chapter the progression from color study through design elements and principles comes full circle. The important points of color study mesh with design fundamentals to aid the process of designing in color. The impact of color dynamics integrated with design leads to more choices and greater complexity for the artist. A solid foundation of design and color knowledge strengthens the design process.

COLOR UNITY

When designing chromatically, the concepts of repetition, proximity, and continuity are aligned with color concepts for visual unity. Unity in design also applies to compositional color selection and placement.

Color Repetition

Formal color harmonies are one option for color unity in design. Color schemes are hue selection guides, each scheme possessing a different color character. All color harmonies will visually unify a composition. The success of standard color harmonies is based on inherent color repetition built-in by the limited number of hues in each scheme. [10.1] Most color schemes are based on one (monochromatic) to four hues (tetrads) and their variants. The hues of a color harmony may be manipulated into many colors, but the commonality of a small number of base hues in an analogous scheme, for example, makes them visually cohesive.

Color repetition can also be implemented without standard color harmonies. By using a single pigment in many different color mixtures for a painting, painters employ color repetition to harmonize diverse images, shapes, and elements. A painting's colors also can be generated from a small number of pigments, supplying a subtle

213

Figure 10–1 Color similarity. Top: Repetition by an analogous scheme (based on blue and BG) and continuity by a color gradation unify this composition. Bottom: The same composition with arbitrary color appears to be less unified than the previous illustration.

harmony between compositional areas. In contrast, colors chosen at random with no sense of harmony can disjoint a composition.

Consistent Color Key or Temperature

Color keys use consistency of one color attribute or a characteristic such as saturation or value to hold a composition together. Visually matching colors to the same value or saturation key can organize a large variety of colors into unified groups. Colors can be keyed by forming groups of all light, medium, or dark value levels for harmony. Consistant color saturation keys hold together. All high-, middle-, or low-saturation colors will visually adhere. [10.2] Choosing a consistent saturation, for example, lends a similar color personality to a composition. For example, low-saturation colors seem quiet; high-saturation colors seem loud. Color keys produce color unity by optical mixture. A single color key blends a wide range of hues into one low-contrast unit, because colors seem to be interwoven together in the same spatial plane.

Consistency of color temperature is another type of color repetition that also produces compositional unity. An all-warm or all-cool colored composition is easily perceived as a whole. [10.3]

Color Continuity

Color continuity can be expressed by a compositional sequence of colors. Our eye follows a logical color sequence in the same way that we follow a continuity path

Figure 10–2 Color keys can also effectively implement unity. Here, all the warm and cool colors are at a similarly high-saturation key. Student work by Lorraine Mattar.

through a composition. A color sequence should have a perceptible color progression or gradation such as a value gradation, chromatic gradation, some type of pattern/color alternation, or a saturation gradation. [10.4]

Color Similarity, Proportion, and Distribution

The Gestalt concept of grouping according to similarity of visual characteristics may also be applied to color. Because of visual grouping, objects of the same color will connect parts of a composition regardless of placement. The concept of color similarity makes color distribution an effective compositional devise for unity. Similar

Figure 10–3 Color unity can be established by a narrow selection of color characteristics, such as an overall warm color for unity. Line study, computer illustration. Student work by Colin Kahn.

Figure 10–4 A color gradient. Top: Colors can be chromatically gradated from one hue to another to lead the eye. Bottom: Colors can become progressively lighter or more saturated to lead us to the focal point of pure red.

Figure 10–5 *Ewe Textile,* twentieth century, Ghana. Cotton. The Tess E. Armstrong Fund. © The Minneapolis Institute of Art. Color unity is achieved by the colors distributed throughout a patterned textile, because our eye groups repeated colors.

colors distributed throughout a composition form a type of inner balance between the parts of a composition. [10.5]

Color dominance or proportion also has an effect upon the unity of a composition. Color proportion is simply the relative physical area covered by each color in a composition. An effective method of visual unity is to allow one color in a given harmony to dominate the composition. A large proportion of blue, for example, in a blue-orange complementary harmony effectively unifies the composition better than equal areas of blue and orange. [10.6]

Figure 10–6 The dominant blue in this composition unifies a blue–orange dyad. Student work by Laurie Stahrr.

COLOR EMPHASIS

Color Contrast

A point of emphasis or focal point attracts attention visually to become the most important area of a composition. The color strategy behind color emphasis directly opposes that of color unity. Rather than all colors unifying together and/or blending, the strategy in emphasis is to have one color area visually dominate or contrast the rest of the composition. Establishing a point of emphasis with color is relatively simple because of color's ability to visually *contrast.* Johannes Itten outlined the numerous ways that colors contrast in his book *The Elements of Color* (1970). Itten presented the principal types of color contrasts as light-dark contrast (value), hue contrast, cold-warm contrast (temperature), saturation contrast (purity), simultaneous contrast, complementary contrast, and contrast of quantity (proportion). Color contrasts are always relative to and dependent on compositional color environments. Specific examples of color contrast include a dark value green in light yellow environment (value contrast), a highly saturated color such as orange in low-saturation, muted gray-blue surroundings (saturation contrast), or a cool blue-green in a warm, dark-red color environment (temperature contrast).

Complementary contrast is a powerful type of color contrast, for example, a composition that contrasts pure yellows with muted violet draws attention to the yellow areas. [10.7] Cool/warm contrast is also an effective way to establish a focal point. Two examples are an area of warm color placed in a dominantly cool composition or a cool color used in a dominantly warm environment.

Several types of color contrast can be combined for even stronger emphasis. For example, a light-value warm color in a low-saturation, dark-value, or cool composi-

Figure 10–7 In this study, the complementary contrast draws our eye to the yellow area. Student work by Bonnie Sue Bacon.

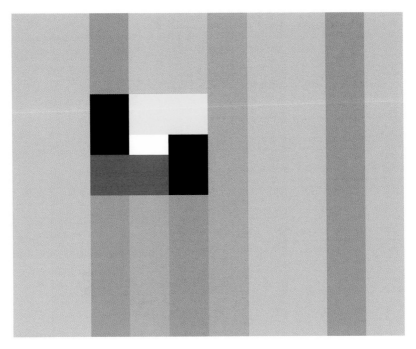

Figure 10–8 An area of value and hue contrast stands out in an environment of low contrast colors.

tion draws interest. Any type of chromatic contrast paired with value or saturation contrast is an effective way to let a color dominate visually.

Hue contrast also forms a focal point, especially the strongest hue contrasts between the medial primary hues: red, green, yellow, and blue. For instance, a red focal point can be located in a blue environment or a blue focal point in a yellow environment. The additive color circle can be a guide for contrasting hues, such as magenta contrasting with green; blue (violet) opposite yellow and cyan opposite red. Secondary hues can also be paired to contrast such as an orange focal point in a green environment. For hue contrast to be effective, colors must be high in saturation.

An area of high contrast between two or more colors, which forms an effective visual hierarchy, can also create a focal point. An area of high saturation complementary colors, such as cool/warm colors or light/dark colors, draws visual interest. [10.8] An area of color contrast must somehow oppose or stand out in some manner from its color environment because visual competition weakens a focal point. For example, a strong light/dark contrast focal point in competition with several other light/dark value contrasts in a composition will lose its visual impact. When a single color dominates a composition, an area that opposes in it hue, value, color temperature, complement, saturation, or strong color will contrast and be emphatic. [10.9]

Figure 10–9 Focal point study. Student work by Bonnie Sue Bacon.

Unique Color

A *unique color* is a color that is unlike the dominant colors of a composition. Unique color is also defined as a color placed in one single, important location in a composition. A color unique to a composition attracts attention because it visually contrasts and stands alone in its color identity. [10.10] A color can be unique because of its complementary, hue, temperature, or value contrast with surrounding colors.

Figure 10–10 Higher saturation and unique color establishes a point of emphasis. Student work by Christopher J. P. Guzdek.

Color Gradation

A color gradation is a gradual change in color that functions to direct our eye compositionally. Color may be gradated by changes in saturation (getting purer or duller), by changes in value (lighter or darker), or by chromatically blending from one hue to another. A color gradation provides us with us a logical progression to visually follow. [10.4] The gradation can end with a strong color that contrasts with the gradient or simply end logically with the color progression.

COLOR BALANCE

Relative Weight of Colors

The relative weight of colors is a major consideration in color balance. The visual weight of any specific color is always relative to and interactive with its color environment. Some colors are innately visually heavy and others are inherently light in weight. [10.11] Inherently heavy colors include dark colors (dark values), high-saturation colors (pure colors), or powerful hues. Powerful hues include warm hues, which at full strength, tend to visually dominate other colors: red, red-orange, orange, yellow-orange, and yellow. Lightweight colors are those that are light in value or low in saturation (muted). Cool colors are traditionally considered less dominant than warms, but this is certainly not an ironclad rule. Light or medium value achromatics

LIGHT HEAVY

ACHROMATIC COLORS	HIGH SATURATION COLORS
LIGHT VALUE COLORS	DARK VALUE COLORS
COOL COLORS: LIGHT VALUE OR LOW SATURATION	WARM COLORS HIGH SATURATION
LOW SATURATION LIGHT COLORS	HIGH SATURATION DARK COLORS
LIGHT INHERENT VALUE HUES	DARK INHERENT VALUE HUES

Figure 10–11 Colors can be considered light or heavy because of factors such as value, saturation, and temperature.

Figure 10–12 Some types of color contrasts have visual weight.

LIGHT/DARK
CONTRAST

COMPLEMENTARY
CONTRAST

COOL/WARM
CONTRAST

HUE CONTRAST

are also visually lighter in weight than, for example, saturated colors. A dark achromatic like black or dark gray is always visually heavy. The relative weight of colors becomes evident in interactive color groups.

High contrast color combinations also have visual weight. [10.12] There are four main types of contrasting color groups: primary or secondary hue contrasts such as blue opposite yellow, complementary contrasts such as red opposite green, cool/warm contrasts such as orange opposite blue-violet, and value contrasts such as black opposite yellow-green.

Asymmetrical Color Balance

Color can be factored into a compositional equation to achieve asymmetrical visual balance. An asymmetrical structure should have compositional balance without color. However, a designer can fine-tune color placement to balance even a seemingly unequal asymmetrical design. Color is such a powerful element that color selection and placement can bear the weight of a balanced design.

Relative color proportions in a composition can control color balance. The concept of color dominance is useful in adjustment of color areas in design. Color weight is relative, dependent both on the placement of each color, and the amount of physical area or mass covered by each color. To equalize balance, the color dynamic of a composition can be manipulated. Color is compositionally balanced by counteracting visual weight from side to side, top to bottom, or diagonally. For example, the bottom of a two-dimensional composition always has more inherent visual weight than the top, because of our sense of gravity. Using heavy colors in the bottom half of a composition may cause an imbalance that can be remedied by placement of a counter weight of color in the top half of the composition. [10.13]

The placement of dominant color groups affects the overall dynamic of a design. An optimal means of constructing a balanced composition is through experimention with different placement options of the same group of colors. [4.27] Color

balance exercises are easily done on a computer, where colors can be moved and changed instantly. Color balance may be achieved by distributing weighted colors throughout a composition. [10.5]

Color and Symmetry

Visual forces in color balance may be better understood by manipulating formal symmetrical balance. A design mirrored on either side of a line of symmetry or axis is symmetrical or perfectly balanced. Perfect symmetry in color design should be laid out both compositionally and by equal placement of colors on either side of an axis. Compositional symmetry with an asymmetrical color placement strongly affects the balance of a design. Compositional balance may be radically shifted by simple color inconsistencies from one side of an axis to another. [10.14] A symmetrical composition that is transformed into an asymmetrical composition merely by color placement aids our comprehension of the relative weight of colors.

Radial Color Balance

A radial color balance format calls for a radial color gradation. The compositional elements in radial balance emanate from one or more points. The "vortex" of a radial color

Figure 10–13 Color distribution equalizes an asymmetrical design: A heavy black shape at the bottom of the composition is balanced by a group of pure contrasting hues at the top. Aysymmetrical Balance Study. Student work by Amy Claroni.

Figure 10–14 A symmetrical structure can be shifted in balance by an asymmetrical color placement.

composition can serve as a starting point for a color gradation. Colors may gradate darker from a light point, lighter from a dark point, or they may gradate in hue or saturation. In a radial composition, a gradation produces both a point of emphasis and compositional balance. [10.15]

Figure 10–15 Radial balance is enhanced by a radial color gradation.

COLOR TO DEPICT FORM, SPACE, AND LIGHT

Artists use colors to depict reality by reproducing in artwork their close observations of the play of light on objects. One of the challenges of art is the creation of form, light, and space by the selection and placement of color.

Form and Color

A novice painter looks at an object, such as an apple, and sees its local color. Upon closer observation, he or she notices that the apple has numerous colors because of both the apple's surface quality and the quality of light upon it. The amount and type of light illuminating an object drastically affects our perception of its color. Forms or volumes are of two main types; either rounded or flat-sided. This affects the way that light describes them. When lit, a round or irregularly shaped object has a color/value gradation. Flat-sided objects or planar forms have distinct areas of light and dark colors defined by the edges of each plane. Upon close observation, numerous distinct colors are evident in even a solid-colored object. Perceptible light/color variations are described as highlight, light, shadow, core of shadow, and reflected light. The rendering of an object is subject to form and color considerations, which can become a complex process for a painter. A painter must perceive color differences, identify the colors seen, and be able to recreate the colors by paint mixtures. Areas of color must be handled and placed accurately to render an illusion of form. Accurate color in correct locations imparts a rendered object with volume and light through shifts of hue, value, and color temperature. [12.2][12.3]

Color and Light

Objects described by color and light are important aspects of Western art. In a spatial illusion painting, the quality of light affects all of the objects in the painting. A cloudy, diffuse light, the light of a candle in a dark room, or warm sunny light at noon all present the artist with different color problems. The light striking reflective objects or a lighted atmosphere (sky) present particularly difficult challenges. Time of day is interconnected with the quality of light and shadow depicted. Strong midday sunlight casts small crisp shadows and is cooler than light in the morning or evening, making colors appear highly saturated. Cool light on an overcast day will mute warmer colors and illuminate cool colors. Dim twilight illuminates blues and violets and subdues reds and greens. Nighttime is about the harsh contrasts of dark and light. The darks of night are depicted as blues, black, or violets. A light illuminating a dark setting is translated in painting into white, yellow, or orange. Artificial light, like florescent light, is cool, in contrast to warm quality of incandescent light or firelight. Identical objects painted or photographed in varied settings change substantially in color. Paintings that are depictions of light itself, such as sunsets and lit skies are particularly difficult to achieve. The artist is, in essence, trying to recreate an additive effect of light with subtractive pigments. The results for many inexperienced artists are heavy and unattractive. A highly refined sense of color and paint application is necessary for the rendering of light in artwork. It is akin to painting "air." [10.16]

Figure 10–16 John F. Kensett (1816–1872, American), *Lake George,* 1869. Oil on canvas. The Metropolitan Museum of Art, NY. Bequest of Maria Dewitt Jesup, 1915. (15.30.61) Photograph © The Metropolitan Museum of Art, NY. In this painting, spatial illusion is formed by atmospheric perspective with colors gradually becoming lighter, less contrasting, and grayer as they recede into space.

A small area of light that seems to glow or emanate can portray the illusion of luminescence. Luminescence is depicted by a sequence of gradated values or hues into a darker or more muted saturation, a chromatic gradation, or complementary gradient. These effects form an illusion of light emanating from the artwork. [10.17]

Figure 10–17 Luminescence is produced by a subtle gradation of one hue into another, using saturation or value steps. An illuminated area should be lighter or brighter than its surrounding colors.

Iridescence is a color effect that can depict the type of rainbow that we see in an oil/water mixture, on the inside of a shell, or in some satin fabrics. This effect is achieved in painting by the layering of colors, or using all light value colors that have subtle hue differences like pastel colors.

Color and Space

Color adds another level of complexity to the creation of a spatial illusion. To create a spatial illusion with color, there should be a perceptible light source on all forms to give them volume. In a spatial illusion, colors must change in some way as they recede into illusionistic space. [10.18] Two specific value strategies will depict space

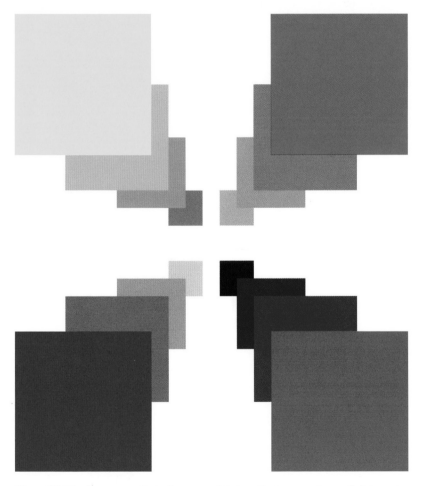

Figure 10–18 Some ways that color can gradate in order to appear to recede into space. Clockwise, from top left: Yellow is muted by the addition of its complement of violet; green is dulled by additions of gray; red is shaded in steps; and blue is tinted in steps.

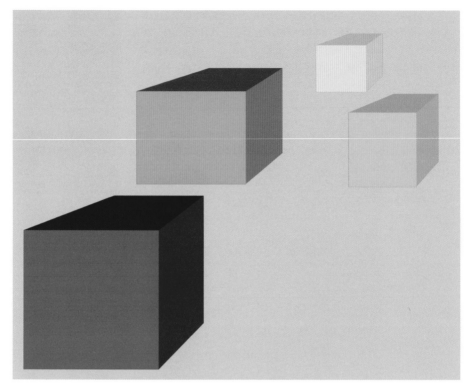

Figure 10–19 Space can be established by giving the illusion of recession into light by sequentially lightening and lowering the saturation of colors (dark into light).

when consistently applied. Colors can be sequentially lightened or darkened, but always must be dulled to recede spatially. In a "daylight" picture the background should be paler and lower in color saturation than the foreground. The colors in a pale background spatial depiction should lighten in value as they recede into the imaginary "space." [10.19] Bright, highly saturated colors advance spatially. For this reason, foreground areas should be stronger in saturation, contrasting in value, very defined, or textural. Muted low-saturation colors recede spatially, duplicating reality by a sequential graying of color caused by the atmosphere. For this reason, distant background areas should be lower in chromatic contrast. Distant mountains, for example, seem to lose their color as they recede toward the horizon. A second value strategy is used for a "nighttime" setting that depicts spatial depth into darkness. To achieve this, light foreground items can gradually become darker and less saturated as they move back into space, enhancing a spatial illusion. [10.20]

 Colors should be lowered in saturation to depict space by using a series of tones or chromatic neutrals as an effective way to make *color atmosphere.* [10.16] Pure, high-saturation colors advance spatially and duller low-saturation colors tend to recede spatially. A traditional color space may also use color temperature to de-

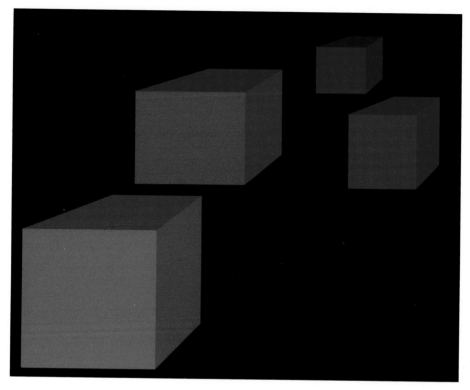

Figure 10–20 Space can be established by giving the illusion of recession into dark by sequentially darkening and lowering the saturation of colors (light into dark).

fine foreground and background. A traditional perception that warm colors advance and cool colors recede can enhance spatial depth. Warm colors and/or light values enhance a sense of light on an object. Cool colors and/or dark values, magnify the illusion of shadows.

Light and Color Atmosphere in Abstraction

Color depiction of form and light is not limited to representational art. Illusion of luminescence, light, and spatial depth is frequently a devise in abstract and nonobjective painting. Abstract forms can be painted with the illusion of a light source. Color atmosphere is established by the application of luminous colors seen in the atmosphere at varying times of day, colors that are transmitted through transparencies, or masses of color that appear to be reflected from brightly lit surfaces. A luminescent quality may arise from heightened cool/warm contrasts and contrasts of value and saturation. The cubists and surrealists, for example, were fond of using color and value gradations to enhance volumes. [12.8]

COLOR RHYTHM AND MOVEMENT

Rhythm and movement can be expressed with color in the same way as the repetition of a line, shape, or a mark can impart these qualities. An internal compositional rhythm produced by a systematic color repetition makes the eye move through a composition. Optical movement is formed from a juxtaposition of opposing hues (complementary vibration), color gradations, alternating colors or color patterns. Marks or gestures in color also enhance a sense of movement. [10.4] Gestural marks give us a sensation of speed because of the character of paint application or brushwork. Small marks or lines of vibrating colors cause optical effects. [4.22][11.7] Optical kinetic effects based on perception and knowledge of optical mixtures are simultaneously exciting and disturbing.

Color unity, emphasis, weight, contrasts, space, and movement are all considerations in the placement of color in a composition. A thoughtful placement of color selection can form emphasis, make the eye move, balance or unite a composition.

ACTIVITIES

1. COLOR EMPHASIS STUDY

Objective: The student will create a point or points of emphasis both compositionally and with color.

Media: Colored paper on board.

- This study uses an organic shape or a shape derived from a man-made shape. Design a composition using the shape flexibly in the picture space, using repetition with variety.
- For variety, the shapes can have varied scale, also using the shape's parts.
- Do not create a traditional pictorial composition. The shape should be positioned for design purposes regardless of any subject.
- For variety, use overlapping and make sure that both the positive and negative spaces are well designed. The composition may have large or small areas of negative space.
- One area of the composition should be established as a point of emphasis. Remember the techniques for creating emphasis: isolation, the contrast of color, scale, position, and direction.
- The color scheme is a group of two to three analogous hues along with the tints, shades, and tones of the hues. Make sure that the point of emphasis is reinforced by color.
- A color, size, or position gradation can also be used to direct the eye to a specific point in the composition. [10.21] [10.9] [10.10]

2. COLOR BALANCE STUDIES

Objective: For the student to demonstrate knowledge of compositional and color balance by working from an asymmetrical, symmetrical, or radial compositional model.

Media: Colored paper, paint, or computer illustration mounted on board.

Figure 10–21 Color emphasis study, student work by Nicole Land.

A. Asymmetrical composition
- Line, shape, form, texture, or space may be used to execute this study. Choose one to three of these elements.
- Shapes may be invented or symbolic, but the overall composition should be nonrepresentational.
- Draw a horizontal, vertical, or diagonal axis through the center of the composition before you start. This will help to assess balance.
- Create a composition that takes an asymmetrical balance risk. Make at least three compositional sketches in colored pencil for a composition that has more visual weight on one side of the axis.
- Manipulate the elements and colors that have visual weight: forms, complexity, dark values, high-saturation colors, textures, and so forth.
- Using a formal or informal color scheme, try to balance the composition with color. [10.22] [10.7] [10.13]

B. Symmetrical composition
- For this composition, divide the picture area with an axis, as in A (above).
- Design a perfectly symmetrical compositional structure. Make several different sketches of symmetrical compositions, varying the positioning of the axis.
- Use colored pencils to plan color on one of the sketches using color scheme. [10.14]
- Use the relative weight of colors to "unbalance" the composition by color placement.

C. Radial balance study
- Make a composition with radial balance. Radial balance has sequential components, radiating from one or more parts of the composition.
- A hue, value, or saturation should gradate from one or more points in the composition. Colors may gradate from light to dark, from brighter to duller, or chromatically from the main point(s) of the composition. [10.15]

Figure 10–22 Color asymmetrical balance study. Student work by Christopher McIntyre.

3. COLOR SPACE ILLUSION STUDY

Objective: The student will use both perceived and invented color to create form and space in color.

Media: Choice of colored paper, collage, and/or paint on board.

- Start with one or more invented or geometric shapes. Make sure that they have form.
- Create depth by repeating the shapes and diminishing the scale. You may use any of these three formats: a linear perspective interior, an architectural exterior, or a ground/sky plane. You may also float overlapping forms as a spatial environment for your shapes.
- The composition should have a foreground, middle ground, and background. It should be imaginative rather than realistic.
- You may choose your own colors, but keep in mind the color and spatial guidelines that follow.
- Pick a group of colors, using a formal or informal color scheme.
- Using the symmetrical composition, place the colors in such a way as to create a feeling of asymmetry, merely by color placement. Keep in mind the relative weight of colors and color contrasts.
- The shapes should have some sense of a light source. [10.23]

4. GUIDELINES FOR CREATING DEPTH IN COLOR:

A. Foreground should:
- Have large-scale items.
- Have more highly saturated colors.
- Have more detailed items.
- Have light-value objects if background is dark and dark value objects if background is light.
- Use warm colors, which appear to advance spatially.

Figure 10–23 Color spatial illusion study. Student work by Branden A. Kautz.

B. Background should:
- Use diminishing scale.
- Have less detail.
- Have less value contrast.
- Have less-saturated colors.
- Use cool colors, which appear to recede spacially.
- Let items get darker as they recede into a dark background.
- Let objects become lighter as they recede into a light background.

C. Remember to:
- Pick the value of your background first.

Chapter 11

Expressive Color

INTRODUCTION

Much of this book is dedicated to the *formal* area of art. The formal aspects of art include media, art elements, and design principles. *Form* concerns the purely visual characteristics of art.

The nature of expressive art and expressive color is categorized in the *content* area of art. The *content* of art covers several concepts: *subject matter* (what a work depicts), *iconography* (the symbols present in a work), and *theme* (the ideas behind the work of art).

Because color is the most complex art element, it may function either formally or expressively. A viewer reacts to color in art based on personal, cultural, environmental, symbolic, and psychological human preferences. The collective unconscious combines with our experience of the world to influence color preferences. The term collective unconscious is based on the theories of Carl Gustav Jung (1875–1961), a Swiss psychiatrist who distinguished the personal unconscious from the collective unconscious. He defined the collective unconscious as the inner feelings, thoughts, and memories that we inherit and all share, as human beings. Color preferences are thus guided by our instinct rather than by rational color systems. Color communicates visually because it is an essential part of our psychological makeup.

Color can be the most expressive tool in art. The expressive quality of color stems from the fact that color is the art element most enriched with associations. Color plays a role in cultures worldwide, aesthetically, symbolically, and through the media. An artist or designer communicates through color to express specific ideas in an artwork.

COLOR PSYCHOLOGY

Psychology can be broadly defined as the science of the conscious and unconscious mind, and of mental functions, behaviors, feelings, and dreams. Color is an external visual experience, but also part of our psychological makeup. Color is part of our psyche, demonstrated by our ability to respond emotionally to it as well as by

Figure 11–1 Our color preferences may be rooted in experiences of special things and places.

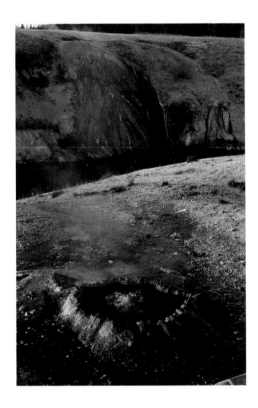

our ability to visualize color internally. For human beings, color is both a physical and an emotional experience.

Color is directly connected to light because color is a component of light, and our color perception is light dependent. The effect of light on our psychological and physical well-being is profound. The amount, type, and variation of light in the day/night cycle and throughout the seasonal year are closely tied to human life. Light determines our pineal and endocrine functions, our behavior, sleep, and metabolic patterns. It has a profound effect on our cognitive and emotional well-being. In sunlight, there is a balanced array of spectral colors, which enters our body not only through our eyes but also into our skin through UV rays (hence, our fondness for sunbathing).

Our visual sense is the conduit that connects the external world to our inner mind and psyche. Color associations are thought to be imbedded in our collective unconscious upon birth. A factor in our color likes and dislikes may also arise from our personal history with color. Color preferences may be rooted in childhood and life experiences with certain foods, toys, picture books, and special places. [11.1]

Color psychology is studied by documenting human reactions to both strong colors and color environments. Studies conducted to document common human reactions to the basic hues and neutrals aid in understanding color and human response.

Color associations common to a cross section of people helps link specific colors to human emotions.

Throughout human history, the notion of physical reactions to specific colors has been used to aid healing. The Egyptian physicians prescribed colored minerals such as malachite (green) or red and yellow ochres to heal various maladies. The Greeks employed color along with music and poetry to assist healing. Colored plasters for wounds were used by the ancient Greeks to speed healing. The Greek Claudius Galeneus (A.D. 129–199) framed classic human personality types based on color associations, choleric—red (angry), sanguine—yellow (calm), melancholic—blue (depressive), and phlegmatic—green (stoic and self-possessed). Red continues to be associated with anger and "the blues" with sadness. Picasso strikes a melancholy blue color note in the painting *La Vie*. [9.3] The physician and philosopher Ibn Sina (A.D. 980–1037) of Persia found that red light stimulated the movement of blood and blue light slowed it, findings that still have merit today. Dr Edwin Babbit wrote the *Principles of Light and Color* in 1878, in which he described his color therapy or "chromotherapy" for various illnesses. He used yellow and orange, for example, as nerve stimulants. Chromothrapy is still practiced in some countries, although not in the United States.

Recent research has been conducted to study human reactions to various colors by colored light or environments. In a recent study, colored light was projected into the eyes of human subjects and the reactions were recorded. Red light was found to be arousing because it increased blood pressure and quickened the pulse. Yellow felt sunlike to the subjects and provoked nervous responses, elevating their activity level. Blue-violet was pleasant for subjects, was calming and elevated concentration levels. Green was also calming and had an overall pleasant effect.

Color responses also have been measured by situating human subjects in highly saturated colored rooms. Subjects in a red room found the color over stimulating, and red heightened both blood pressure and pulse levels. A blue room lowered blood pressure and slowed the activity of the subjects. A yellow room had no effect on the subjects' blood pressure but caused eyestrain. A green room caused no physical reactions, and was considered a calm but monotonous environment by the subjects. All these reactions were based on exposure to pure intense hues. Colors based on the pure hues, but lower in saturation or different in value, provoke modified versions of the same responses.

Color association sometimes engages our other senses in addition to our visual sense. For instance, colors are often described in terms of food or taste associations, such as candy colors: mint green, candy apple red, bubble gum pink, and so forth. [11.2] Food references extend to descriptive color names such as pumpkin, persimmon, tomato, tangerine, and celery. Analogies are often made between color and the aural sense because color is often described in terms of sound or music. Colors are loud, soft, quiet, harmonious, or discordant. Colors have tactile associations as well; dry colors can be thought of as earth reds or yellows, wet colors as blues, greens, or grays.

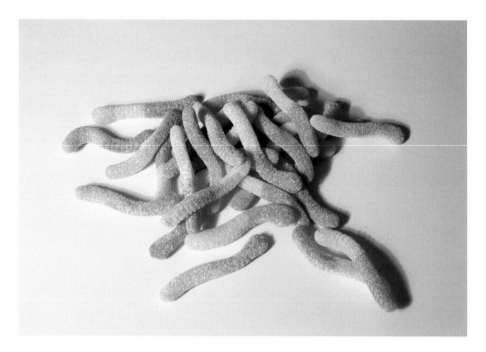

Figure 11–2 Color is also associated with music, sound and tastes; candy colors are "sweet."

Figure 11–3 Green is considered a calm, relaxing color.

Figure 11–4 Egon Schiele, *Portrait of Paris von Gütersloh,* 1918. Oil on canvas. Gift of the P. D. McMillan Land Co. © The Minneapolis Institute of Art. The dominant red conveys a powerful personality in this expressive portrait.

Concepts are often commonly associated with particular colors. Subjects asked to associate colors with specific ideas, for example, connected love to red and red-violet, hate to black, peace to blues and greens, and happiness to yellows and oranges. Generalized associations with specific colors are revealing: green is thought to be relaxing, refreshing, and quiet, but also is linked with illness and poison. [11.3] Blue is affiliated with calmness, contemplation, and yearning, but also with melancholy. Red is erotic and conveys excitement as well as pain. [11.4] Violet is connected to dignity, magic, and royalty, but is also mournful. Orange is stimulating, extroverted, and suggests sunsets and sunlit rocks. Brown is comforting, conveying earth, wood, and warmth. Yellow is luminous, hopeful, joyful, and warming. White stands for light and hope. Black conveys evil, darkness, but also formality. Gray signifies the calm and conservative.

COLOR SYMBOLS

Symbols, or iconography, and colors that communicate a particular idea have been used throughout art history. *Color iconography* is based on cultural or universal factors. Culturally based color associations include red for sexuality and black for death. Other color symbols are cross-cultural or universal, for instance, blue often symbolizes the concept of the celestial, heavenly, or spiritual.

Standard color symbols can cross cultural boundaries to symbolize similar ideas. Various meanings of traditional Western or cross-cultural color symbols are listed as follows:

	Western	Cross-cultural
Red	Blood	Fire
	Martyrdom	The sun
	Sin	Sexuality
	War	Evil
	Anger	Fertility
		Masculinity
		Festivity
Yellow	Treachery	Spirituality
	Cowardice	The sun
	Light	Gold
	Truth	Radiance
	Warning	Earth
	Cheerfulness	
Blue	Heaven	Coolness
	The celestial sphere	Eternity
	Water	Faith
	Baptism	Serenity
	Space	Wisdom
		Feminine
Green	Spring	Holiness
	Resurrection	Charity
	Envy	Regeneration
Black	Death	Sadness
	Evil	Mourning
	Darkness	Time
	Void	Rebirth
	Witchcraft	
White	Light	Death
	Air	Redemption
	Purity	Innocence
	Marriage	Surrender

Color associations may also be derived from the physical environment. Color may be indicative of an individual's environment, such as urban, northern, tropical, or arid. For example, an arid environment might be expressed in earth colors—oranges, reds, and browns. Colors also align with various seasons. Seasonal color associations include Winter: blues, grays, white; Spring: light value colors such as pale greens, yellows, pinks; Summer: highly saturated greens, blues, reds, yellows; Fall: brown, oranges, reds, yellows.

Through history, artists have employed colors from their cultural iconography. Color symbolism may be indicative of a certain period of art, for example, the Virgin Mary in medieval, gothic, and Renaissance art was often portrayed wearing a blue robe, symbolizing her heavenly or celestial presence.

To symbolize the virginity and unspoiled youth of a woman, a Western artist might portray her in delicate whites. In contrast, in Asian culture, a woman in white might be in mourning, because white symbolizes death and rebirth in Asian cultures.

Graphic designers exploit our bias toward color symbols. Many car advertisements, for example, display a bright red-colored vehicle. In addition to being eye-catching, the cultural color message sent by a bright red car is power, heat, and masculinity. In advertising design, the designer is aware of and willing to manipulate color symbols to promote a particular product. Appropriate color selection is a critical part of communication design used to convey a product-specific message to the consumer. For example, the appropriate color packaging of a fragrance might be pale blue-green, while the packaging of a power tool might be red and black.

ENVIRONMENTAL COLOR

Environmental designers must be sensitive to color selections in order to reflect and enhance the function and mood of an interior space. A place of worship, for example, may not be appropriate for very high saturation warm colors such as red or red-orange, because they stimulate, warm, and increase blood pressure. Meditative colors such as blues, neutrals greens, and violets might be more appropriate choices for a place of worship.

Architects often use nature as a color inspiration for their building designs. This approach visually unites the building with its site. Color temperature is an important factor in environmental color design. The warm or cool climate of a site can be reflected in the actual design of a building as well as in its colors.

Art of indigenous peoples is concerned with visual and spiritual connections to the environment; for instance, this African granary door is carved from indigenous wood. [11.5] African granaries were constructed of wood and mud in each village. The

Figure 11–5 Senufo, *Granary Door*, nineteenth century, African. © The Minneapolis Institute of Art. This decorative door is made out of environmental materials from an African village.

door is richly colored with pigments readily available to the village, directly connecting the colors to artist's environment. The stylized fish, horse, and crocodile are related to Senufo myths, symbolically protecting the grain stored behind this door.

COLOR HARMONY VERSUS COLOR DISCORD

Formal color harmonies are a sound means of color selection, but artists often wish to manipulate colors subjectively. Formal color schemes are restricted, unlike subjective or expressive color, which lack formal color "rules." With an intuitive approach to color, the artist is free to form *personal* color harmonies. Artists working with color subjectively must refine their color instincts, which are founded on color experimentation, color associations, personal color symbols, and color preferences.

Color preferences are pertinent to personal color harmony. Harmonious colors produce a pleasing visual experience for both artist and viewer, called a *positive visual effect*. In contrast, color discord refers to color combinations that create a *negative visual effect*. A color combination that contrasts, clashes, or "fights," rather than harmonizes is called a *color discord*. A color discord is a color dissonance similar to the purposeful dissonance caused by a harsh, strong combination of notes in a musical composition. In a similar fashion, a visual artist uses color discord to produce unease in the viewer. Color discord may enhance a powerfully negative or disturbing theme. For example, *Portrait of Paris von Gütersloh* by Egon Schiele depicts a man in a tempestuous red and green environment. [11.4] The subject of the painting, a friend of the artist, was a writer, painter, actor, and designer. Expressively posed with raised hands, the figure is further accentuated by the strong color discord and brushwork of the background. The red/green dyad also has striking light/dark contrast, accentuated by the purposefully crude expressionistic brushwork. Shiele gives the overall composition a rhythmic, chaotic quality—a commentary on his friend's personality.

There are no set guidelines for discordant color combinations. However, strong value, hue, and saturation contrasts, singly or combined, create a discordant effect. The purpose of color discord is to cause the viewer discomfort in order to draw attention to the formal or thematic content in the artwork. Judgment of color discord, like that of personal color harmony, is highly subjective. In the previously discussed work by Egon Schiele, the powerful color combination could be viewed as discordant. Another artist could use the same theme of chaos and express it in a completely different personal color dissonance. This is the nature of color expression.

COLOR PREFERENCE

The artist, like everyone, has "favorite" colors. An individual's preferred colors range from one particular hue to favorite color combinations. Color preferences are based on personality types, culture, inner psychology, the subconscious mind, the physical environment, and past color associations. The colors that we wear, the colored objects we

Figure 11–6 Signature colors are a group of individualized colors that express the personality.

buy or collect, or the colors from our home environment are all manifestations of our color preferences. Personal color expression begins with the acknowledgement of our color preferences through exploration of favorite colors and color combinations.

Johannes Itten employed a color exercise at the Bauhaus School that allowed students to choose (from paper) or create (with paint) a set of personally significant colors. Students generated a group of colors that were indicative of their personality or character. The initial step in this process is to select preferred primary, secondary, tertiary, or neutral colors. Light, dark, saturated, and unsaturated variations on these hues (totaling ten or more) can be then made from colored pencils, paint, markers, colored papers, or printed from the computer. A group of personally harmonious colors is called one's *signature colors*. [11.6]

COLOR EXPRESSION

Color is the most expressive art element available to the artist. Through color choices, cultural, symbolic and personal *themes* can be expressed. Instinctive color has an inner rather than a formal logic. Many times colors just "feel" right for a particular subject matter or design. Color iconography can be personal as well as cultural. Personal color symbols are colors that an artist chooses based on his or her inner life and subjective experience. An artist might use yellow for love and black for purity, instinctive color choices based on individual personality. Several periods and styles of art were instrumental in freeing color for expressive purposes. The Neoimpressionists (Post-Impressionists) Paul Gauguin and Vincent van Gogh, in particular, liberated the use of color for expressiveness. Another group of artists, the Fauves, later expanded on color

Figure 11–7 Vincent van Gogh, *Gauguin's Chair,* 1888. Oil on canvas. Van Gogh Museum, Amsterdam. Vincent van Gogh Foundation. The chair depicted is meant to be an expressive color "portrait" of Paul Gauguin.

expression, notably the painters Henri Matisse and Andre Derain. Several Expressionist artists also explored personal color, including Edvard Munch, Gustav Klimpt, and Egon Schiele. A common ideal upheld by these artists was a desire for self-expression through color. Expressionist artists sought freedom from perceptual color, using color subjectively to enhance personal aspects of their subjects. Expressive color selections were based on the artists' inner reality and personal reaction to their subjects and themes, rather than their visual perception of the external world.

High-saturation colors do not always add up to shock and color discord. In Van Gogh's painting *Gauguin's Chair,* blue-green and earth red contrast to emphasize his commentary on the artist Paul Gauguin's personality. [11.7] Van Gogh's color choices were based on his "portrait" of Gauguin through the depiction of his empty chair. The dramatic color shifts, and images of a candle and French novels, are meant to convey the essence of Gauguin's powerful and dynamic personality.

Personal color harmony or discord is ultimately in sympathy with the aims of the artist or designer. The artist manipulates color harmony or discord to provide a visual experience that emotionally enhances the subject, function, and theme of the work of art.

FREE FORM COLOR HARMONY

Since expressive color is without formal rules, how can color instinct or expression be learned? A "free form" study with associative color choices can provide experience by communicating emotionally with color.

Free form color harmonies are most effective when based on specific ideas, which link color with concept. A list of verbal/conceptual opposites can be a springboard for the color-association process. Color association focuses on the communicative quality of color by affiliating a group of harmonious or discordant colors with each verbal idea. [11.8] A sample list of visual/verbal opposites follows.

VISUAL/VERBAL OPPOSITES

Bright—Dull	Close—Far
Night—Day	Ordered—Random
Morning—Evening	Light—Heavy
Light—Dark	Stationary—Moving
Uniform—Gradated	Open—Contained
Expanding—Contracting	Cold—Hot
Simple—Complex	Wet—Dry

A simple word association exercise leads to two to ten colors to be associated with each verbal concept. For example, the word "simple" might be associ-

Figure 11–8 Part of free form color study is selecting colors that illuminate specific concepts for color expression. TOP: color selections for the words, light & heavy. BOTTOM: Moving and stationary..

Figure 11–9 Free form studies based on the words (top) *hot* and (bottom) *cold.* Paint, collage, and assemblage. Student work by Bonnie Sue Bacon.

ated with a group of primary hues or a monochromatic color scheme, both being simple color groups. The opposing concept, "complexity," for example, might correlate with a wide range of full saturation colors. As a second step, the verbal list can be employed to synthesize a vocabulary of lines, marks, media, texture, scale, or shapes that communicate each verbal concept in an abstract, nonimage format. [11.9]

THEMATIC COLOR

Color elicits emotion as well as visual responses. In this manner, colors can effectively convey the underlying theme of an artwork. Art represents virtually any subject matter or idea in a visual format. The content of art includes its subject, underlying theme, and iconography (symbols). *Subject matter* is what is perceptually evident in an artwork. In other words, what is is obviously depicted in the piece of art—a house, a face, or lines and shapes? The traditional subjects of perceptual art are human figures, portraits, still lifes, and landscapes. Conceptual art differs from perceptual art because it pertains to our inner world of feelings—our dreams, our—ideas—expressed about the world, rather than depicting the outward appearance of things. Conceptual art ranges widely in subject: distortions of reality, expression of inner thoughts, fantasy or dream images, formal subjects such as texture or line, unconventional views of everyday life, and ideas about political, or gender subjects.

The theme of an artwork is a concept that is both separated from yet dependent upon a subject. A *theme* is the underlying meaning or idea in an artwork, in other words, its inner statement. For example, if the subject matter of a painting is a deserted street, the inner meaning or theme of the piece could be human alienation. The thematic content of art may touch upon the environmental, political, sexual, universal, or spiritual aspects of living. The theme can be any aspect of life communicated in either a functional or aesthetic manner.

Color can be utilized in a symbolic, personal, and psychological manner to convey a visual message and express a theme. An inner message of an artwork can be gleaned from visual clues provided by the artist. The artist's subject, symbols, color harmony, color discord, or style forms statements about specific moods, social issues, human characteristics, spirituality, and everyday situations.

In Henri Matisse's *The Egyptian Curtain,* the artist uses strong pure colors to convey sunlight through a window and visual exuberance. Matisse's color makes a statement about the positive energy and excitement associated with this space. The color seems to stimulate ideas and the joy of making art. Matisse said of his work, "What I dream of is an art of balance, purity, and serenity, devoid of troubling or depressing subject matter." Matisse's subject matter is life, his theme is joy, and the vehicle of his message is color. [12.7]

Figure 11–10 William Blake, *The Good and Evil Angels,* 1805. Color print on paper, finished in ink and watercolor. Presented by W. Graham Robertson, 1939. Tate Museum, London © 2000 Tate Museum. Blade presents a good versus evil dichotomy expressed by dark/light color contrast.

Much of the art of William Blake lies in an opposite, spiritually disturbing thematic territory. The *Good and Evil Angels* juxtaposes the enlightened spiritual side versus the dark side of human nature. [11.10] This print alternates dark and light value keys and strong colors versus pale colors to convey good versus evil. The evil angel is depicted hovering against an earthy, orange-brown flamelike drapery that surrounds him like an aura. In contrast, the good angel holds a child, is represented in pale, delicate colors, and is backed by a view of an elegant, pale sunrise. Blake's color selections present us with a strong dichotomy between two floating figures, a dark wicked image and a light saintly one.

The separate disciplines of art and architecture can meld perfectly in thematic content. Leon Baskt (1866–1924) was a great designer of costumes and scenic art for the Ballet Russes in the early part of the twentieth century. [11.11] Bakst designed sets with the power of color in mind saying, "I have often noticed that each color has some specific shades which sometimes express frankness and chastity, sometimes sensuality, and even bestiality, sometimes pride and despair. It can be felt and given over to the public by use of certain effects . . . The painter who knows how to make use of this . . . [and] . . . can draw from the spectator the

exact emotion which he wants them to feel." Baskt designed an environment of a tented harem that used exaggerated perspective, textural motifs, and strong saturated color contrasts to set the emotional stage for the ballet *Scheherazade* by Rimski-Korsakov.

An artist can express any theme by a combination of subject matter, art elements, design, and color selections. Making a two- or three-dimensional study based on a specific theme broadens our comprehension of color expression. Two common thematic subjects are either human characteristics and emotions or cultural and environmental conditions. A verbal list is invaluable to help specify a theme. A theme can be chosen from the provided list or a more individualized thematic list can be compiled. After the selection of a specific theme, brainstorming ideas for the study encourages multiple approaches to the same idea. For example, the shapes, images, and colors that express a theme of war are vastly different from the elements selected to express a theme of peace. Formal aspects of the artwork should be thus dictated by the conceptual idea.

A sample list of themes for an expressive color study follows.

Figure 11–11 Leon Baskt, *Set Design for Scherazade,* 1910. Watercolor and graphite on paper. © Collection of The McNay Art Museum. Gift of Robert L. B. Tobin. Bakst's use of color in set design was meant to establish a color atmosphere for the audience.

HUMAN STATES, CHARACTERISTICS, OR MOODS

Anger	Serenity	Meditation
Thoughtfulness	Mourning	Whimsy
Greed	Animation	Paranoia
Envy	Tenseness	Victoriousness
Compassion	Obsessiveness	Hostility
Hunger	Callousness	Growth
Confusion	Health	Worshipfulness
Lust	Arrogance	Frailty
Alienation	Calmness	Death
Illness	Hate	Love

ENVIRONMENTAL AND CULTURAL THEMES

War	Pollution	Justice
Peace	Humidity	Celebration
Richness	Urban	Darkness
Austerity	Aridness	Coldness
Silence	Infinity	Oppression
Noisiness	Confinement	Imprisonment
Dirty	Winter	Airy
Cleanliness	Summer	Pastoral
Wealth	Purity	Poverty

After a theme is chosen, a composition that visually expresses the concept is planned. The process of brainstorming begins with writing or sketching any possible ideas without prejudging their appropriateness. Brainstorming should be spontaneous enough to make instinctive color and image selections. Thinking in a quick stream of consciousness fashion, rather than laboring pictorially facilitates this process. A theme may be expressed by either image or abstraction or by a combination of both. To start with, appropriate images, shapes, and colors are selected for expression of the theme. [Figure11.12] After compiling word lists and sketches one may omit the overobvious, clichéd, or tired ideas.

The final step is to choose the best sketches, refine one visual composition, and choose the art elements to be used, such as line, texture, and colors. For any theme, compositional layout should be evaluated as a factor. Colors should reflect the theme through either cultural or personal color choices. For example, if a theme of anger is chosen, art elements, words, and images associated with anger can be drawn or written down. How can the theme of anger be expressed abstractly without specific images—by color, mark, shape, and composition? What colors are culturally associated with the idea of anger? The answer may be red, as in "seeing red" when we

Figure 11–12 Thematic study on the word *arid.* Assemblage and paint. Student work by Marlene Shevlin.

are angry. What colors does one personally associate with anger? Should color harmony or discord be used to express anger? A list of adjectives or verbs for the word "anger" can then be compiled, for example, rage, aggression, seething, stewing, and conflict, to suggest specific images associated with these words. Images extracted from this written list might include saws, nails, guns, swords, light rays, shouts, or fists. A two-dimensional or three-dimensional format will be chosen along with a list of media, objects, or textures that visually communicates the theme. Images can be used not necessarily locked into a traditional pictorial structure but out of context or juxtaposed. Once multiple ideas have been generated the piece of art can be executed. [11.13]

Expressive color is highly subjective, entailing a process of personal and cultural self-discovery by the artist or designer. Color expression leads art making away from merely a formal study to the inner world of ideas, symbols and imagination.

ACTIVITIES

1. SIGNATURE COLORS

Objective: To understand one's own color preferences. Learning to develop a selection of personal color harmonies or signature colors.

Figure 11–13 Thematic studies on the words (top)*organic* and (bottom) *man-made*. Assemblage and paint. Student work by Laura Shoemaker.

• Pick or create one or two groups of colors that you think of as creating a personal harmony or that represent some aspect of your personality. Start with several hues and variations or make colors according to descriptive color names. Colors can be pure hues, neutrals, or any variation.

- Use markers, colored pencils, computer color, or colored paper swatches for one or two sets of signature colors with ten colors each.
- Present these color sets in a nonimage manner, such as a pattern, as stripes, or as a grid, so that the colors will be read as being independent of image or composition. [11.6]

2. FREE FORM COLOR STUDIES

Objective: This study is for the student to learn about the free association of colors with verbal concepts. Also, the student should to be able to express the idea of visual opposites with both color and composition.

Media: Cut or torn papers or paint on board.

- From the list of verbal and visual opposites in Chapter 11, pick a set of opposite concepts, for example, light and heavy. You can start by making a verbal list of colors that you consider light and those you consider heavy. For example, some people may consider dark shades of colors heavy; others might think that full saturation colors are heavy.
- An instinctive word/visual association process is most appropriate for this. Try not to prejudge your choices. Come up with a group of five to ten colors for each concept. Draw them out with a marker, use computer color, or colored pencil.
- As you create these groups of colors, think in terms of harmonies or dissonances. Which is appropriate for the chosen concept?
- Free associations can be utilized to create some quick drawings that express the concepts with other art elements, such as line, scale, and texture.
- The products of the free associations can be synthesized into a composition with color, and at least one other design element, such as shape, to fully express the visual opposite.
- There should be one composition per concept and:

 -A series of compositions on each pair of visual opposites.

 -Visual opposites together in one composition.

 -Totally nonobjective or abstract means to express each concept.

 -Images to symbolize each concept.

 -Simplified or abstracted images to expresses each concept.
- Remember that however the concepts are expressed, color should be the primary means of communication in the composition. [11.14] [11.15, see page 355]

3. THEMATIC COLOR STUDY

Objective: The process of using color to express a human characteristic or an environmental or cultural theme. Also, an exploration of making an object in three dimensions with color and found objects.

Media: On foam board, wood, or illustration board, constructed with glue. Includes found objects, painted and/or colored paper.

- Pick out several themes from the list of human states and characteristics or environmental and cultural themes in this chapter.

Figure 11–14 On the words elegant, (top) and crude, (bottom). Free form study. Collage, paint, and assemblage. Student work by Mary Ann Best.

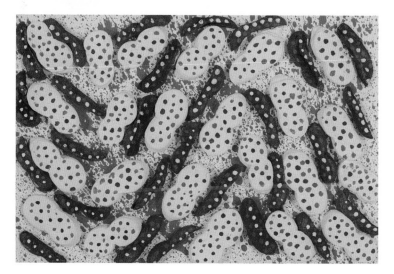

Figure 11–15 Free form studies on the words *stationary* and *moving*. Paint and assemblage. Student work by Isabelle Caruso.

- Brainstorm images, shapes, colors, symbols, and compositions by a free association process. Take into account personal reactions as well as the cultural views of each theme.
- Write lists of ten or more images, shapes, or colors that you connect with each theme.
- Pick the five best ideas from the verbal list and sketch out possible compositions to be executed in two or three dimensions. If three-dimensional, draw top and side views.
- If the structure is complex, make a paper model to prevent any possible structural problems.

Figure 11–16 Thematic study on nature vs. technology. Paint and assemblage. Student work by Lisa Webb.

- Plan colors that enhance and strengthen your thematic message. If the theme is a negative one, such as war or tension, color discord may be used to more aptly express the theme.
- The final piece should not be overly obvious, clichéd, or appropriated from media sources, but the viewer should have some indication of what theme is being expressed. Imagery should be used in a symbolic fashion to avoid a literal reading of the subject.
- The structure can be made from wood, foam core, illustration board, or another material. Use hot glue or craft glue. You may use some found objects to enhance your idea. [11.16] [11.13]

Chapter 12

Color in Art

Color has been a primary aspect of art since prehistoric times. The role that color plays in art is always in flux, shifting throughout art history. The artist uses color perceptually, symbolically, intuitively, expressively, and formally to create light and form illusion. This chapter notes a very selective group of artists and art movements that have altered the role of color in art history. This discussion is certainly not comprehensive but does provide a look at key points of color exploration in art history.

Artists employ color in one of three general styles—as luminist, tonalist, or colorist. The *luminist* emphasizes the color effects of light. A *tonalist* applies subtle tonal steps in a narrow range of hues to create volume. The *colorist* interests lie in color contrasts and interactions applied for formal or expressive purposes.

Before written history, in 13,000 B.C., paintings were being made. While the specific rites or function of the cave paintings of Lascaux, France, remain a mystery, we have to admire the resourcefulness of the artist(s). Red and brown ochre and manganese dioxide black paint was applied with the fingers or sprayed on with the hand as a template. The Lascaux paintings are remarkable in their freshness of the bisons, horses, and men depicted. Most amazing, perhaps, is the evidence of man's compulsion to make art, which was akin to making magic. We share the inner drive to create art with our primitive ancestors.

REFLECTED LIGHT—BYZANTINE MOSAICS

Color and symmetry were considered the foremost elements of art from ancient times through the medieval period. In Byzantine art (A.D. 550–1450), color was equated with precious stones, symbolic of wealth and spirituality. The reflective colors of glass, stone, gold, and silver were the most prized materials, due to their ability to redirect light.

Mosaic is a form of painting that becomes an integral part of architecture, built onto a wall. [12.1] Byzantine mosaics utilized optical mixtures to create both color

Figure 12–1 Byzantine Mosaic, *Christ Flanked by Emperor Constantine and Empress Zoë,* early eleventh century. Votive mosaic, south gallery, Hagia Sofia, Istanbul, Turkey. © Erich Lessing/Art Resource, NY. Byzantine mosaics reflected actual light off the tile surfaces to symbolize divine light.

complexity and iridescence. Reflected candle or lamplight from the uneven surfaces of mosaics on church ceilings, apses, and walls sparkled and brought them to life. Mosaics were a physical realization of the concept of divine light executed in iridescent colored glass tiles. Tiles were made by encasing gold or silver foil inside transparent glass cubes. Color in Byzantine art was employed for its iconography: gold, silver, and white depicted divine light; blue symbolized the celestial or the heavens; and purple indicated royalty. In mosaics, colors were modulated by slight color variations of tiles in close proximity; these modulations formed optical mixtures. Pure colors were akin to jewels, representing rarity and preciousness of the Christian image. Jewels were thought to contain light and expressed the highest aesthetic in Christian art, divine power. Stained glass of the Gothic period of Christian art continued this tradition by light's transmission through the divine image depicted in the stained-glass window.

PRIMACY OF FORM—
 THE RENAISSANCE

Sistine Frescos—Michelangelo Buonarroti

The Renaissance period has a wide span of both time and geography, covering the period approximately from 1400–1560 in northern and southern Europe. High Renaissance painting in Italy was characterized by the correct depiction of forms in space, the employment of perspective, and classical ideals. Michelangelo Buonarroti (1475–1564) exemplified the Italian High Renaissance in his mastery of painting, sculpture, and architecture. Michelangelo's Sistine Chapel ceiling is considered one of the apexes of Renaissance art. [12.2]

During the Renaissance, the art guilds often controlled the quality of pigments to execute a commissioned work. Specific top quality pigments could be requested

Figure 12–2 Michelangelo, *Libyan Sibyl*. Fresco, detail of the Sistine Chapel ceiling. Sistine Chapel, Vatican Palace, Vatican State. © Scala/Art Resource, NY The Sistine frescos display the primacy of form favored by Renaissance artists. The newly cleaned colors, however, are pale, saturated, and rich.

and provided by the art patron when they commissioned a painting. Red and vermilion were the most expensive pigments and dyestuffs; so only important personages were represented wearing these colors.

In the Renaissance, color was subject to form. The painted form or volumetric aspect of the image reigned over color. Color was considered to be merely a decorative element of art. Form was regarded as a masculine art element, and color as a feminine art element. Michelangelo, who thought of himself primarily as a sculptor, painted a *trompe l'oeil* architectural framework for his volumetric, modeled figures of the Sistine frescos. Old Testament prophets and classical sibyls, which were female Greek prophets believed to have foretold the birth of Christ, flank the Old Testament scenes from the Creation to the Flood. Characters in Michelangelo's Old Testament drama were distinguished by beautifully painted drapery, meant to depict the iridescence of the "shot" silks of the artist's time.

For many years, Michelangelo's color aesthetic was regarded as dark, subtle, and muted. Years of candle soot and dirt in the Sistine Chapel made the artist's original color intention unclear. When the Sistine ceiling was cleaned from 1989–1994, it uncovered a revelation about Michelangelo's color aesthetic. The fresco's colors emphasized the volumes of the figures, but the colors were paler in value and chromatically richer than previously suspected. Controversy surrounded the newly cleaned work. Some art historians believed that some of the artist's subtleties were being removed along with the dirt. The cleaned fresco compelled scholars to revise their interpretation of Michelangelo's vision and his original color statement.

LIGHT AND MOVEMENT— THE BAROQUE

Caravaggio

The Baroque period of Western art spanned the late sixteenth century through the seventeenth century. Movement of figures and drapery through space along with potent light/dark value contrasts characterized the Baroque period of painting. The naturalistic high contrast lighting of forms is called *chiaroscuro*. Several artists of this time employed the luminist approach of chiaroscuro, including Rembrandt van Rijn. Michelangelo Merisi, an Italian artist commonly called Caravaggio (1573–1610) after his birthplace, rendered scenes from the Christian gospels with unparalleled naturalness and realism. The theme of his paintings is light itself, which he presented as a subtle indicator of the presence of God. Caravaggio never used older devices such as halos or gold-leafed surfaces to convey spirituality. Instead, he plunged his figures into a dark space with narrow depth and then illuminate the scenes with dramatic, harsh light and shadow. Caravaggio's *The Crucifixion of St. Andrew* (1607) presents executioners of the saint

Figure 12–3 Michelangelo Merisi Caravaggio (1573–1610, Italian), *The Crucifixion of St. Andrew,* 1607. Oil on canvas, 202.5 x 152 cm. © Cleveland Museum of Art 2001. Leonard C. Hanna, Jr. Fund 1976.2. Caravaggio used chiaroscuro, a dynamic light/dark contrast, to dramatize his subjects.

miraculously frozen in space, a divine event that allowed the saint to die on the cross as a martyr. [12.3] Caravaggio projects the impression that the onlookers' faces are immobilized. Caravaggio also inserted a note of naturalism in the contemporary dress of the spectators. The directional forces of two flanking figures, whose eyes are transfixed by the crucifixion, reinforce the painting's dynamic. Caravaggio uses the direction of light to convey divine power. A light source emanating from the left illuminates key sections of figures and faces, radiating to the right, as an indicator of the light of God. The drama of the painting is provided by its high light/dark value contrast, which serves as a metaphor for the sacred event. The "gloomy darkness," called *tenebrism,* controls light and color, heightening the narrative of the painting.

POETRY IN COLOR—ROMANTIC PERIOD

Joseph Mallord William Turner,

From the late 1600s onward, artists were influenced by the discoveries of Newton, and later by the color theories of Goethe. The art of the Romantic period, from the late 1700s to the 1860s, pertained to human emotions, man's relationship with

Figure 12–4 James Mallord William Turner (1775–1851, English), *Sun Setting Over a Lake,* 1840, 911 x 1226 mm. © Tate Gallery, London 2001. Bequeathed by the artist, 1856, NO 4665. Turner's paintings established color atmosphere by brushwork and gradients of hue and value.

nature and self-expression. The English painter Joseph Mallord Turner (1775–1851) was a product of his time and also a color innovator. His paintings were a documentation of history along with a unique depiction of dramatic light, as in the painting *Sun Setting over a Lake* (1840). [12.4] This painting presents color as light, space, time, and atmosphere. Turner placed his hues in sequential values to produce luminescent effects. The style of loose painterly marks accentuated almost formless areas of color in his paintings. Turner seems to have adopted Goethe's prejudice toward warm colors as positives and cold colors as negatives in his pictorial emphasis.

Turner's work is often seen as a precursor to both Impressionism and Abstractionism; however, his focus was not on the formal color achievements of his work, but on thematic content. His great themes included monumental ships and architecture of the past in addition to the luminous depiction of light. His romantic philosophy toward painting pushed him to an ever-increasing merger of subject with pure color, indicating the spirituality of nature. Turner was both a luminist and a colorist in his employment of both intuitive and theoretical color combinations. His paintings reinforce the theories of Goethe, through his use of

cool and warm colors, and Newton, through his acknowledgment of colors as components of light.

TIME AND PLACE—IMPRESSIONISM

Claude Monet

Unlike the Romantics, the Impressionists were engaged in a formal study of color and light. Several factors contributed to the Impressionist's stylistic developments and use of color. By the late nineteenth century, the artist's physical studio became portable, due to the availability of artist's colors in tubes. This portability allowed the artist to work outside on the actual site of the landscape. Cheveruel's discoveries of simultaneous contrast and optical mixing had an enormous influence on Impressionist painting. The advent of photography was also a factor in transforming the role of artists from recorders of reality to creators of subjective, expressive art.

The French Impressionist painter Claude Monet (1840–1926) was a great colorist and innovator. [12.5] The art movement of Impressionism conveyed the fleeting effects of light and weather on a particular time and place. Monet's objective observations of color and his painting work on site *(plien air)* were often subjectively finished in the studio. Theoretically, his small marks of color optically mixed together, but Monet's paint application was actually looser and more painterly than that of either Seurat or Pissaro. Monet's marks unite with his forms in a light and tenuous manner. Upon close inspection, Monet's paintings are essentially an abstract array of marks, a fact that shocked and appalled viewers of his time.

Figure 12–5 Claude Monet (1840–1926, French), *Water Lilies (Agapanthus),* 1915–1926. Oil on canvas, 201.3 x 425.8 cm. © Cleveland Museum of Art 2001. John L. Severance Fund 1960.81. Monet broke ground by his palette of spectral colors and small marks of color to optically mix.

In his specification of color to the quality of light, Monet is a pure colorist. His cool and warm tints of hues weave together to formulate light, temperature, and a particular time and place. Monet was an innovator because he only had spectral hues on his palette, deleting the earth colors of the past. His late paintings of waterlilies forged new territory toward both abstraction and color freedom.

SIMPLE ELEGANCE—JAPANESE ART

Woodblock Prints

Japanese art emphasizes balance, color, and a strong compositional aesthetic. Areas of flat color emphasize the graphic quality of both Japanese prints and screens from the eighteenth and nineteenth centuries. In Asian art, shape and line are dominant over both color and form. Color masses are either flat or textured but always have highly structured contours. The preferred harmonies of Japanese color are either contrasting complements or analogous hues, in addition to black, white, and red. The neutral black and white aesthetic stems from traditional ink paintings and calligraphy, which emphasized line and mark. Japanese ink paintings have sensitive modulations of light and dark that are not quite as apparent in the color prints and screens.

The famous wood block print "The Great Wave at Kanagawa" (from a series of Thirty-six Views of Mount Fuji) by Katsushika Hokusai exemplifies the refinement and stylization of Japanese wood block prints. The graphic flatness of color and linear quality of this image is enhanced by the dynamic force of the stylized wave. Mount Fuji is a stable point, far in the background, and the fishing boats present a counterpoint to the great wave, balancing the composition. The flat areas of color operate as design elements, contrasting with Western color usage of the time, which used color to depict light, form, and atmosphere. When the United States commenced diplomatic and trade relations with the Japanese in the late nineteenth century, Japanese art was a revelation to Western artists. The impact of Japanese art on Western art was highly influential on several developing modern styles. [12.6]

COLOR EXPRESSION—
NEOIMPRESSIONISM

Van Gogh and Gauguin

The influence of Japanese art on the Neoimpressionists Vincent van Gogh (1853–1890) and Paul Gauguin (1848–1903) was profound. Van Gogh's approach to color was revolutionized by his exposure to Japanese art. Both Gauguin and Van Gogh were influenced by both the linear quality and juxtaposition of flat colored areas in Japanese prints. Post-Impressionism, or Neoimpressionism, is a loose cate-

Figure 12–6 Katsushika Hokusai, *The Great Wave at Kanagawa 1831–33* (1760–1840 Japanese), from the series, "Thirty-six Views of Mount Fuji," polychrome wood block print, Metropolitan Museum of Art, NY, H. O. Havermeyer Collection, Bequest of Mrs. H. O. Havermeyer, 1929. JP 1847 Photograph © 1994 The Metropolitan Museum of Art. The Japanese refined the art of relief printing in their polychrome wood cut prints. These prints were instrumental in a new approach to color in Western art.

gory for a highly individualized group of artists that include Georges Seurat, Paul Cézanne, and Toulouse Lautrec, whose work succeeded Impressionism.

Gauguin and Van Gogh, who lived together for a time, sought to revolutionize art through a fresh approach to color. Van Gogh's color was drawn onto the canvas with individual linear marks and highly saturated complementary hues, which accentuated the expressive quality of his subjects. The visual force in Van Gogh's paintings is also due to his mode of aggressive color application with thick impasto paint. [11.7] The physicality of his textured surfaces serves to emphasize his color contrasts in a dramatic fashion. Instead of painting his subjects in local colors, Van Gogh employed imaginative color as an indirect mode of thematic communication.

Paul Gauguin was also drawn to the dramatic "flat" effects that he saw in Japanese art, and in the sculptures and motifs of Tahiti, where he lived in later life. Gauguin lived in Tahiti for several long periods of time starting in 1891. His desire to live a primitive life devoid of Western culture motivated his artistic growth. His work was informed by Egyptian, Asian, and Indian art, which at the time was thought of as "primitive art." Van Gogh and Gauguin released color from representation and utilized it for self-expression.

FAUVISM AND BEYOND

Henri Matisse

In his youth, Henri Matisse (1869–1959) was affiliated with the Fauves, a group of young French painters. The Fauves were known as the "wild beasts" because of the vivid colors and distortions of reality in their paintings. [12.7] Fauvism wished to establish a new expressionist colorist tradition in French painting. In Henri Matisse's early paintings he used strong combinations of cool and warm color, very saturated, to indicate modeling on faces and figures. Later in his career, he introduced flat color into his paintings, and line, color, and shape became his primary elements. The fresh, direct quality of his paintings shocked viewers of his time. The same qualities of direct, pure, saturated colors painted in a spontaneous, fluid manner are what draw us to his art today. Matisse freed color from depiction and form saying, "I cannot copy nature in a servile way; I am forced to interpret nature and submit it to the spirit of the picture." His joyful paintings have a color resonance due to the transparent, almost watercolor-like surfaces of his oils. The decorative, flat colors of his subjects—figures, foliage, and themes of the joyful essence of life—led to his later colored paper cutouts, which are the distillation of his work.

Figure 12–7 Henri Matisse, *Interior with Egyptian Curtain,* 1948. Oil on canvas, The Phillips Collection, Washington, DC. © 2002 Succession H. Matisse, Paris. Artists Rights Society (ARS), New York. Matisse used expressive, flat color, to project a theme of ease and joy.

Figure 12–8 George Braque (1882–1963, French), *Violin and Palette,* 1909. Oil on canvas, 36½" x 16⅞". Solomon Guggenheim Museum. 54.1412. George Braque © 2002 Artists Rights Society (ARS), New York/ADAGP, Paris. Cubism deconstructed reality into planes with nearly achromatic colors.

STRUCTURED SPACE—CUBISM

Picasso and Braque

In 1909, after Pablo Picasso (1881–1973), the Spanish artist, painted the revolutionary *Les demoiselles d'Avignon,* he joined forces with Georges Braque (1882–1963), a Frenchman, to produce one of the most influential styles of art in the twentieth century. Color had become an expressive element due to the innovations of the Fauve and Expressionist art movements, but most subjects were recognizable in painting until this time. From 1909–1914, Picasso and Braque worked in close proximity to develop a new art movement subsequently called Cubism. Cubism viewed the subject (mostly traditional still lives, figures, and portraits) in a revolutionary manner. While the Fauves abstracted reality by flattening space and color areas, Cubism readdressed spatial and form issues. Multiple views of the subject existed simultaneously, in an attempt to deconstruct reality. The views were fractured into a cubic structure, virtually eliminating the negative picture space and making figure and ground ambiguous. Forms merged together into a single surface making the identities of each object vague.

In the painting *Violin and Palette* by Georges Braque, there are recognizable objects such as a violin, music, and an artist's palette, arranged in a vertical composition. [12.8] Braque enjoyed the tactile quality of the fragmented surfaces, which was a metaphor for the processes of both visual art and music. Subtle color, value, and tonal shadings formed the shattered cubic planes in a Cubist vision of reality. Most early Cubist paintings are almost achromatic, but subtle tonalities of cool/warm low

saturation colors cause areas to advance or recede spatially. Braque's *Violin and Palette* (1910) uses color as well as value gradations to differentiate objects. The resultant simultaneous views cause us to continually move through the shallow space of the painting. Cubism set the stage for abstraction as the artist's alternate visual language.

COLOR UTOPIANS—MODERNISM AND DE STIJL

Mondrian

Modernism began in the early twentieth century, and reached an early century culmination in the Bauhaus School, a pre–World War II art school in Germany. Modernism sought to put aside the traditions of art in favor of a newer, purer form of utopian art.

Piet Mondrian (1872–1944) was a Dutch artist and one of the founders of the De Stijl (The Style) art movement in the Netherlands, which spanned the years 1917 to 1931. The De Stijl movement adhered to the belief that there were two kinds of beauty, sensual and subjective, or rational and objective. The De Stijl group concluded that rational objective art was art in its highest, purest form. Modernism thus set up a dichotomy between expressionism and formalism.

Mondrian honed his art to only formal elements: using geometric shapes, eliminating representation, refining his color to the three subtractive primary hues, and using the two essential values of black and white. [12.9] Mondrian used exclusively horizontal and vertical directions to symbolize opposing forces. These forces were symbols for either opposite genders or the spiritual versus the material worlds. In his compositions, Mondrain wished to obtain "dynamic equilibrium," his definition of the balance between opposing forces. The Modernist aesthetic was both rational and antiorganic. To Mondrian, the primary hues of red, yellow, and blue were the only true colors, as sources for all the other colors. He saw yellow and blue in opposition to red for balance. In

Figure 12–9 Piet Mondrian, (1872–1944, Dutch), *Tableau 2,* 1922. Oil on canvas, 21⅞" x 21⅛". Solomon R. Guggenheim Museum, NY. 51.1309. Photograph by David Heald © The Solomon Guggenheim Foundation, NY. © 2002 Mondrian/Holtzman Trust c/o Beedrecht. Artists Rights Society (ARS), NY. Mondrian purveyed a modernist aesthetic through his restriction to the three subtractive primary hues in balance.

Figure 12–10 Pierre Bonnard (French), *Dining Room on the Garden,* 1934–1935. Oil on canvas. 50" x 53¼". Solomon R. Guggenheim Museum, NY. Gift, Solomon R. Guggenheim, 1938. Photograph by Carmelo Guadagno © Solomon Guggenheim Foundation, NY. © Artists Rights Society (ARS), New York/ADAGP, Paris. Bonnard demonstrated his ability as a colorist in his tapestry-like patterns of color.

Mondrian's personal color iconography, red represented anger and sensuality, blue stood for spirituality, and yellow for the intellect. The aim of De Stijl was similar to other types of Modernism in its attempt to forge a universal visual language through art.

PIERRE BONNARD—PREMIER COLORIST

The paintings of Pierre Bonnard (French, 1867–1947) are traditionally thought to belong stylistically to the nineteenth rather than the twentieth century. This conception stems from his work being superficially Impressionistic in style, which also kept his work from the being accepted in the mainstream Modernist European painting of his time. Bonnard's paintings seem to elude categorization. In his twenties, Bonnard was a part of a group of artists called the Nabis who desired to formulate color into mood. Bonnard's later paintings show "qualities of daring" (as the critic John Russell said) that were conceptually on the same level as the inner worlds depicted by the Surrealists. [12.10] Bonnard's subjects of domestic life and nudes are explorations of sensations

of light, representing the complexities in the colors that we perceive. Bonnard's paintings are a visual challenge in the "feminine" realm of color. He was not interested in the masculine deconstruction of form that was at the base of Modernism. Bonnard's approach to painting was a synthesis of symbolism and impression. Unlike Impressionism, the paintings seem to occupy memory rather than being built from perception. The spaces in his paintings are defined by color, distorting traditional ideas of depth and making the forms fluctuate. Spaces are not merely flattened but completely rethought in a visual language of colored pattern that weaves a color tapestry of colored marks. Bonnard seems to unify a wide number of hues, saturation, and color temperature shifts effortlessly. His highly pitched colored saturation is visually exuberant but at the same time thematically melancholy.

INNER LIGHT—ABSTRACT EXPRESSIONISM

Mark Rothko

Abstract Expressionism, the first American art movement, came into the forefront of world art as a style in the late 1940s through the 1950s. The Abstract Expressionists returned to the instinctive color of Expressionism, putting aside the theoretical approach of Modernism in favor of subjectivity. The automatism of Surrealism was applied to large-scale paintings that were expressive, abstract in form, and indicative of the painting process itself. Jackson Pollack, William de Kooning, and Mark Rothko, among others, further released color from form and shape, using marks and drips to record the encounter of artist and canvas. One of the strongest colorists of this period was Mark Rothko (1903–1970). His paintings are more reflective and contained in mark than the work of either Pollack or de Kooning. Operating with the spiritual, meditative quality of color, Rothko's soft rectangles of color counteract and balance each other. [12.11] Like Albers, in each painting Rothko set up a new color situation. However, unlike Albers, Rothko's color juxtapositions resonate emotional states, rather than formal color relationships.

LIGHT REFLECTED—MINIMALISM AND BEYOND

In the late 1960s and the 1970s, two American art movements followed Abstract Expressionism and Pop Art, namely Minimalism and Op Art. Both of these styles, which are also referred to as Post-painterly Abstraction, revisited earlier Modernist ideas of formal color and composition, but these styles refined the earlier Modernist ideas to bare essentials. The subjects for minimalism and op art were generally nonobjective, involved with pure, geometrically based shapes and lines. Post-painterly Abstractionism was primarily concerned with formal visual relationships rather than with emotional or symbolic content.

Figure 12–11 Mark Rothko (1930–1970, American), *Untitled.* 1949. Oil on canvas, 80⅜" x 66¼". National Gallery of Art Washington, DC. 1986.43.138. PA. Photograph © 2001 Board of Trustees, National Gallery of Art, Gift of the Mark Rothko Foundation, Inc. © 2002 Kate Rothko Prizel and Christopher Rothko Artists Rights Society, (ARS), New York. Rothko's meditative juxtapositions of color were expressive rather than formal.

Dan Flavin

Dan Flavin (1933–1996) is the only artist listed here that made art of light itself. Flavin was a sculptor associated with Minimalism. He worked with one medium—commercial colored fluorescent light. His light sculptures are dependent on an architectural context, for they are as much about reflected color and light as about the actual bars of fluorescent light. His sculpture's are installed in corners, staircases, or as freestanding units. They cast a complex color glow on their surroundings. He considered his work, often dedicated to other artists or religious figures, to be icons "of limited light." He contrasts the spiritual (light as a symbol of the divine) with the ordinary commercial light that he uses to construct his sculptures. This sculpture, *Greens Crossing Greens,* is dedicated to Piet Mondrian, whose antiorganic philosophy caused him to exclude green from his palette. [12.12] Flavin constructed space with light and color alone, independent of any traditional matrix.

COLOR IN INSTALLATION AND IMAGE

Sandy Skoglund

Sandy Skoglund is a unique artist in both her media and approach to her subject matter. She creates installation art in human scale and makes photographs of them. The photos are another facet of her art. Real figures are often part of her roomlike environments. Her installations are commentaries on suburban life, dreams, and religion.

Figure 12–12 Dan Flavin, American (1933–1996), *greens crossing greens (to Piet Mondrian who lacked green)* 1966. Fluorescent fixtures with green lamps. 2 and 4-foot fixtures 52½" x 230½"" x 120". Solomon Guggenheim Museum, NY. Panza Collection, 1991. 91.3705. Photograph by David Heald © The Solomon Guggenheim Foundation, NY. © 2002 Estate of Dan Flavin/Artists Rights Society (ARS), NY. Flavin made sculptures from illumination, the reflected light is as important as the piece itself.

Surfaces in Skoglund's art have unexpected colors that communicate, contrast, and glow visually and which unify the considerable number of objects that occupy her spaces. The installations are balanced between fantasy and reality, often addressing serious political and human issues. The mystery of Skoglund's work is the everyday settings that are radically transformed by two things, an unexpected event and color. The unexpected event in this piece is leaves blowing through an office environment. The surreal or disconcerting twist in her art is her use of color for its own sake, unrelated to the reality of the spaces. In *A Breeze at Work,* all the office surfaces are painted with oranges and red-oranges causing the dreamlike blue leaves to vibrate as they float through the orange space. A mundane day has thus a strange infusion of nature, captured both in time and space.

Artists as colorists have spanned all periods and locations of art history. Artists have embraced color as a central part of their emotional symbolic, formal, and structural language.

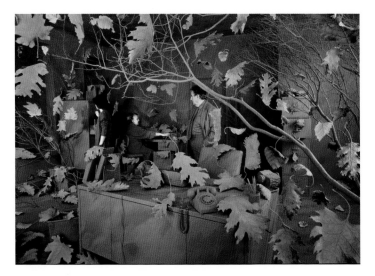

Figure 12–13　Sandy Skoglund, *A Breeze at Work,* 1987. Installation: plastalene leaves made from bronze molds, furniture, live models. Cibachrome photograph 40" x 60". © Sandy Skoglund. Sandy Skoglund uses color in room-sized installations (also presented in large scale photographs) that shift our perceptions of reality.

Glossary

ACHROMATIC Achromatic colors are neutrals, meaning that they contain no chroma or hue. An achromatic color scheme uses all achromatic or neutral colors; black and white, and a full value tonal range of grays.

ACTUAL COLOR TRANSPARENCY The perception of or use of transparent materials. When we perceive a transparent object the light is *transmitted;* that is, it is allowed to go through the object to create a color sensation.

ADDITIVE SYSTEM The system of color that uses light. When all the light primaries are combined, the result is white light.

ANALOGOUS COLORS Colors that are adjacent to each other on the color wheel, for example, blue, blue-violet, and violet. An analogous color scheme is based on the idea of a color family, using two or three neighboring hues from the color circle as a starting point.

ASYMMETRICAL BALANCE The balance of unequal art elements in an artwork; also called *informal balance.*

ATMOSPHERIC OR AERIAL PERSPECTIVE The differences we see between foreground, middle ground, and background objects in space that are caused by effects of atmosphere.

BALANCE A design principle that addresses the equal distribution of visual weight in any given piece of art.

BASE HUE A hue from the color circle to which a color is related. The concept of a base hue means that the thousands of colors that we perceive can be traced back to the twelve hues on the traditional color wheel.

BEZOLD EFFECT The effect of changing the dominant color in a given design and the subsequent varying of all the other colors.

BITMAP Images that use pixels to create areas of color on the computer screen; sometimes they are called raster images.

CHROMATIC NEUTRALS Subtractive intermixtures of complementary hues that create neutral colors based on chromatic, rather than achromatic, colors.

CIE The Commission International D'Eclairage introduced a standard color table in 1931 based on the additive primaries of red, green and blue. It uses a mathematical formula to create its color areas, providing an objective perceptual color model. A more recent incarnation of the *CIE system* (1976) is called CIE $L^*A^*B^*$ color.

COLOR A color is specifically a wavelength of light received by our eye that causes a color sensation to be produced in our brain. The word *color* also means any color derived from any hue; for example, violet is a hue and light violet is a color. A color is not necessarily chromatically pure and a hue is.

COLORANT A compound that imparts its color to another material.

COLOR ATMOSPHERE A color effect produced by the suggestion of luminous colors seen in the atmosphere at varying times of day. Also defined as color transparencies, or colors reflected from brightly lit surfaces.

COLOR ATTRIBUTES The variables or characteristics of color, which are hue, value, and saturation.

COLOR CHORD A group of hues chosen from the color circle that are spaced apart, such as red, yellow, and blue. The music chord–color chord analogy refers to the spacing of three or four color "notes" to produce harmony.

COLOR DISCORD Discordant colors are colors combinations that contrast, clash, or "fight" rather than harmonize. Color discord can make the viewer uncomfortable, but can be used to enhance the thematic content in a piece of art.

COLOR DOMINANCE A dominant color effect can be achieved by letting a single hue, value, or saturation dominate a composition. This influences all the other colors in the composition.

COLOR ENVIRONMENT Color choices that reflect and enhance the function and mood of an interior or architectural space.

COLOR EXPRESSION Color can function as the most expressive tool in art. Expressive color is a subjective, personal, cultural, or symbolic use of color in art or design.

COLOR INTERACTION A color illusion that occurs in our perception of color due to the interconnected relationships of colors. Also called relative color.

COLORFASTNESS Defined as the resistance of a color to the loss of its original color quality. High colorfastness means that a color will not darken, fade, bleed, or washout.

COLOR KEYS The notes on a piano keyboard are analogous to the concept of color keys. Two types of color keys are *value keys,* which are levels or light (high) to dark (low) colors, and *saturation keys,* which are levels of pure to muted colors.

COLOR PHYSICS The science of color, particularly the science of light and color perception. Color is defined as a visual sensation caused by the components of light either transmitted or reflected to the receptors in our eye.

COLOR PROPORTION Johann Goethe conceived of a system of color proportion in which a simple ratio system is used for balancing areas of pure hues in a composition.

COLOR SCHEMES OR HARMONIES Color circle–based formal hue selections used to achieve color harmony.

COLOR SYMBOLS Color associations that stand for ideas and/or are culturally based, for example, red for sexuality and black for death.

COLOR TEMPERATURE Refers to our sense of warm or cool colors. For example, red is warm in temperature because it refers to blood, fire, and the sun; blue is cold in temperature because of its reference to water, ice, and the sky. Each primary and secondary hue also has a cool or warm *aspect;* for example, red is cooled when blue is added, creating red-violet.

COLOR WEIGHT The visual weight of colors is relative to their interactive color environment. Some colors are innately heavy or inherently light in weight. For example, yellow is light and a black is heavy.

COLOR CIRCLE OR COLOR WHEEL Newton is commonly credited with the origin of the color circle or wheel format. By adding purple to the spectral band, Newton attached the spectrum to itself in a circle. The color circle provides a format to understand hue relationships.

COMPLEMENTARY COLORS Chromatic opposites directly across from each other on the color circle. These are called complementary hues or *dyads,* since they are in pairs. The major subtractive complementary opposites are blue to orange, yellow to violet, and red to green. A *complementary color scheme* is a perfectly balanced opposing pair (or dyad) from the color circle.

COMPLEMENTARY VIBRATION Complementary vibration occurs when two full saturation complementary hues are in close proximity. When these conditions exist, the colors will generate the illusion of movement.

COMPUTER COLOR Color generated by a computer in digital format. It also refers to display color on a computer monitor and the various color modes contained within a graphic program. A computer can produce 16 million colors from which to choose.

CONTENT Content in art can be *subject matter* (what a work depicts), *iconography* (the symbols present in a work), and *theme* (the ideas behind the work of art).

COOL/WARM COLOR HARMONY A four-hue color scheme that is less structured than most. Cool/warm contrast emphasizes differences in color temperature. Example: RO and red opposite BG and blue.

CONTINUATION OR CONTINUITY A visual pathway through a composition.

CRYSTALLOGRAPHIC BALANCE A pattern or subdivision of the picture plane, such as a grid, used to achieve balance.

DESIGN ELEMENTS The visual tools used to create both two-dimensional and three-dimensional art and design. The design elements are line, shape, space, form, value, scale, texture, and color.

DESIGN PRINCIPLES Theoretical guidelines for the compositional placement of art/design elements.

DOUBLE COMPLEMENTARY A four-hue contrasting color scheme. This scheme uses two adjacent complementary pairs, for example, yellow, YO, violet, and BV.

DYES Soluble colorants. Dyes transfer their color by being dissolved in liquid and staining or absorbing into a given material or surface.

ECONOMY The use of a minimal amount of visual information in art or design.

ELECTROMAGNETIC SPECTRUM Energy waves produced by the oscillation of an electrical charge. Electromagnetic waves do not need any material for transmission, that is, they can be transmitted in a vacuum. Light is part of this spectrum.

EMPHASIS A design principle that establishes a particular place of interest in an artwork. Emphasis is synonymous with a point of focus or *focal point* in art.

FORM Referring to the purely visual characteristics of art.

FORM OR VOLUME A shape that is realized in three dimensions is called a *form* or a *volume.*

GESTALT The perception of a configuration, pattern, structure, or wholeness. The word *Gestalt* can be roughly translated from the German as *configuration.*

GRADATION Anything that changes gradually in a visual sense. Scale, shape, color, position, texture, value, and color all can be gradated.

HSB OR HSV A computer color mode. The H stands for hue, the S for saturation, and the B or V for value or brightness. All three color attributes can be manipulated to produce a huge variety of colors.

HUE Hue means any wavelength from the visible spectrum. A hue is a specific color selection from the spectral color circle in its pure state, sometimes referred to as a *spectral hue.* Hues may be a primary, secondary, or a tertiary color.

INHERENT VALUE The light/dark value of a pure hue at its maximum saturation.

INFORMAL COLOR HARMONIES Harmonies with flexible rules, created by an artist.

LINE A pathway, the closest distance between two points, a moving point. A line is a mark with length greater than its width.

LINEAR PERSPECTIVE Lines and vanishing points used to depict the diminishing sizes of and recession of objects as they seem to more further away in the picture plane.

LOCAL COLOR The general color of an object under normal lighting conditions.

MEDIAL PRIMARY COLORS Red, green, blue, and yellow—a combined group of both the subtractive and additive primaries.

MONOCHROMATIC A color scheme based on one hue choice from the color wheel.

MOVEMENT Both the literal and the suggested motion in a work of art.

OPAQUE Refers to media through which light cannot pass. Opaque paint is also called *body color* because it uses white as part of the paint mixture and completely covers the surface onto which it is painted.

OPTICAL MIXTURES Colors that use tiny amounts of two or more colors that visually blend to create another color. An optical mixture can mix either pigmented materials or light.

PHYSICAL COLOR MATERIALS Those materials that are used directly, such as paints, colored drawing materials, and textile dyes.

PICTURE PLANE A given entity of art and design, the rectangle or square that is used to contain the composition.

PIGMENT A colored powder that gives its color effect to a given surface, when distributed over that surface in a layer or when mixed with a substance.

PIXEL A square unit that subdivides the computer screen is the words picture and element combined, thus a pixel is a picture element.

PLANE A shape that has height and width, but no breadth or depth. It is two-dimensional and flat but can have any type of outer contour.

POINT Either a dot or a location in space. A point can be visible or invisible and be of any size, but refers to a particular location or place in a composition.

PRIMARY COLORS Hues that are not obtainable by any other color mixtures

PROCESS COLORS The four colors used for commercial printing and color photography: cyan, magenta, yellow, and black, also abbreviated as CMYK. Cyan, magenta, and yellow are close to the traditional subtractive primary hues of red, yellow, and blue. The CMYK color mode on computer is meant to match with process printing colors.

PROCESS MATERIALS Those materials that are used indirectly through printing, photography, and computer graphics.

PROXIMITY Referring to the Gestalt concept of the physical grouping of objects.

RADIAL BALANCE This form of balance employs radiating or emanating forms from a given area or object.

REPETITION To repeat any art element or concept in order to unify a design.

RGB Red, green, and blue are the additive primaries of light. RGB also is a color mode used by both the computer monitor and scanner.

RHYTHM A design principle that encompasses the visual quality of movement, describing the manner in which our eye moves through an artwork.

SATURATION The property of color that refers to its purity, intensity, or chroma. High saturation key colors are pure, bright, and intense. Low saturation key colors are duller, subtle, and muted.

SCALE Refers to the relative size of objects in an artwork.

SECONDARY HUES The halfway points between the primary hues, for example, a mixture of red with blue will yield violet (red + blue = violet). Violet is a secondary hue.

SHADE A hue plus black which makes a darker value of a hue.

SHAPE A two-dimensional closed form or plane. A shape can have any contour, height, and width, but no depth. A shape has mass or area defined by its edges.

SIMILARITY According to Gestalt theory, when we perceive similarity in a design, our eye picks up the pattern or configuration of the similar elements.

SIMULTANEOUS CONTRAST Refers to colors that interact and affect each other, which can give them a different or varied appearance. Also refers to when the eye

simultaneously "wants" to see the complement of any given hue, affecting our perception of color in relationships.

SIMULATED TRANSPARENCY A color illusion, in which opaque media is used to create an illusion of transparency.

SPACE Actual physical space has three dimensions, height, width, and depth. Three-dimensional space can also be depicted on a two-dimensional format by spatial illusionary devices such as overlapping, diminishing size, vertical location, form and modeling, linear perspective, and atmospheric perspective.

SPLIT COMPLEMENTARY HARMONY A contrasting or a balanced harmony. A split complementary scheme has three hues and is based on an opposing dyad. Instead of using a direct complement, however, the two adjacent hues to the actual complement are chosen. Example: The split complement of violet is YO and YG.

SUBTRACTIVE SYSTEM In our perception of surface color some light waves are subtracted resulting in a reduction of the amount of light reflected to our eye. The subtractive color system is also in use with physical colors such as pigments and dyes, which lose intensity as they are mixed.

SUCCESSIVE CONTRAST A spontaneous color image produced in direct succession to the eye's overexposure to a single full saturation color. Also called *afterimage*.

SYMMETRY Formal balance, which is perfect balance vertically, horizontally, or diagonally along an *axis*. In a symmetrical composition, the elements of the composition are perfectly equal.

SYSTEMS OF COLOR NOTATION Color theorists have developed various systems of notation for the three color attributes of hue, value, and saturation.

TERTIARY HUES Those hues produced by the mixtures of a primary and a secondary: RO, RV, YO, YG, BG, BV.

TETRAD A four-hue color system that is balanced based on either a square or rectangle inscribed in the color wheel.

TEXTURE The characteristic surface quality of an object. Texture is related to our tactile sense, but we also experience texture visually.

TINT A hue or color plus white, which makes lighter values of a color or a hue.

TRANSPARENT MEDIA Media that light can pass through to the support below. Watercolor, oil glazes, markers, dyes, and some inks are transparent.

TRIAD An equilateral triangle inscribed in the color circle describes three equidistant hues that compose a *triadic* color system. The triadic system is a classically balanced color scheme and is used by many artists and designers. Example: orange, green, and violet.

UNITY A design principle that addresses the way the parts of a composition visually hold together. Unity is also referred to as *harmony*.

VALUE Value simply refers to all the perceptible levels of light and dark from white to black and the lightness or darkness of achromatic or chromatic colors.

VARIETY The variation of any art element or art concept in a repetitious visual structure.

VECTOR Computer graphic programs based on line drawing. Defined by math objects called vectors. Vector programs use mathematical locations or points to form lines and shapes.

VEHICLE OR BINDER Pigment is mixed with a vehicle or binder to become paint. A vehicle or binder must support and bind pigment particles as a well as easing the application of a pigment to a surface.

VISIBLE LIGHT SPECTRUM A small part of the electromagnetic spectrum that we can actually see.

VOLUME A plane that has been pushed back or comes forward into space. It has three dimensions, height, width, and depth.

WAVELENGTHS OF LIGHT Each hue in the visible spectrum has a corresponding wavelength measured in nanometers, which are only one billionth of a meter. Hue differences are tiny measurement differences between the crests of each wavelength. Red has the longest wavelength and violet the shortest.

Bibliography

ALBERS, JOSEF. *Interaction of Color,* rev. ed. Yale University Press, New Haven, CT. 1971.

ARHEIM, RUDOLF. *Art and Visual Perception.* University of California Press, Berkeley 1971.

BANN, DAVID AND GARGAN, JOHN. *How to Check and Correct Color Proofs.* Quarto Publishing, London 1990.

BALL, PHILIP. *Bright Earth—Art and the Invention of Color.* Farrar Straus and Giroux, New York. 2001.

BIRREN, FABER. *Color, Form and Space.* Reinhold Publishing Corp, New York. 1961.

BIRREN, FABER. *Creative Color.* Van Nostrand Reinhold, New York. 1961.

BUSER, THOMAS. *Experiencing Art Around Us.* West Publishing, New York. 1995.

CHEVREUL, M. E. *The Principles of Harmony and Contrast of Colors.* Van Nostrand Reinhold, New York. 1981.

COHEN, SANDEE AND WILLIAMS, ROBIN. *The Non Designers Scan and Print Book.* Peachpit Press, Berkeley, CA. 1999.

COLE, ALISON. *Eyewitness Art Color.* Porling Kindersley, London and New York. 1993.

CURRENT, IRA. *Photographic Color Printing.* Focal Press, Boston. 1987.

ELLINGER, RICHARD. *Color Structure and Design.* Van Nostrand Reinhold, New York. 1963, 1980.

ESSERS, VOLKMAR. *Matisse, Master of Color.* Barnes and Noble Books, New York. 1996.

FEISNER, EDITH ANDERSON. *Color Studies.* Fairchild Publications, New York. 2001.

FABRI, RALPH. *Color.* Watson Guptill, New York. 1967

GAGE, JOHN. *Color And Culture.* Bullfinch Press, Little, Brown and Co, London. 1993.

GARDINER, HELEN. Revised by Horst de al Croix and Richard G. Tansy. *Art Through the Ages,* 6th ed. Harcourt Brace, NY. 1970.

GASSAN, ARNOLD. *The Color Print Book.* Light Impressions Corp. Rochester, NY. 1981.

GERRITSON, FRANS. *Evolution in Color.* Schiffer Publishing, Westchester, PA. 1988.

GLENDINNING, PETER. *History, Theory and Darkroom Technique.* Prentice-Hall, Englewood Cliffs, NJ. 1985.

GOLDSTEIN, NATHAN. *Design and Composition.* Prentice Hall, Englewood Cliffs, NJ. 1989.

GUPTILL, ARTHUR. *Color Manual for Artists.* Van Nostrand Reinhold, New York. 1962.

HOPE AND WALCH. *The Color Compendium.* Van Nostrand Reinhold, New York. 1990.

ITTEN, JOHANNES. *The Art of Color.* Van Nostrand Reinhold, New York. 1973.

ITTEN, JOHANNES. *The Elements of Color.* Van Nostrand Reinhold, New York. 1970.

KANDINSKY, WASSILY. *Point and Line to Plane.* Dover Publications, New York. 1979.

KIERAN, MICHAEL. *Desktop Publishing in Color.* Bantam Books, New York. 1991.

KNUEPPERS, HARALD. *The Basic Law of Color Theory.* Barrons, New York. 1982.

KUEHNI, ROLF. *Color, Essence and Logic.* Van Nostrand Reinhold, New York. 1983.

KUWITCH, JOHN AND EAKIN, GARRET. *Interior Architecture.* Van Nostrand Reinhold, New York. 1993.

LADAU, ROBERT, PLACE, JENNIFER AND SMITH, Brent. *Color in Interior Design and Architecture.* Van Nostrand Reinhold, New York. 1989.

LAING, JOHN AND SAUNDERS-DAVIES, RHIANNON. *Graphic Tools and Techniques.* North Light America, Cincinnati, OH. 1986.

LAMBERT, PATRICIA. *Controlling Color.* Design Press, New York. 1991.

LAUER, DAVID A. AND PENTAK, STEPHEN. *Design Basics,* 5th ed. Harcourt Brace, New York. 2000.

LECLAIR, CHARLES. *Color in Contemporary Painting.* Watson-Guptill, New York. 1991.

LELAND, NITA. *Exploring Color.* North Light Books, Cincinnati, OH. 1985.

MAHKE, FRANK. *Color, Environment and Human Response.* Van Nostrand Reinhold, New York. 1996.

MARTINEZ, BENJAMIN AND BLOCK, JACQUELINE. *Visual Forces,* 2nd ed. Prentice Hall, Englewood Cliff, NJ. 1995.

MARX, ELLEN. *Optical Color and Simultaneity.* Van Nostrand Reinhold, New York. 1983.

MAYER, RALPH. *The Artist's Handbook of Materials and Techniques,* 3rd ed. Viking Press, New York. 1978.

NORMAN, RICHARD. *Electronic Color.* Van Nostrand, Reinhold, New York. 1990.

OCVICK, OTTO G., STINSON, ROBERT E., WIGG, PHILIP R., BONE, ROBERT O., AND CAYTON, DAVID L. *Art Fundamentals, Theory and Practice.* McGraw Hill, Boston. 1998.

OSBURN, ROY. *Lights and Pigments—Color Principles for Artists.* Harper & Row, New York. 1980.

PARRAMON, JOSE. *The Book of Color.* Watson-Guptill, New York. 1993.

POLING, CLARK. *Kandinsky's Teaching at the Bauhaus: Color Theory and Analytical Drawing.* Rizzoli International Publishing, New York. 1986.

PYLE, DAVID. *Prints and Colors.* Krause Publications, Iola, W.I. 2000.

SARGENT, WALTER. *The Enjoyment and Use of Color.* Dover Publications, New York. 1964.

SIDELINER, STEPHEN. *Color Manual.* Prentice Hall, Englewood Cliff, NJ. 1985.

SIMON, HILDA. *Color in Reproduction.* Viking Press, New York. 1980.

STOKSTAD, MARILYN. *Art History,* rev. ed. Prentice Hall, Upper Saddle River, NJ. 1999.

VERITY, ENID. *Color Observed.* Van Nostrand Reinhold, New York. 1980.

WONG, WUCIOUS. *Principles of Color Design.* John Wiley and Sons, New York. 1997.

ZELANSKI, PAUL. *Color,* 3rd. ed. Prentice Hall, Upper Saddle River, NJ. 1999.

ZELANSKI, PAUL. *Design Principles and Problems,* 2nd ed. Harcourt Brace, New York. 1996.

INTERNET SOURCES

www.colorsystem.com
www.handprint.com
www.enabling.org
www.humboldt.edu
www.nga.gov
www.smithsonianmag.org
www.webexhibits.org

Index of Student
Illustrations
and Photography
Credits

Chapter 1

1.11 Photo: David J. Koenig
1.20 Photo: Becky Koenig

Chapter 2

2.2 Photo: Becky Koenig

Chapter 3

3.27 Photo: David J. Koenig
3.29 Student work: Marlene Shevlin, Villa Maria College. Photo: Keith
 Broadhurst

Chapter 4

4.18 Photo: David J. Koenig
4.19 Photo: David J. Koenig
4.20 Photo: David J. Koenig
4.21 Photo: David J. Koenig
4.28 Photo: Becky Koenig
4.29 Student work: Andrea La Macchia, Villa Maria College. Photo: Laura Snyder
4.31 Student work: Donna Briceland, Villa Maria College. Photo: Laura Snyder
4.32 Student work: Marlene Shevlin, Villa Maria College. Photo Laura Snyder

Chapter 5

5.1 Photo: David J. Koenig
5.3 Photo: David J. Koenig
5.4 Photo: David J. Koenig
5.7 Photo: Mark Lavatelli
5.8 Photo: David J. Koenig
5.10 Photo: David J. Koenig
5.12 Photo: David J. Koenig

5.19 Photo: George Emery

Chapter 7

7.4 Student work: Kelly Mordaunt, State University of New York at Buffalo.
 Photo: Keith Broadhurst
7.16 Student work: Mimi Fierle, Villa Maria College. Photo: Laura Snyder
7.24 Student work: Simone Theriault, Villa Maria College. Photo: Laura Snyder
7.25 Student work: Mimi Fierle, Villa Maria College. Photo: Laura Snyder
7.26 Student work: Graysya Bush, State University of New York at Buffalo.
 Photo: Keith Broadhurst
7.27 Student work: Simone Theriault, Villa Maria College. Photo: Laura Snyder
7.28 Student work: Priya Patel, State University of New York at Buffalo. Photo:
 Keith Broadhurst
7.30 Student work: Branden Kautz, State University of New York at Buffalo.
 Photo: Keith Broadhurst
7.31 Student work: Jennifer Kopra, Villa Maria College. Photo: Brian Duffy

Chapter 8

8.4 Student work: Allyson Carreon, State University of New York at Buffalo.
 Photo: Keith Broadhurst
8.5 Student work: Liza Palillo, State University of New York at Buffalo. Photo:
 Keith Broadhurst
8.7 Student work: Alicia King, Villa Maria College. Photo: Laura Snyder
8.8 Student work: William Otis, Villa Maria College. Photo: Laura Snyder
8.11 Student work: Merrill Rose Stephans, State University of New York at
 Buffalo. Photo: Keith Broadhurst
8.21 Student work: Catherine Van Galio, Villa Maria College. Photo: Laura
 Snyder
8.22 Student work: Michelle Priano, State University of New York at Buffalo.
 Photo: Keith Broadhurst
8.26 Student work; Alicia King, Villa Maria College. Photo: Laura Snyder
8.27 Student work: Amy Claroni, Villa Maria College. Photo: Laura Snyder
8.28 Student work: Darlene Mastrangelo, Villa Maria College. Photo: Laura
 Snyder
8.29 Student work: Amberly Strzalka, Villa Maria College. Photo: Laura Snyder
8.30 Student work: Priya Patel, State University of New State at Buffalo.
 Photo: Keith Broadhurst

Chapter 9

9.7 Student work: Michelle Brzezowski, Villa Maria College. Photo: Keith
 Broadhurst
9.9 Student work: Andrea La Macchia, Villa Maria College. Photo: Laura Snyder

Chapter 10

Chapter 11

Index

A

Abstract expressionism, 270, *270*
Achromatic colors, 34, 36, *36,* 48
 afterimage/simultaneous contrast and, 74–75, *76*
Achromatic harmony, 193, *193*
Achromatic scale, 34, *53*
Acrylics, *112,* 112–13
Actual line, 149
Actual space, 155
Actual textures, 163
Actual transparency, 92, *94*
Additive color media, 11
Additive color system, 1–2, 6–8, *8*
 color circle in, *19,* 31
 complementary hues and, 16–18, *17*
 subtractive system related to, 15–16
Additive process, for invented shapes, 153, *154*
Afterimage, 41, 73, *73,* 74–75, *76*
Aguilonius, Franciscus, 24–25
Albers, Josef, 75, 77, 270
 color interaction studies, 82–85, *83, 84*
Alberti, Leone Battista, 24, *25*
Alternating rhythm, 185
Analogous hues, 40, *40*
Anomaly, 176, *177*
Aristotle, color theory of, 23–24, *24*
Asymmetrical balance, 181, *182, 183*
 color and, 222–23, *223*
Atmospheric perspective, 160

B

Babbit, Edwin, 237
Background, 156, *157*
Bacon, Francis, 24
Bakst, Leon, 248, *249*
Balance, as design principle, 179–84
 asymmetrical balance and, 181, *182, 183,* 222

crystallographic balance and, 181, 183, *183*
 radial balance and, 183, *184*
 symmetry and, 179, 181, *181*
 See also Color balance
Balanced color harmonies, 202–6
 tetrad harmony, 204, *205*
 triadic harmony, 202–4, *203, 204*
Baroque period, 260–61, *261*
Base hues, *50,* 50–51
Base line, 157
Bauhaus School, 75
Benday dots, 122, 123, *124*
Bezold effect, *91,* 91–92
Binders, 101, *102,* 103, 104, *105*
Bitmap images, 129, *130*
Bits/bit depth, *128,* 128–29
Blake, William, 248, *248*
Blon, Jacques Christophe le, 27
Blurring, suggested motion and, 184
Bocour, Leonard, 112
Body color, 105, *105*
Bonnard, Pierre, 268–70, *269*
Braque, Georges, 267, *267*
Byzantine mosaics, 257–58, *258*

C

Caravaggio, 260–61, *261*
Chalk pastels, *113,* 114
Chevereul, Michel Eugene:
 color relativity and, *73,* 73–74
 optical mixtures and, 85
Chiaroscuro, 260, *261*
Chroma. *See* Saturation
Chromatic gradation color scheme, 207, *208*
Chromatic neutrals, 64, 196, *197*
CMY (cyan, magenta, yellow) process:
 colors, 8, 14, *18, 19*
 color printing/photography and, 19
CMYK color mode, 135–37, *136, 137*
Collective unconscious, 235
Color:
 aspects, 1